RUBY

OTHERWORLDLINESS

A project by Irana Douer

gestalten

Ruby was born as the subjective reaction of a 21 year old art student, in a country at the periphery of contemporary art, to its context. A little longer than five years ago, sitting in front of her computer, Irana Douer decided to trespass the borders of what her environment had to offer in order to go out into the world in search of inspiration. The need not only to show her own work, but to see what was happening out there, drove her to build a virtual platform from which to show the work of young artists that, as herself, could not find a place at the art institutions of their cities. In the case of Argentina, the array of possibilities consisted of stagnant institutions and an absent state, lacking in proper political structures, which, combined with a desolate financial and social conjuncture, drove many artists like Irana to choose self-management.

In this context, Ruby was built as a space of virtual exhibition within the new forms of exposure offered by technology and the internet, as opposed to a stiff and stratified art circuit, which revolves around biennales, fairs, and mega-galleries, concentrated in a handful of cities of developed countries; an exhibition space that attempts to exist outside these structures, ignoring the curricula of the artists and eliminating the hierarchical categorizations that dictate the course of contemporary art. It is a space that breaks with the one-way structure from the center to the periphery by stablishing a reticular and accessible pattern in which information flows in all possible directions, in a clear, dynamic, and decentralized way.

In its desire to see and to be seen, Ruby fuses together in one space all which, according to the criterion of its creator, is a contribution to contemporary art. This criterion is entirely subjective, but at the same time it is the reflection of a generation schooled in the concepts of virtuality, globalization, and dissolution of borders—a generation that negotiates its identity every day. And this is how Irana became the explorer of a virtual geography consisting of websites, blogs, e-zines, and social networks, which entail the challenge of facing a constant outbreak of characters, ideas, and images that coexist chaotically and that come to life the instant that we access them. Irana did not only accept this challenge, but she turned it into her work method, through which she succeeded in forming her own exchange network and which allowed her to finally shake off the stiffness imposed by her own circumstances.

Throughout the years, her own concept of art has changed, and the contents of the magazine expanded to different forms of art, accomplishing a wide and articulate vision, simply by a common search of contemporary expression. Staying away from the mainstream and the artists everybody already knows, that repeatedly occupy exhibitions and publications all over the world, Ruby moves along the edges.

This book is the result of a personal search, which eventually took on a life of its own, and five years later materialized into an object that provides a symptomatic reading of the world we live in: a compilation of an online art magazine, created by an Argentinean girl, to exhibit artists from all corners of the world, edited by a German publisher.

Visit Ruby Mag at www.ruby-mag.com.ar.

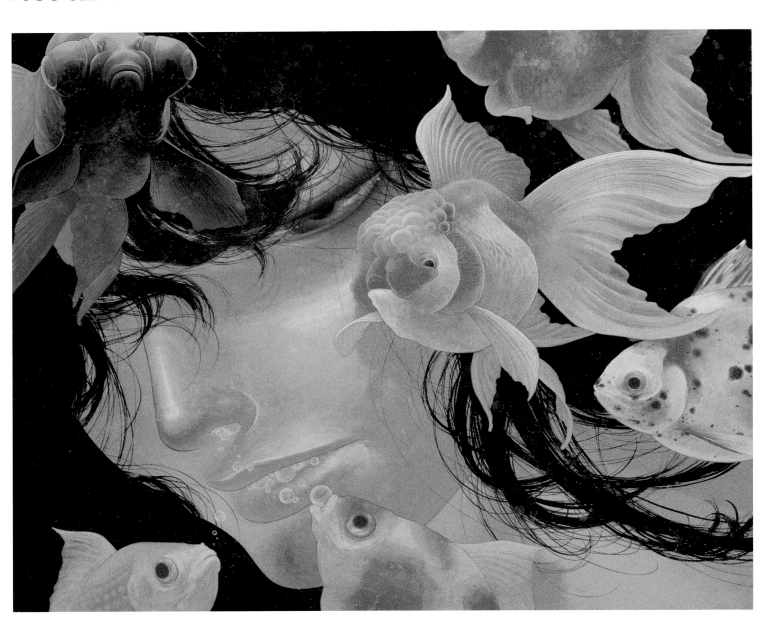

Symbiosis 4, acrylic and shell powder on canvas, 80.3×65.2cm, 2008
Toadstool, acrylic and shell powder on canvas, 65.2×80.3cm, 2009 (opposite)

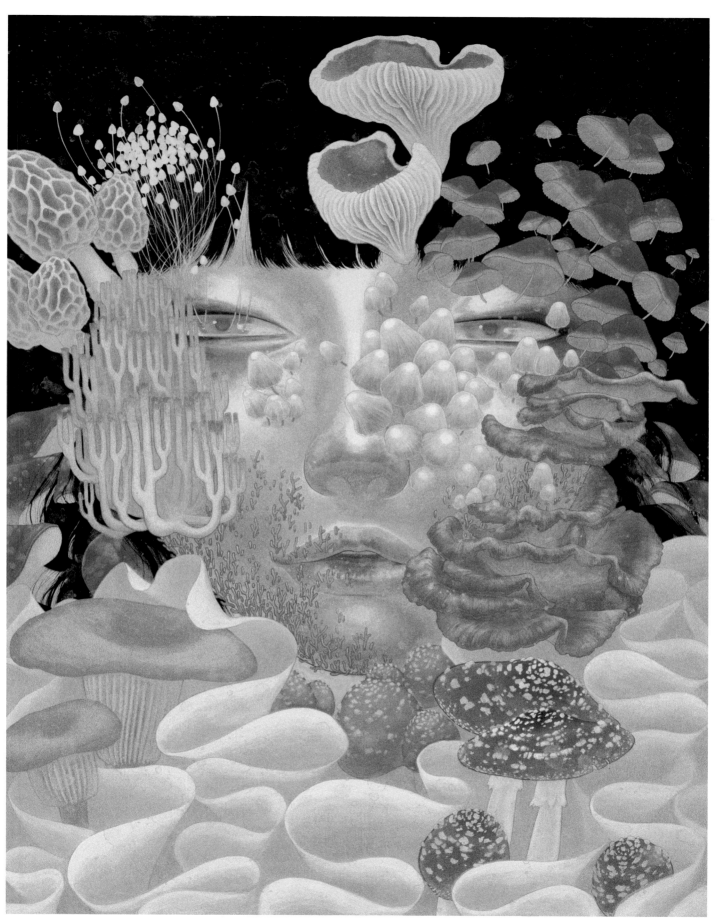

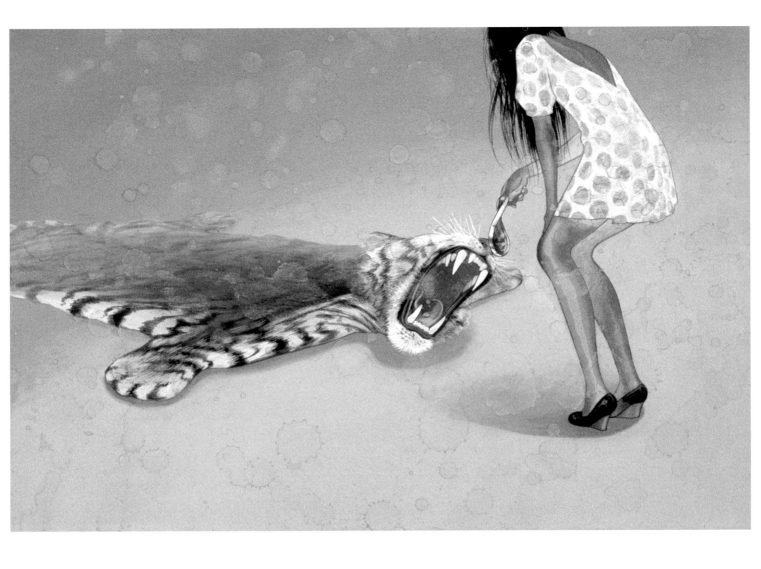

Tiger 1, acrylic and shell powder on canvas, 18.2 × 25.8 cm, 2010

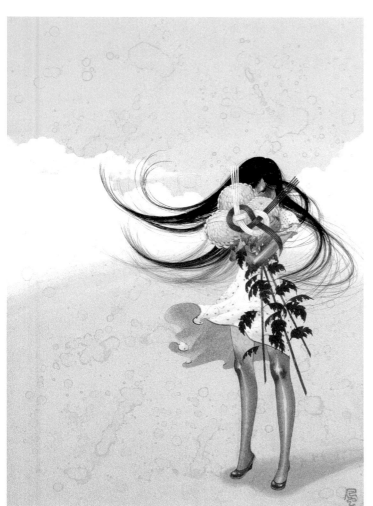
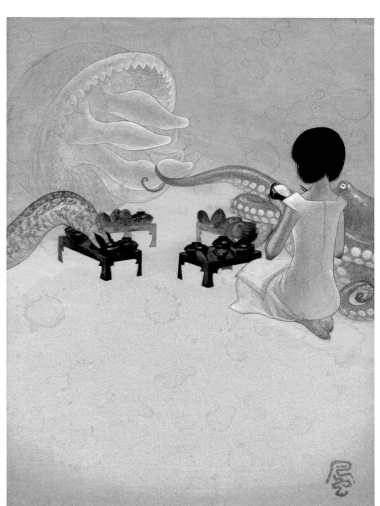

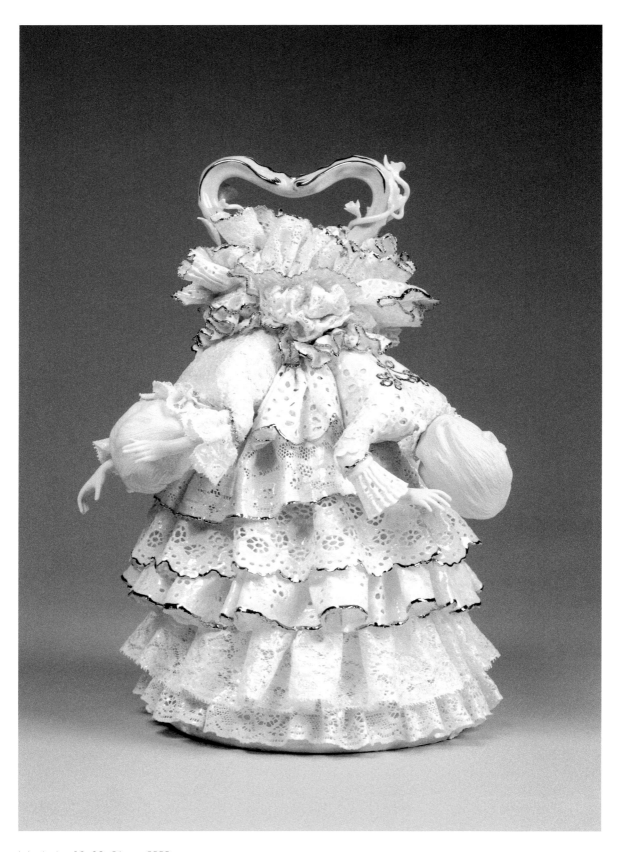

Burden II, porcelain, luster, 18 x 18 x 26 cm, 2009

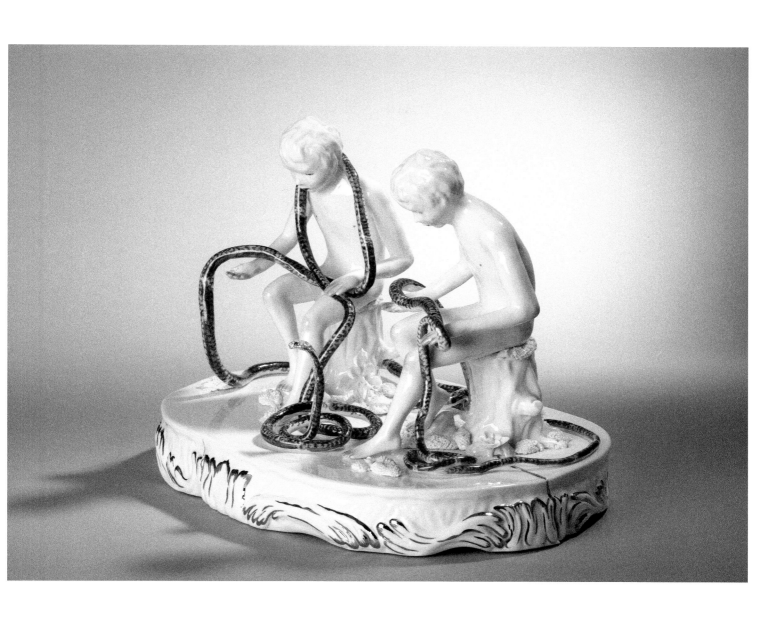

King Cobra, porcelain, china paint, luster, 30 x 24 x 26 cm, 2010

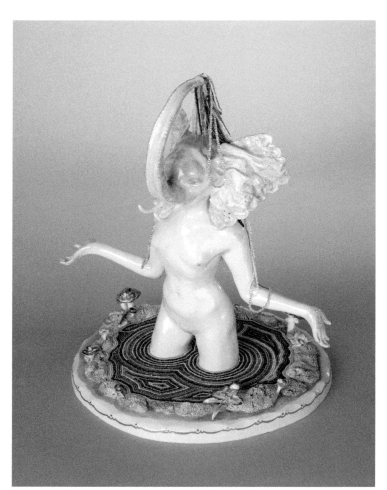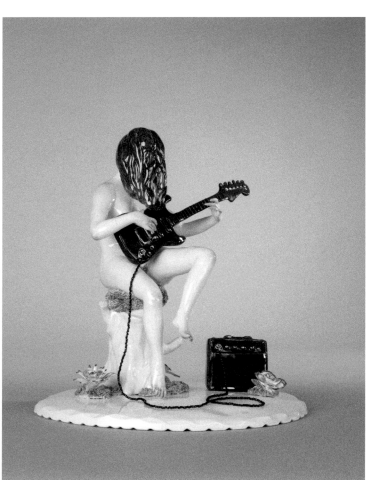

Live Old, porcelain, china paint, luster, beads, 20 x 20 x 28 cm, 2009 (left)
The Lute Player, porcelain, china paint, luster, beads, 20 x 20 x 24 cm, 2010 (right)
Maypole, porcelain, luster, gold chain, 20 x 20 x 25 cm, 2010 (opposite)

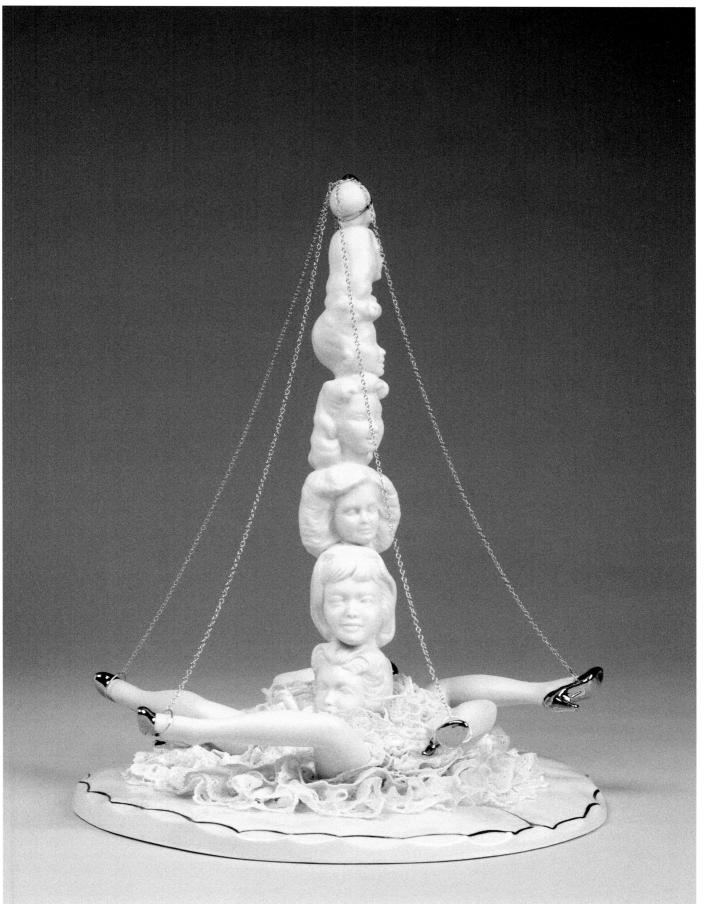

BIANCA GUTBERLET

Der Freizeitpark from the "Lubberland" series, Lambda Diasec, 75 × 100 cm, 2003

Das Volksfest from the "Lubberland" series, Lambda Diasec, 75 x 100 cm, 2003

Der Jungbrunnen from the "Lubberland" series, Lambda Diasec, 75 x 100 cm, 2003

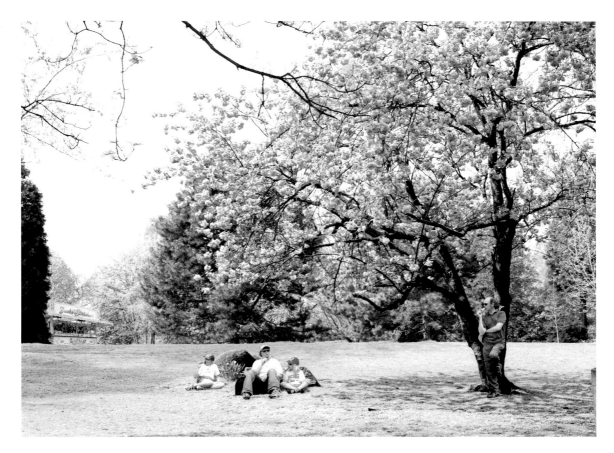

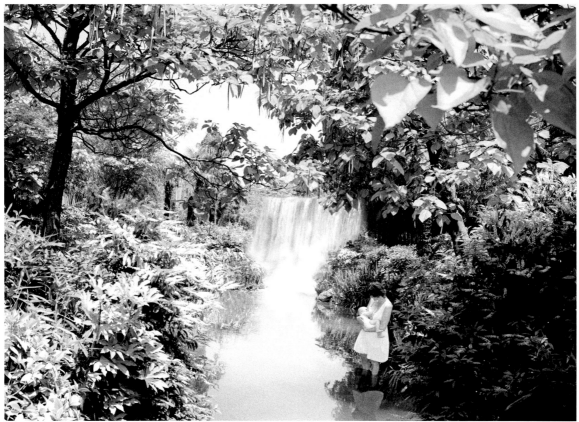

Das Picknick from the "Lubberland" series, Lambda Diasec, 75 x 100 cm, 2003 (top)
Der Milchfluss from the "Lubberland" series, Lambda Diasec, 75 x 100 cm, 2003 (bottom)

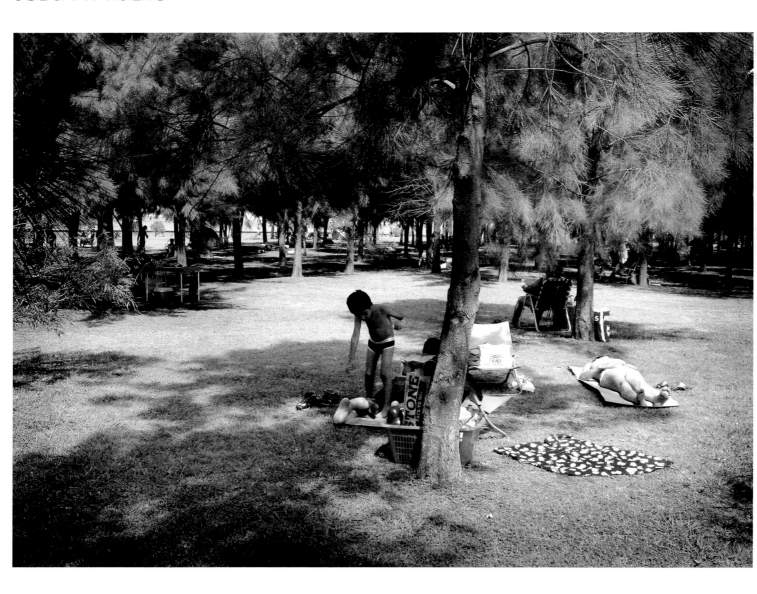

A la Hora de la Siesta, digital photography, 30x40cm, 2010

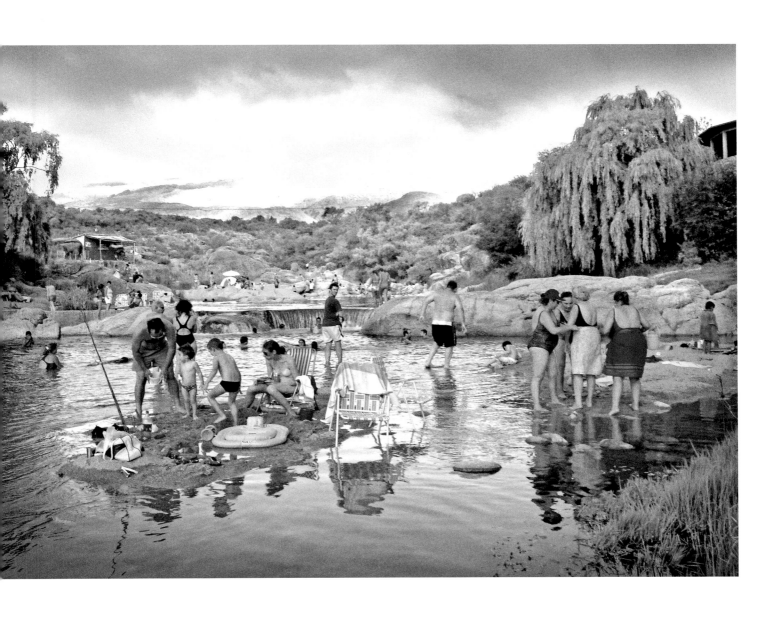

Paso de las Tropas, digital photography, 40×60cm, 2008

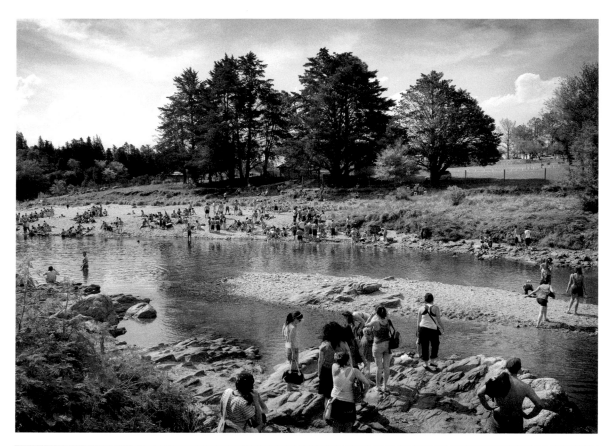

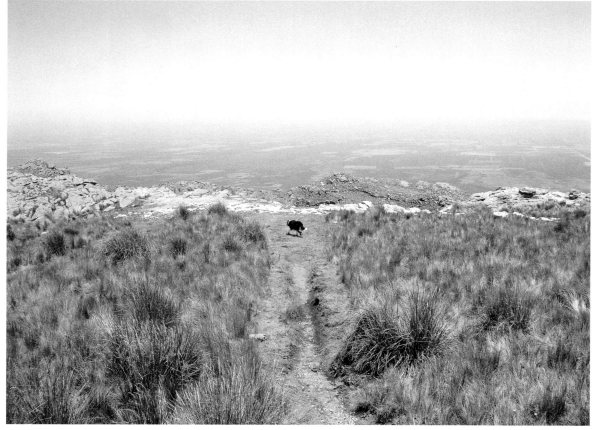

Rio No. 1, digital photography, 20x30cm, 2008 (top)
Al Filo del Abismo, digital photography, 20x30cm, 2008 (bottom)

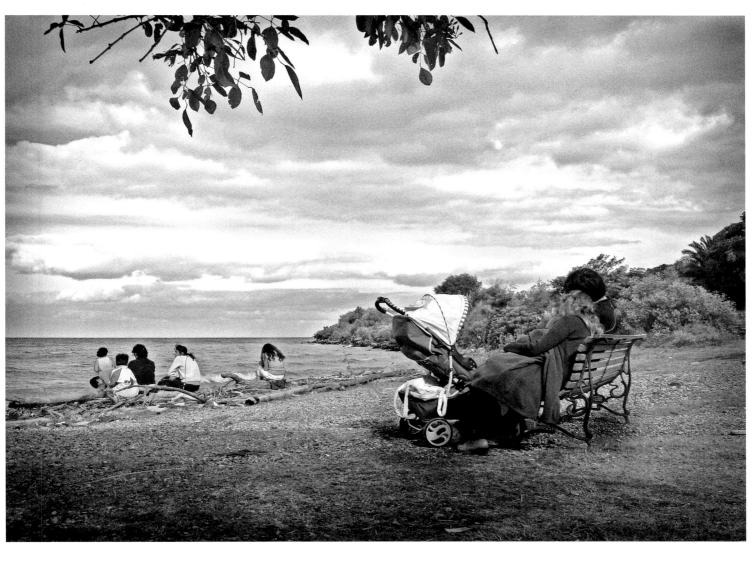

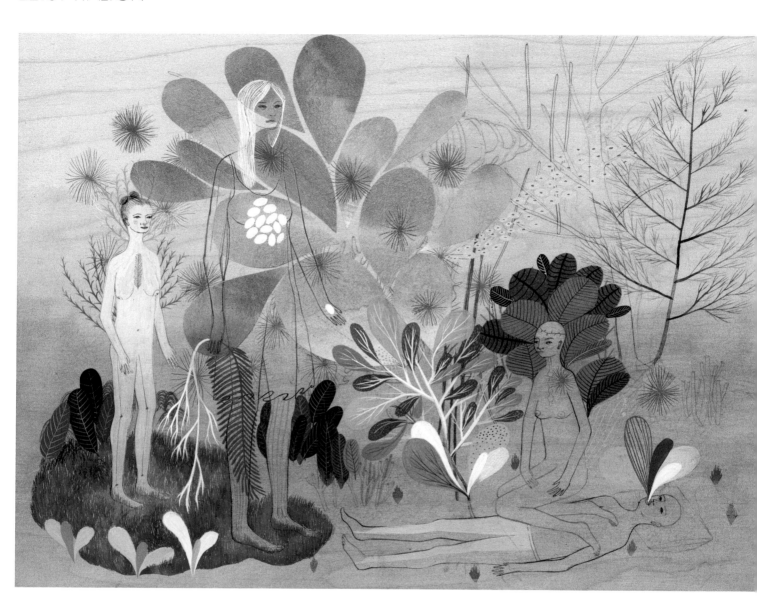

Inhale/Exhale, collage, acrylic goauche on panel, 28 x 35.5 cm, 2009

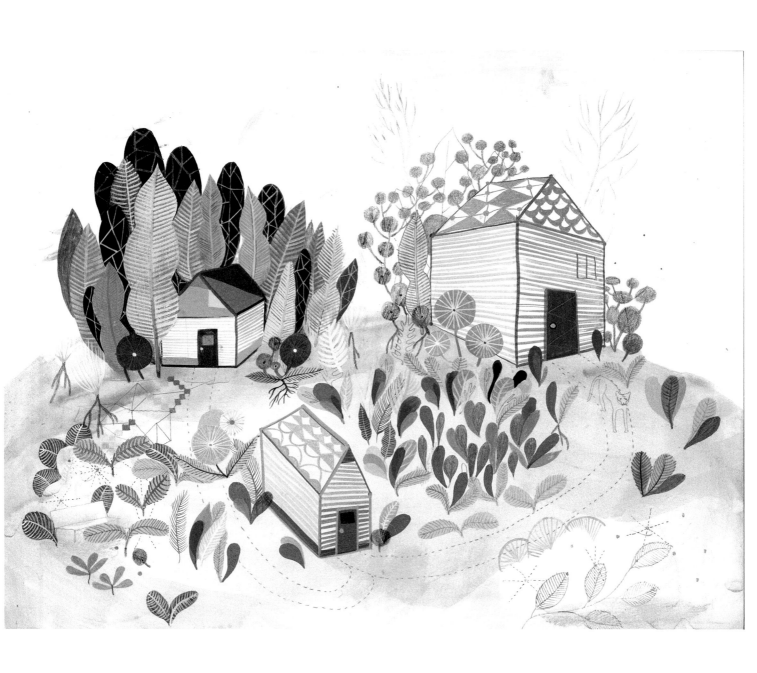

Three Houses in the Field, giclée digital print, 23x28cm, 2010

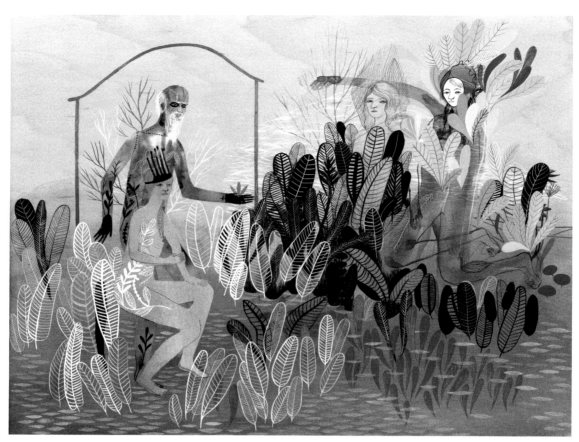

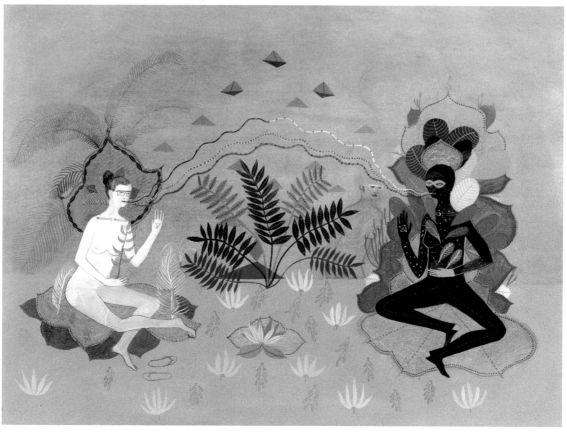

Waterlily, collage, acrylic gouache on panel, 28 x 35.5 cm, 2009 (top)
Connecting Threads, acrylic gouache on paper, 28 x 35.5 cm, 2010 (bottom)

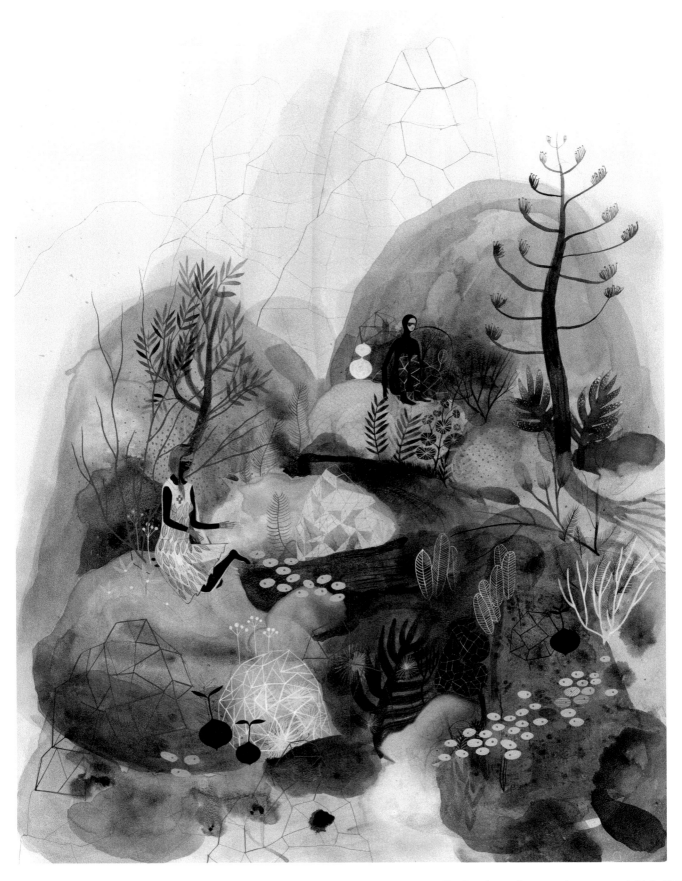

Riverbank, acrylic gouache on panel, 76.2x55.9, 2009

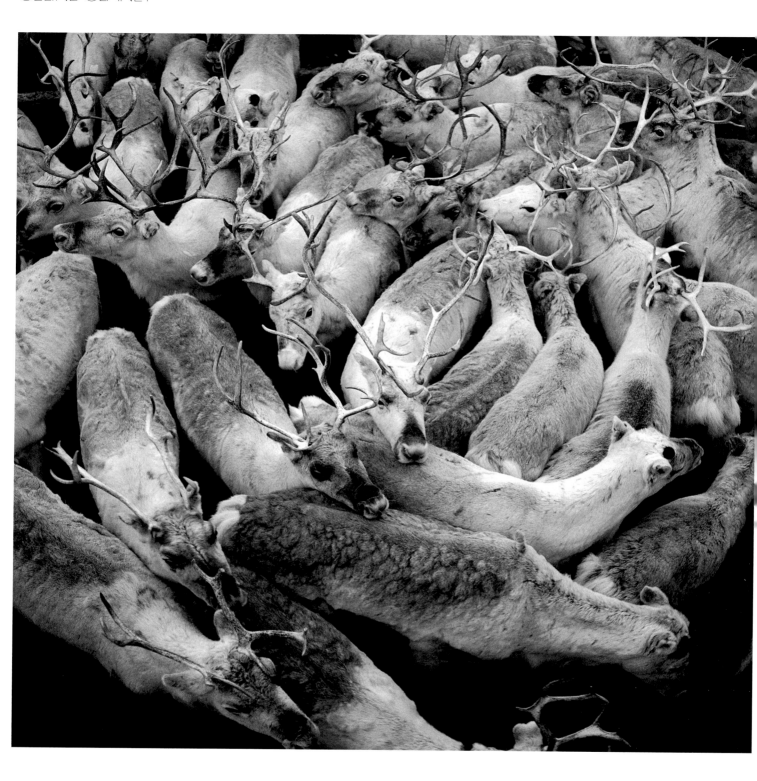

Jon's Herd from the "Máze" series, color archival print, 100x100 cm, 2005

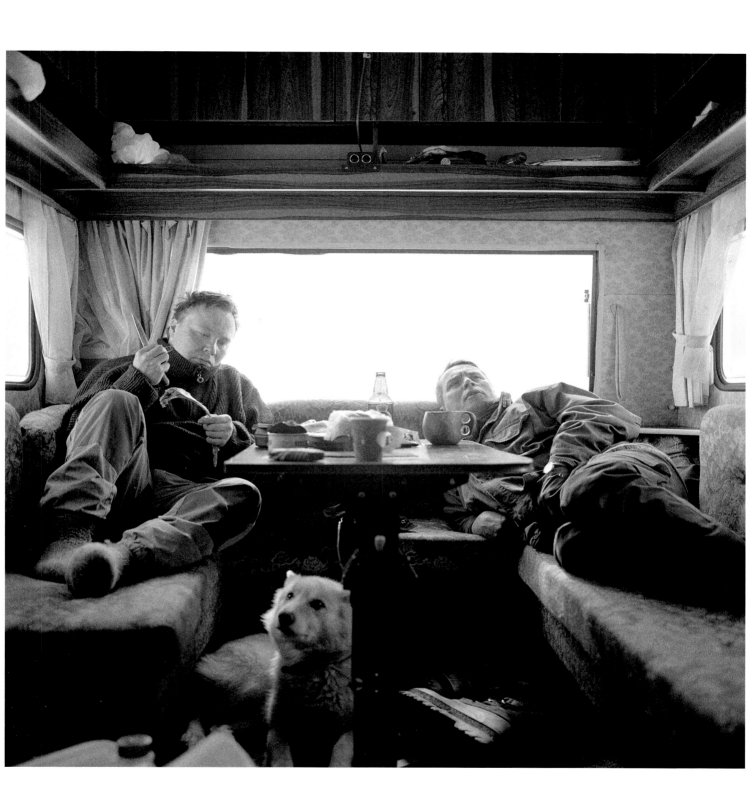

Relaxing In The Trailer from the "Máze" series, color archival print, 100x100cm, 2005

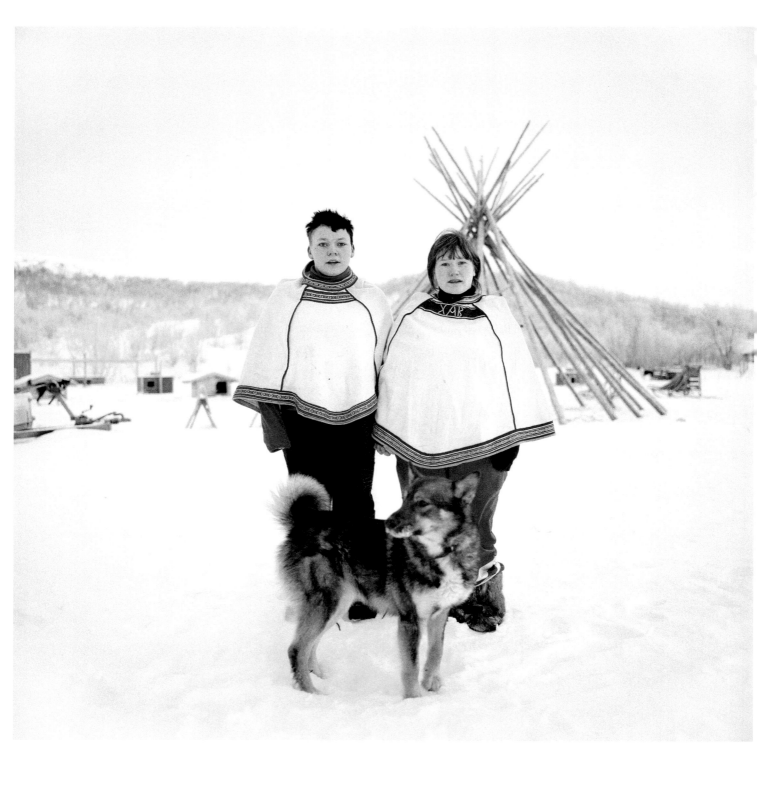

Linn, Marita And The Dog from the "Máze" series, color archival print, 100x100 cm, 2008

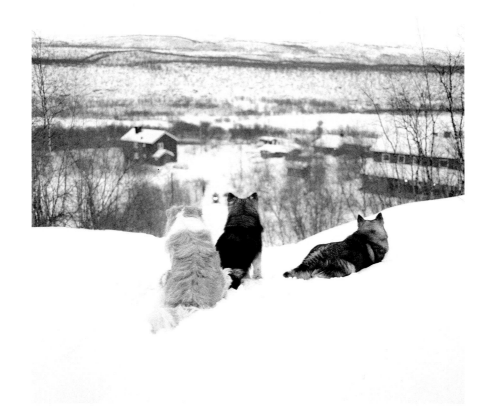

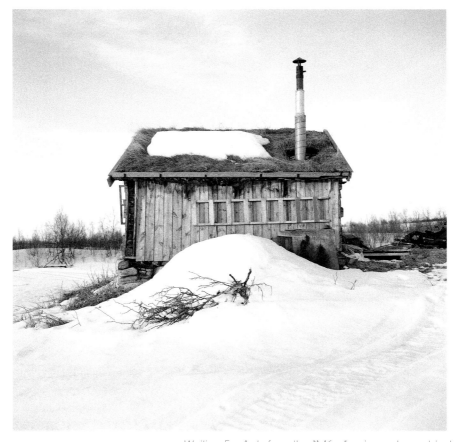

Waiting For Ante from the "Máze" series, color archival print, 100x100 cm, 2008 (top)
The Hytte, Suolojavri from the "Máze" series, color archival print, 100x100 cm, 2005 (bottom)

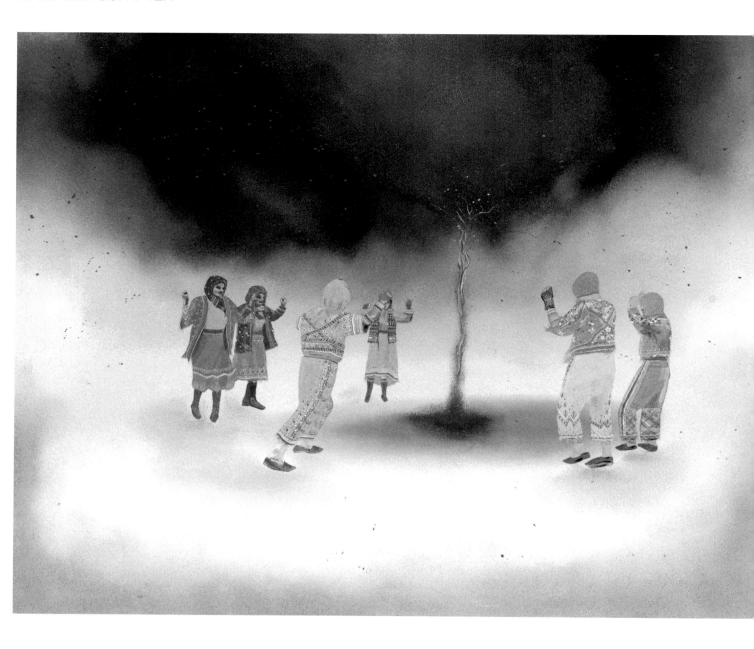

Molten Kin, gouache and pastel on paper, 28x35.5cm, 2009
Isle, gouache and pastel on paper, 28x35.5cm, 2010 (opposite)

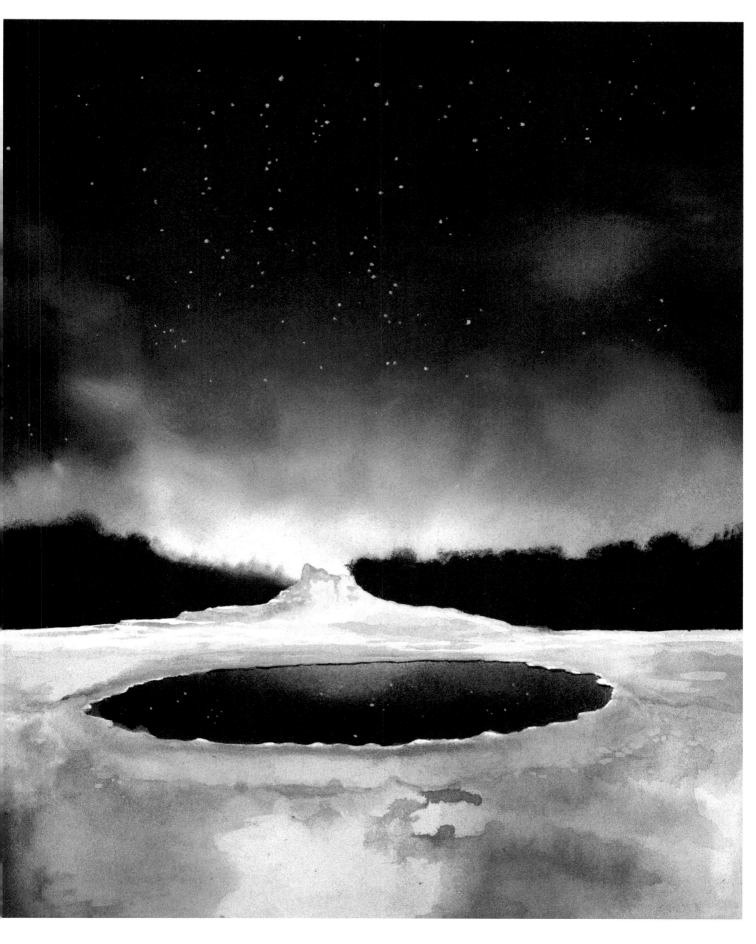

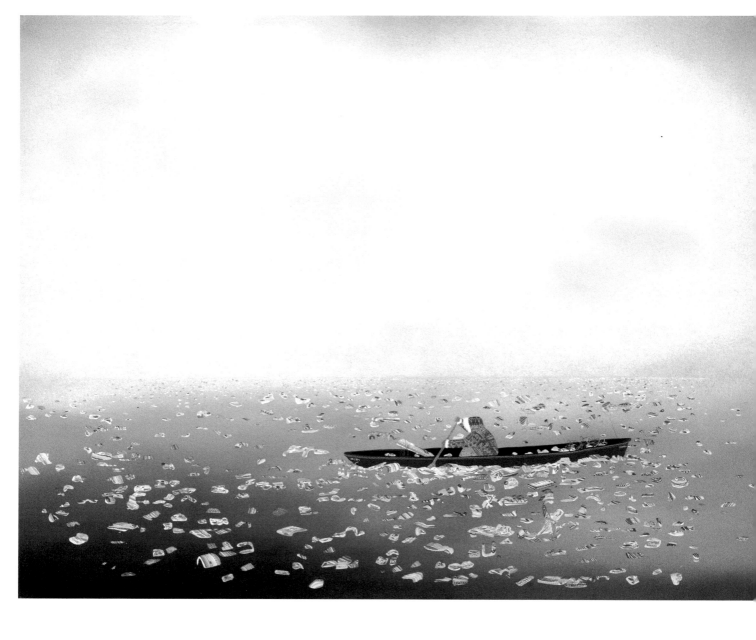

Finery, gouache and pastel on paper, 28 x 35.5 cm, 2009

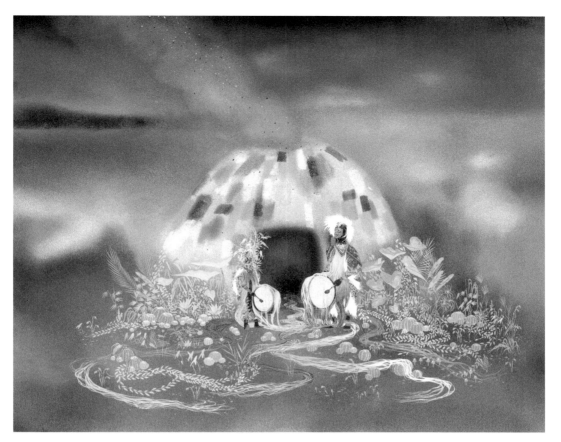

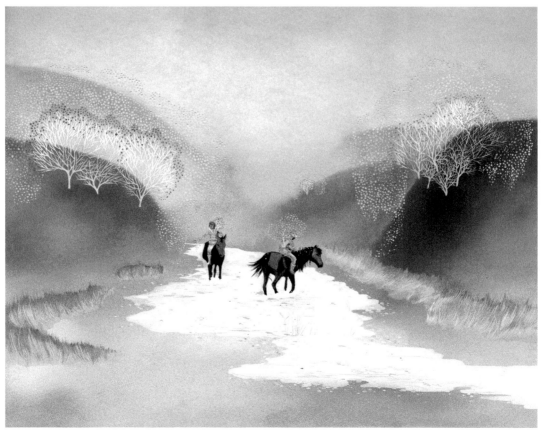

Igloo, gouache and pastel on paper, 28 x 35.5 cm, 2009 (top)
Brothers in Sport, gouache and pastel on paper, 28 x 35.5 cm, 2009 (bottom)

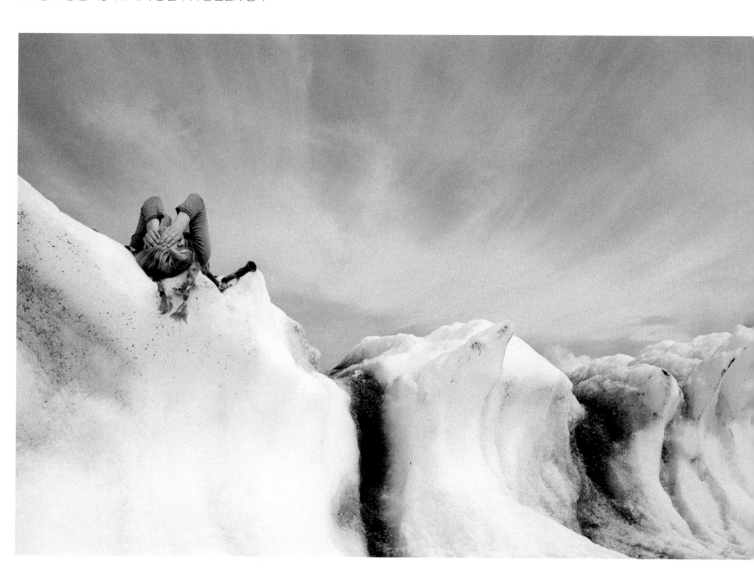

Hannah, analog photograph, 2008

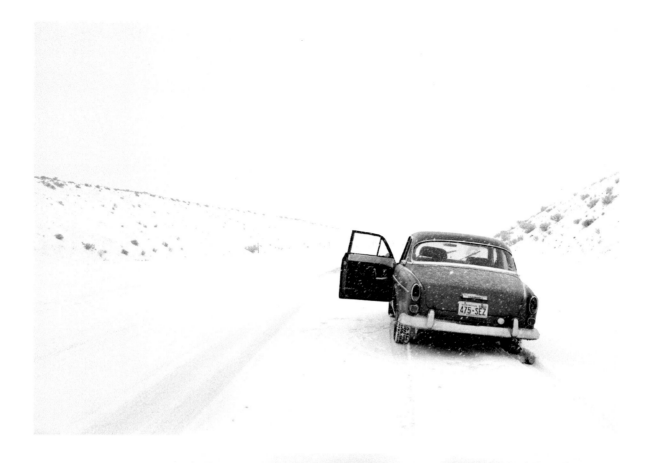

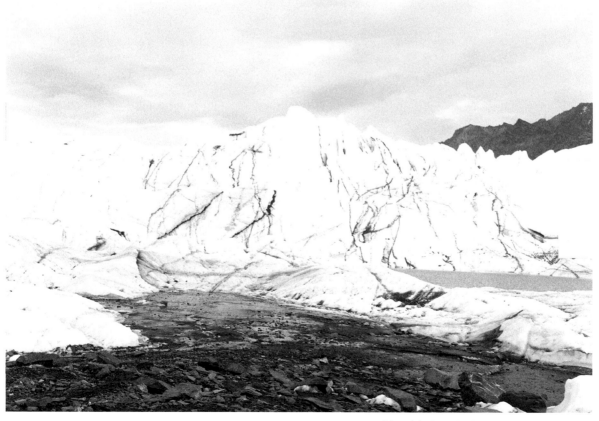

Near Mexican Hat, Utah, analog photograph, 2008 (top)
Matanuska Glacier, analog photograph, 2009 (bottom)

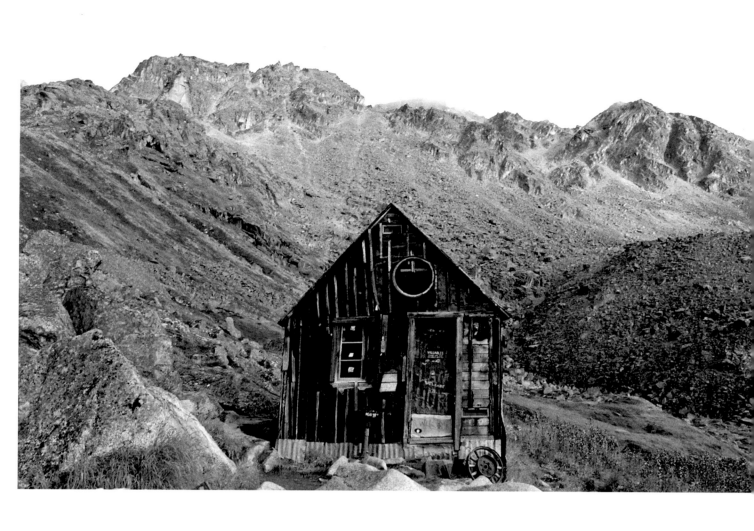

Lane Hut, analog photograph, 2009

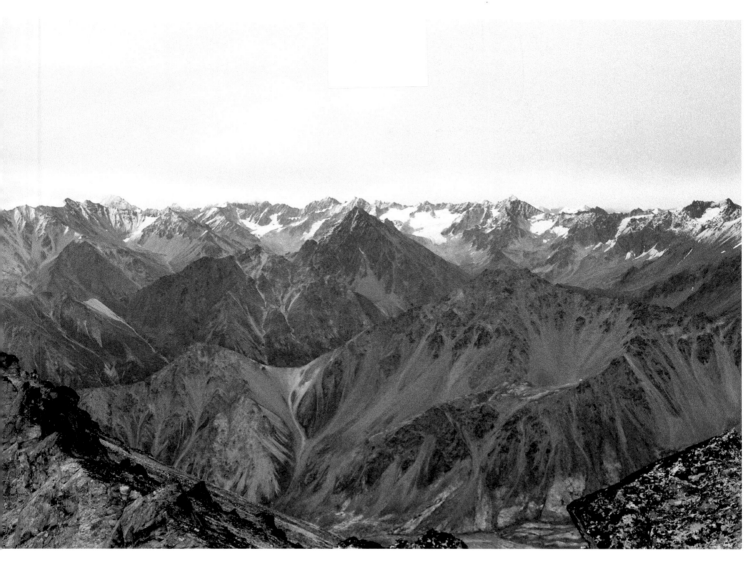

Chugach Mountains, analog photograph, 2009

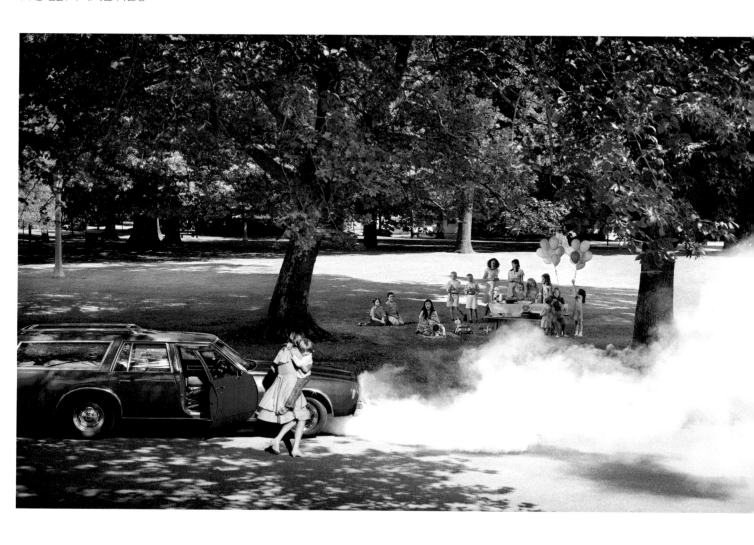

Anna's Birthday Party No. 3, digital C-print, 50.8 x 76.2 cm, 2010

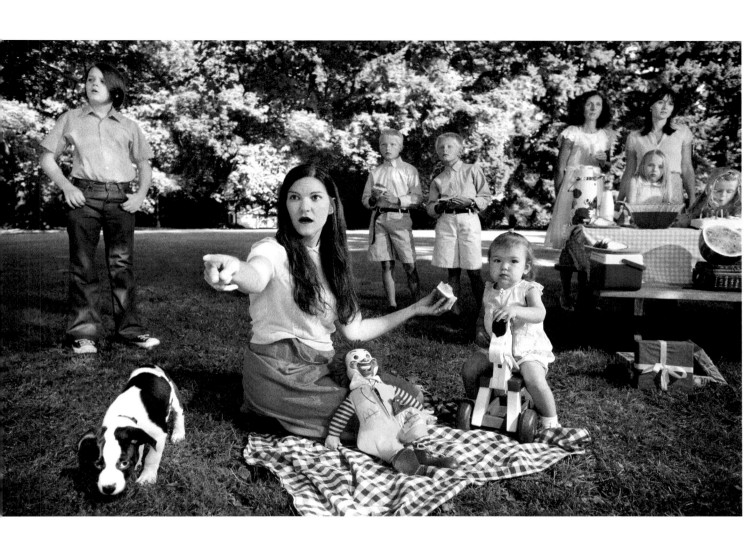

Anna's Birthday Party No. 4, digital C-print, 50.8 x 76.2 cm, 2010

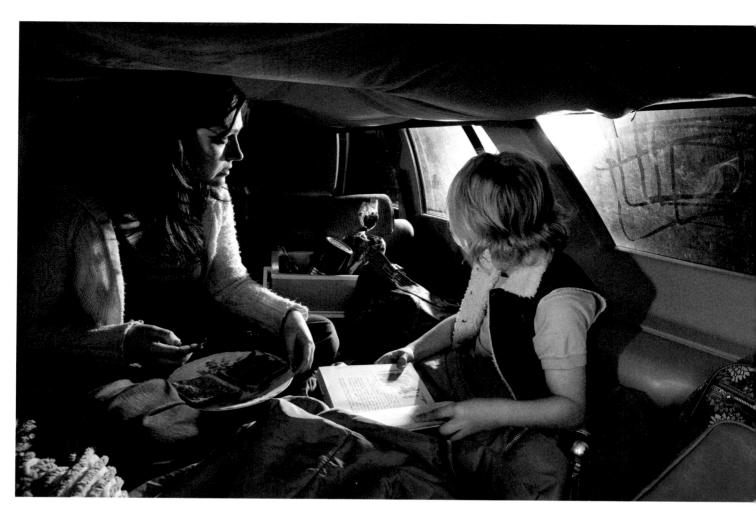

Nolan's Bedtime Story No. 1, digital C-print, 50.8 x 76.2 cm, 2010

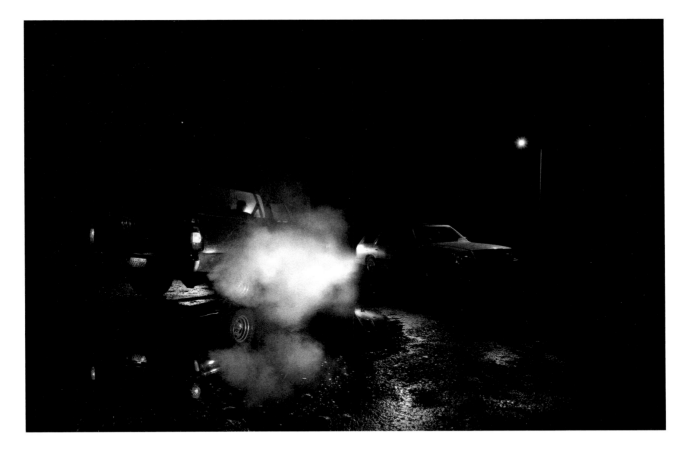

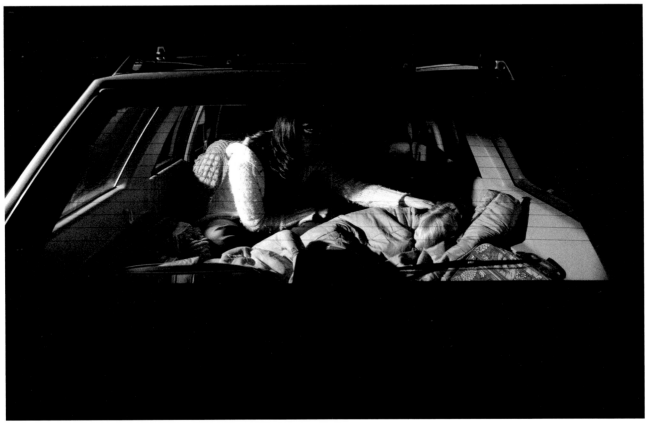

Nolan's Bedtime Story No. 2, digital C-print, 50.8×76.2 cm, 2010 (top)
Nolan's Bedtime Story No. 3, digital C-print, 50.8×76.2 cm, 2010 (bottom)

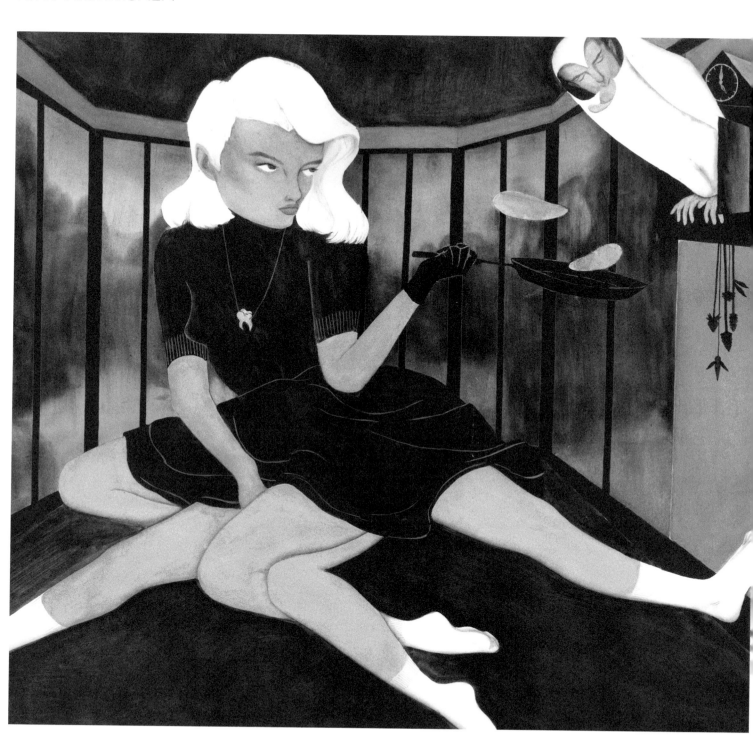

Gimme Five, watercolor and pencil, 51x50cm, 2009
Cruel Summer, watercolor and white gouache, 29x40cm, 2010 (opposite)

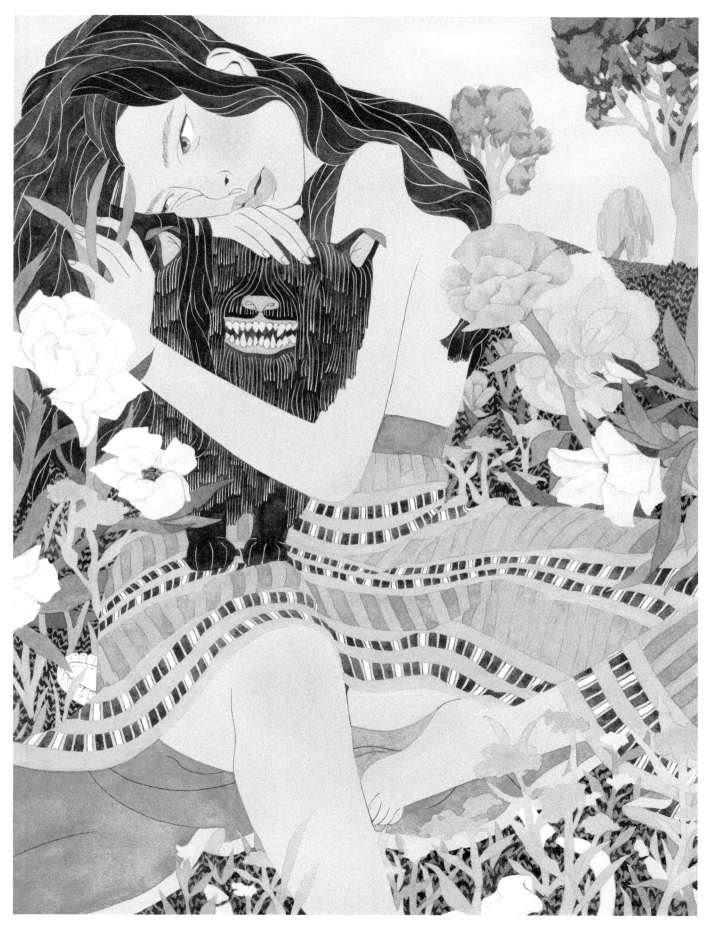

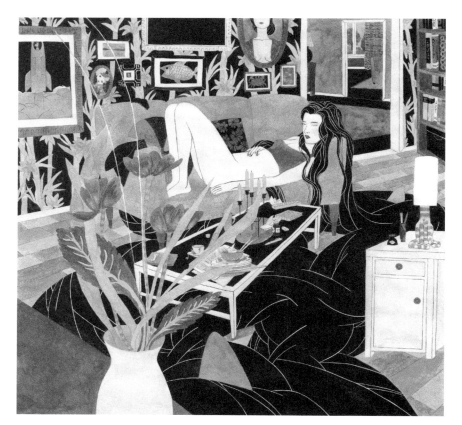

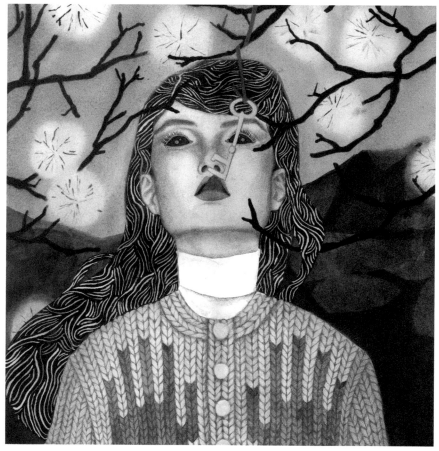

Dark Waters, watercolor and white gouache, 42×40cm, 2010 (top)
Thunder, watercolor, pencil and white gouache, 40×42cm, 2009 (bottom)

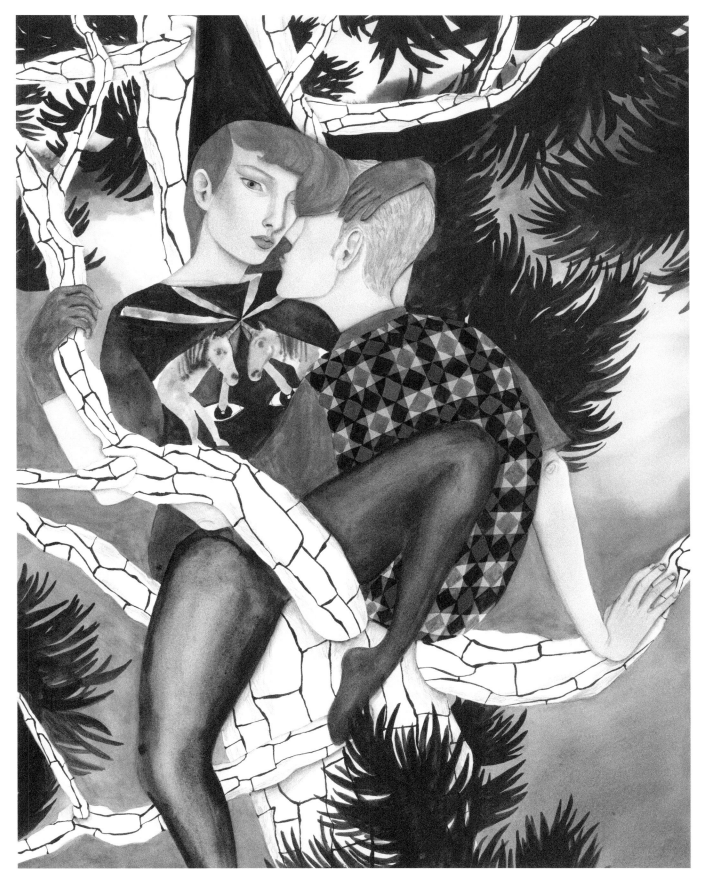

Velvet, watercolor and pencil, 47x62cm, 2009

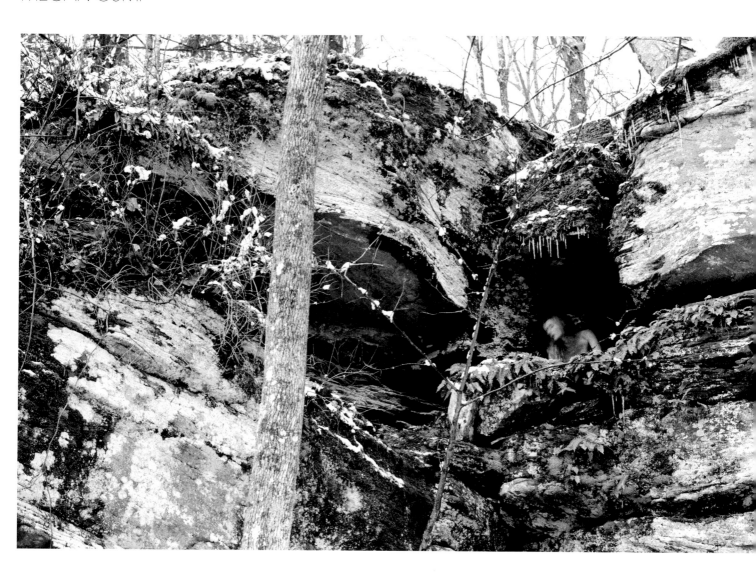

Lair, C-print, 71.1 x 96.5 cm, 2008

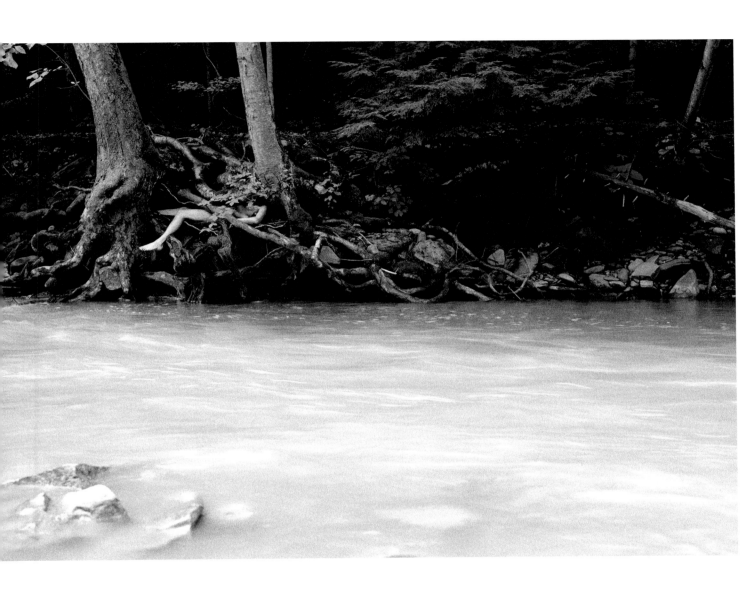

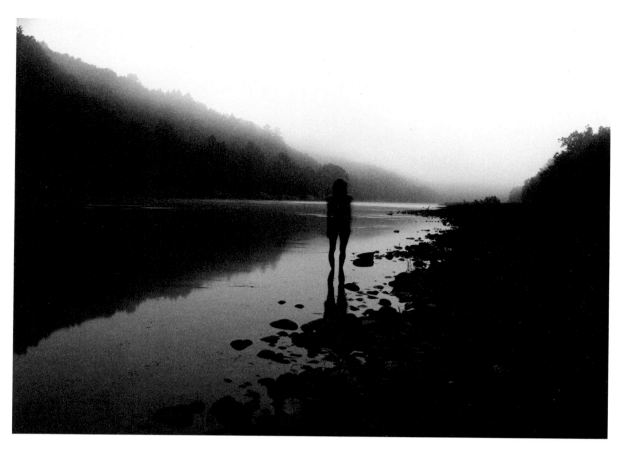

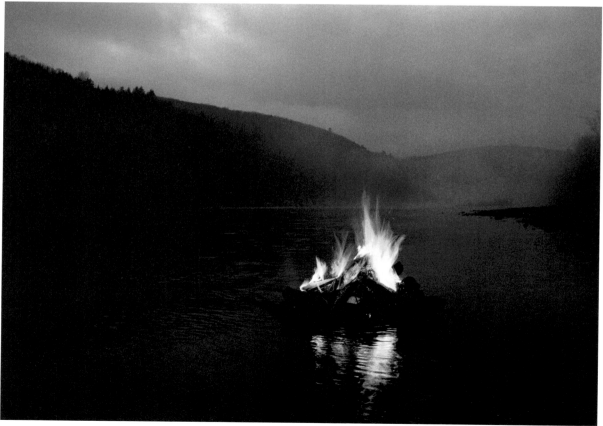

Dark Mirror, C-print, 71.1 x 96.5 cm, 2008 (top)
Spell, C-print, 71.1 x 96.5 cm, 2007 (bottom)

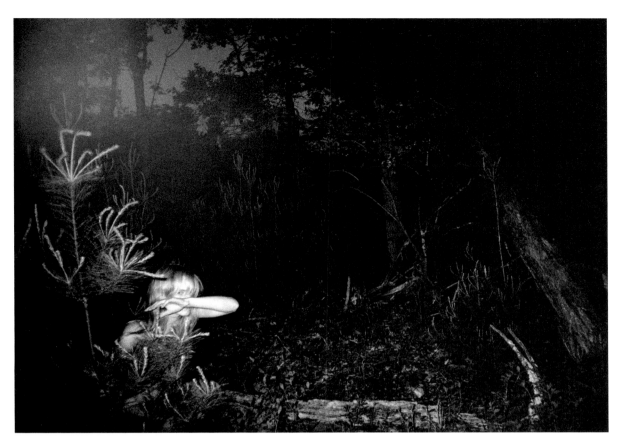

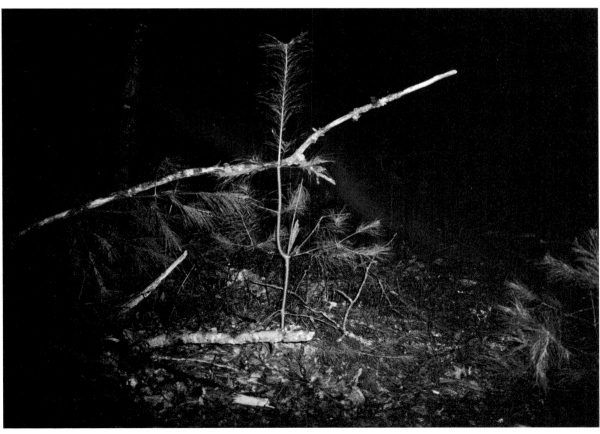

Feral, C-print, 71.1 x 90.1 cm, 2009 (top)
X, C-print, 71.1 x 90.1 cm, 2010 (bottom)

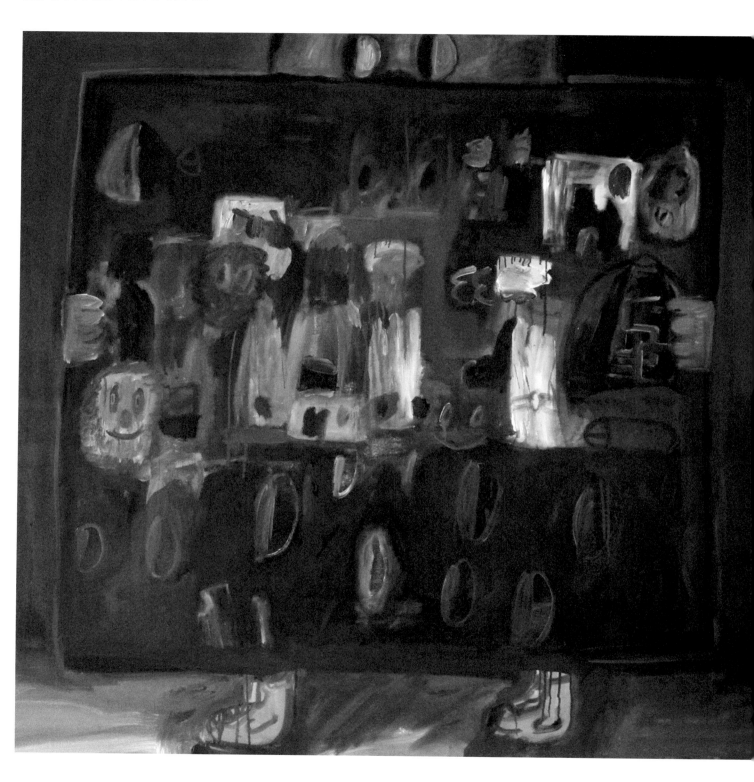

Dream of Stealing a Painting, oil on canvas, 180x180cm, 2010

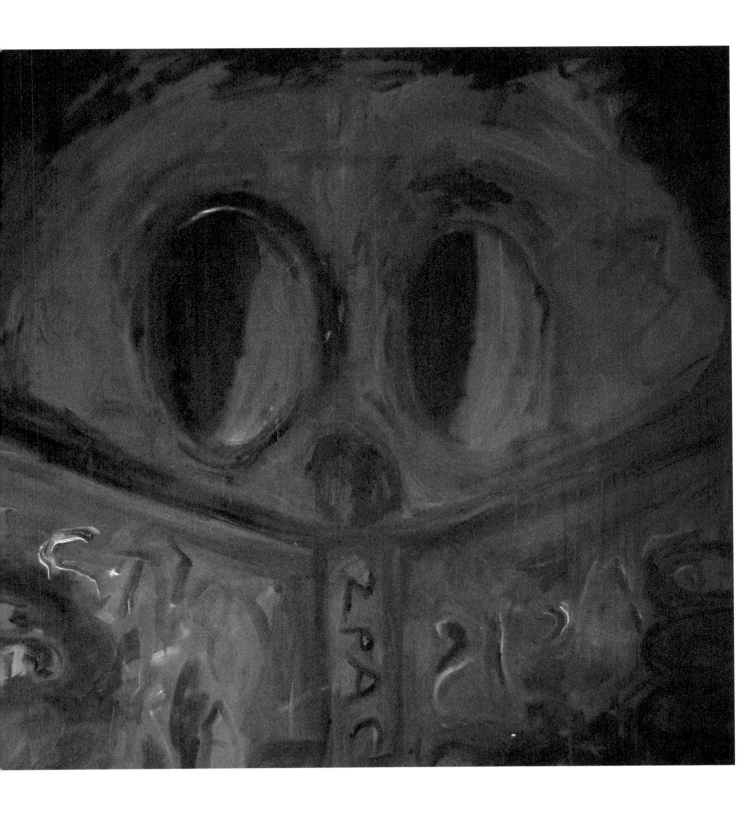

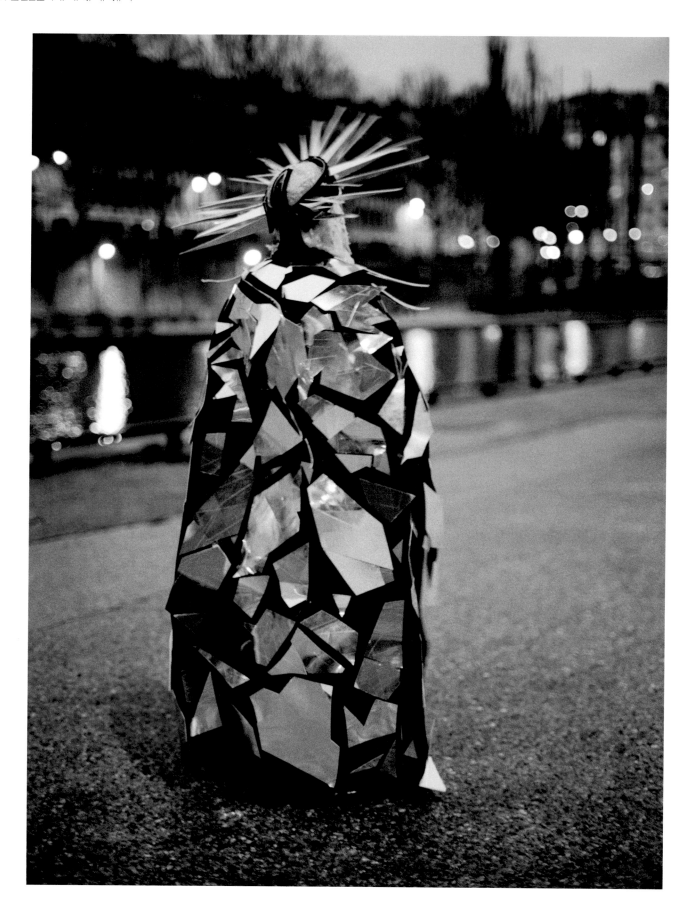

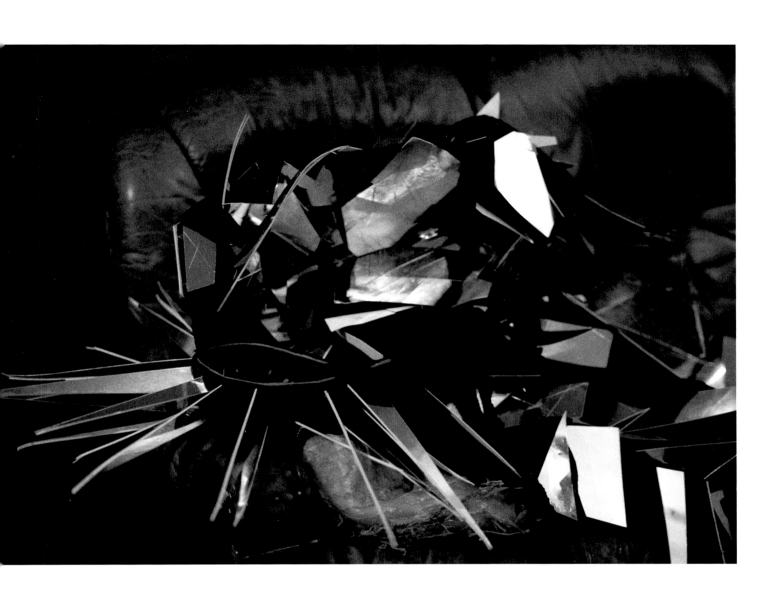

Attila – Broken Light No. 1, color photograph, 80x120 cm, 2010
Attila – Broken Light No. 2, color photograph, 60x90 cm, 2010 (opposite)

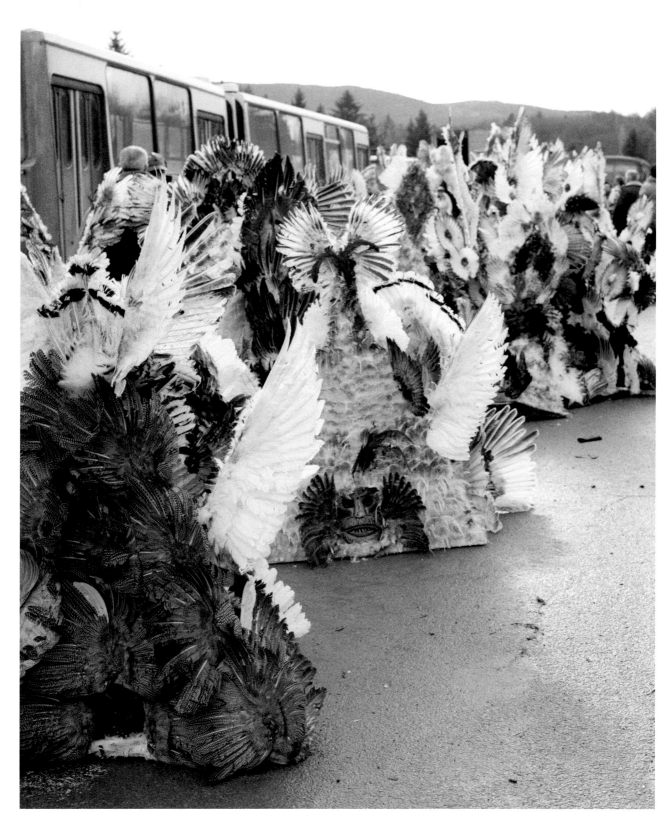

Untitled from the "Parking Lot Hydra" series, color photograph, 80x120cm, 2009

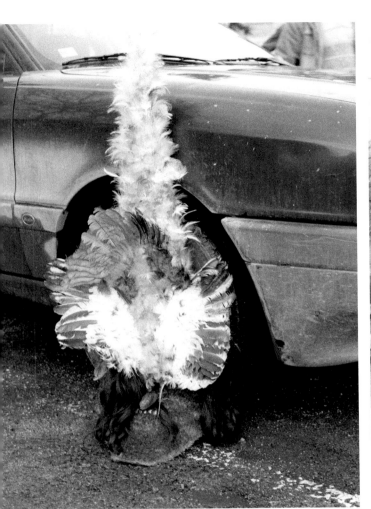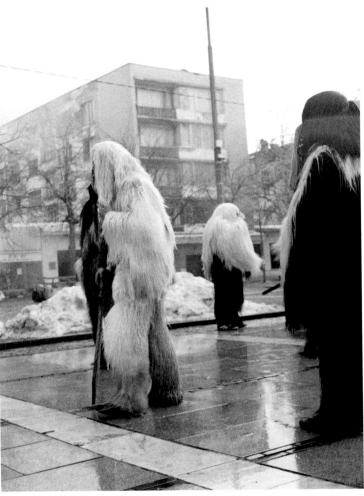

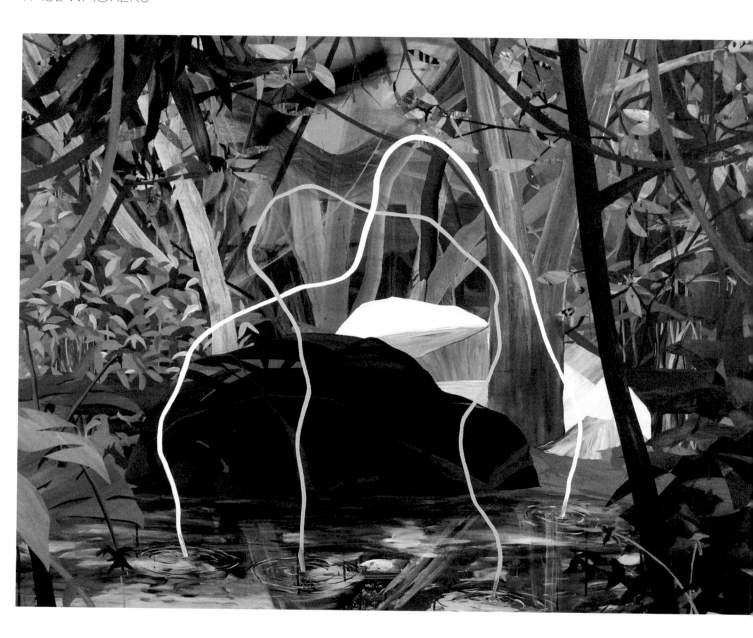

Garden Features, acrylic, spray paint on panel, 101.5 x 127 cm, 2009

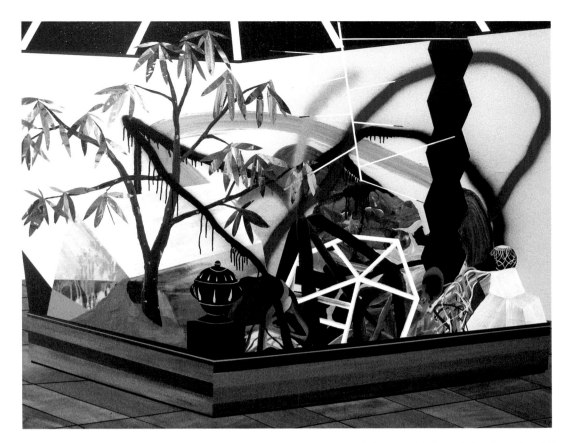

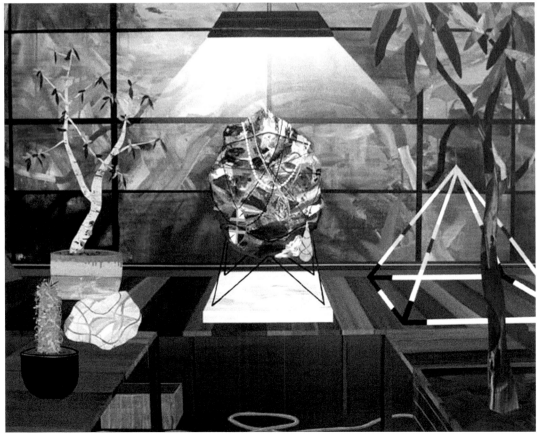

The Sculptor, acrylic, spray paint on panel, 122x152.5cm, 2009 (top)
Quiet Place, acrylic, spray paint on panel, 101.6x122cm, 2009 (bottom)

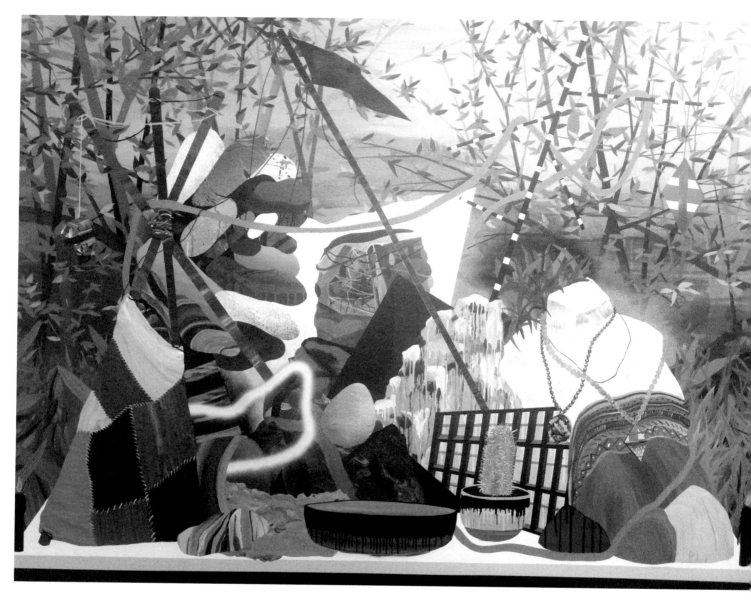

Monument, acrylic, spray paint on panel, 183x152.5cm, 2010

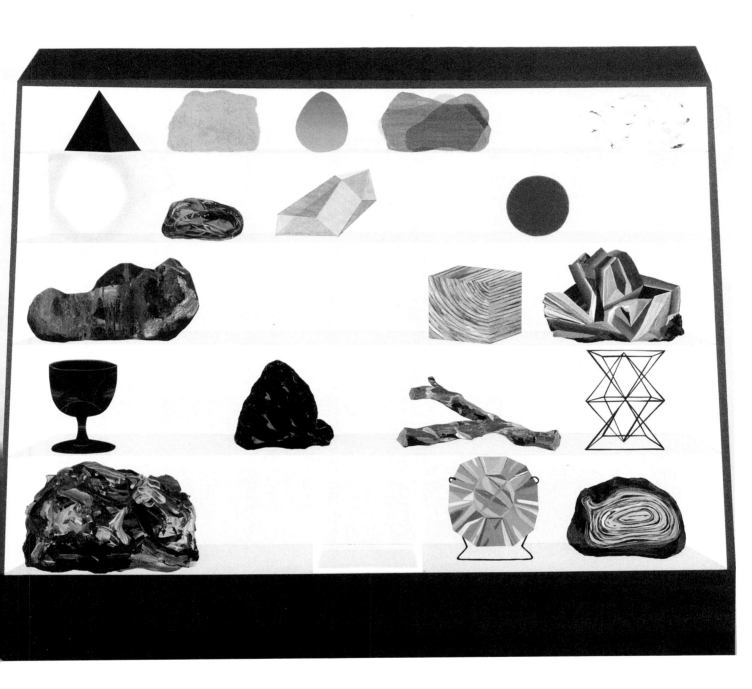

Collector's Cabinet, acrylic, spray paint on panel, 91.5x101.6cm, 2009

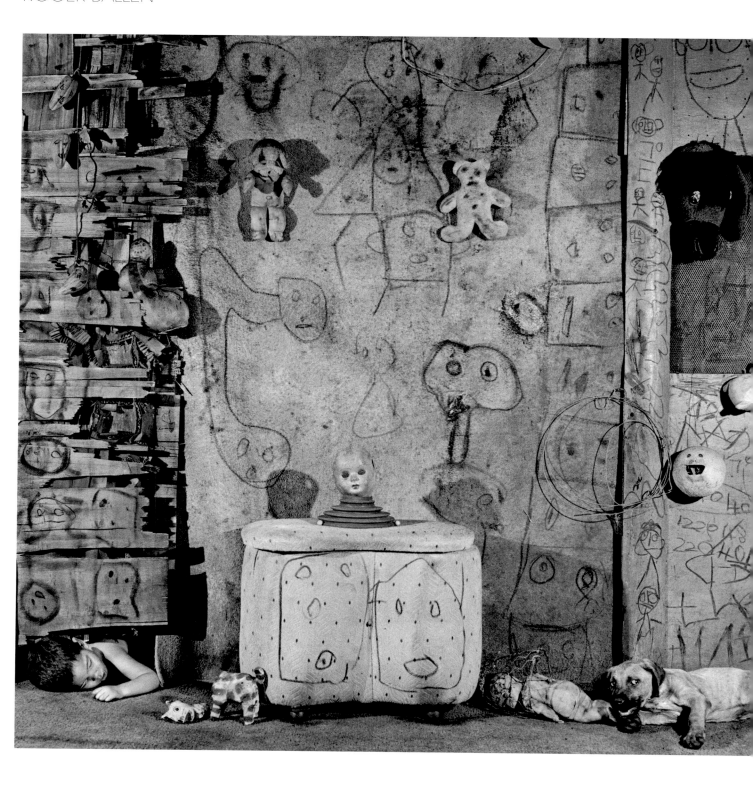

Boarding House, black-and-white film, 50x50cm, 2008

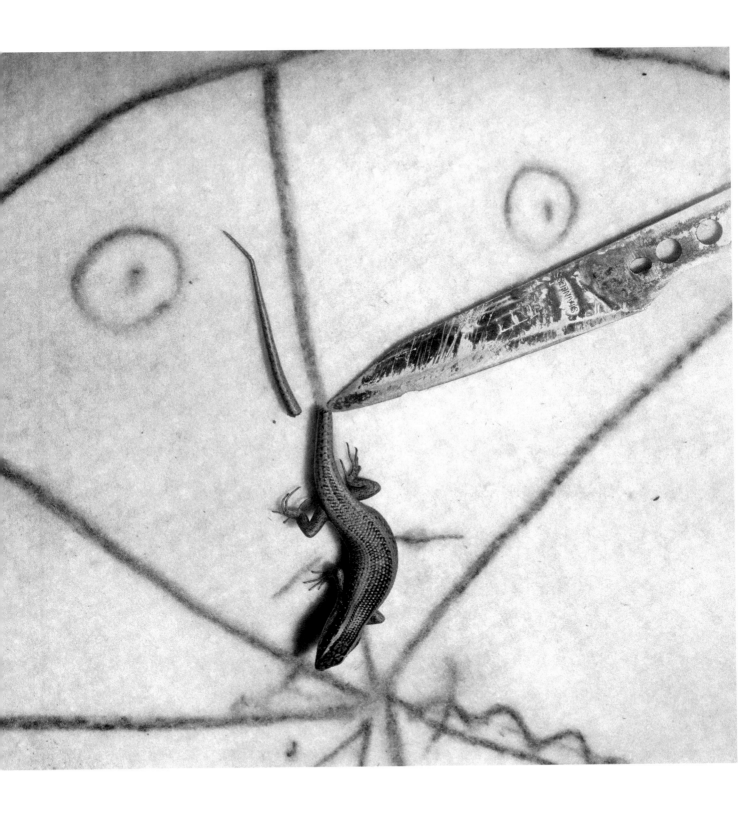

Sliced, black-and-white film, 50×50 cm, 2007

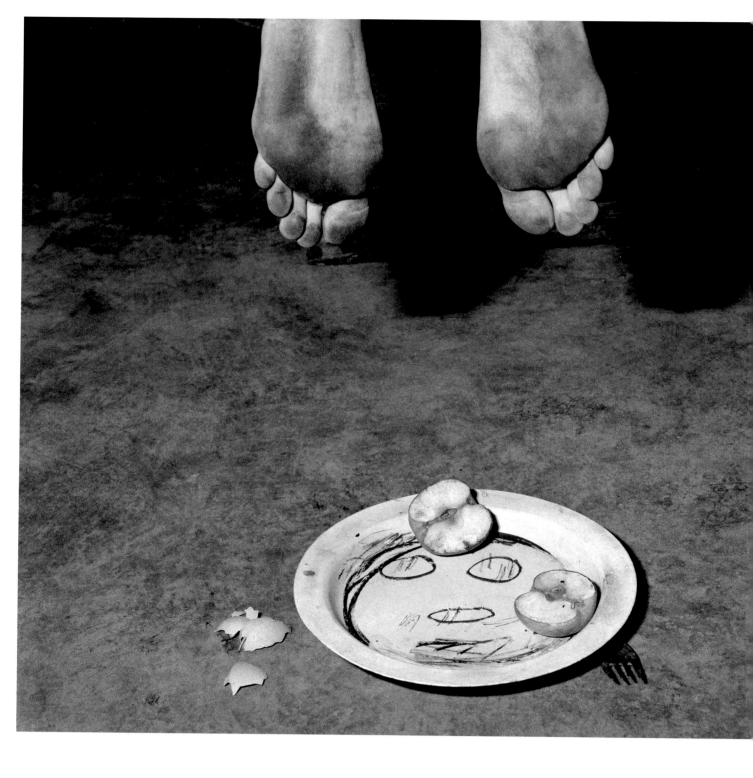

Fragments, black-and-white film, 50x50 cm, 2005

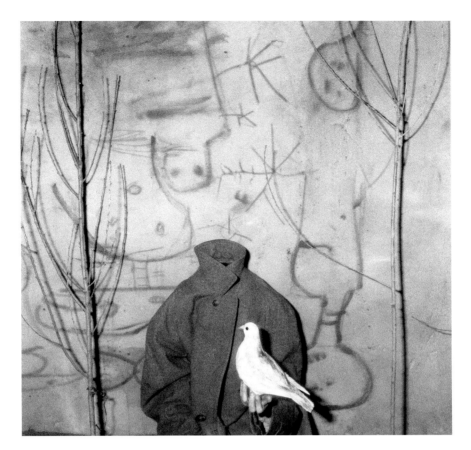

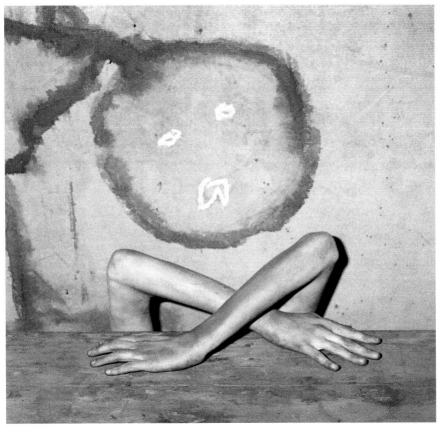

Untitled, black-and-white film, 80×80 cm, 2009

61

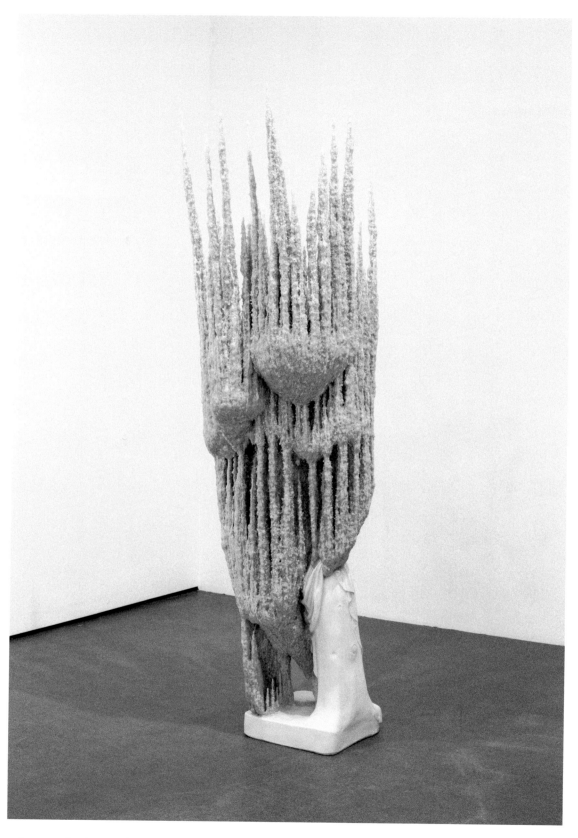

Horror Vacui, polyurethane adhesive and fiberglas sculpture, 241.3x61x61 cm, 2010

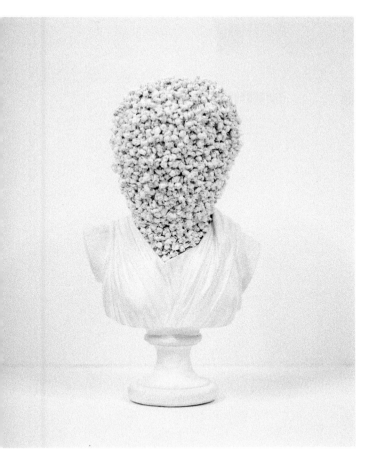 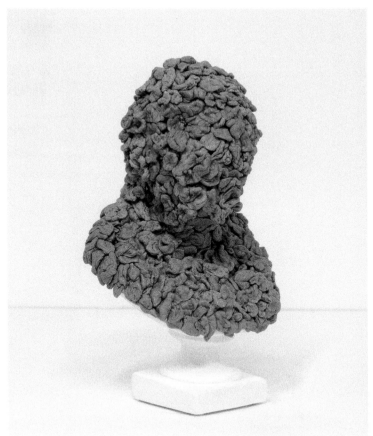

Spitting Image, plaster bust, paper spitwads and glue, 34x18x12cm, 2009 (left)
Sugar Free, plaster bust, sugar-free gum, 17.8x15.2x28cm, 2010 (right)

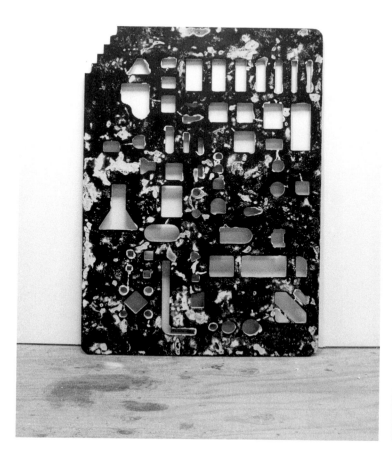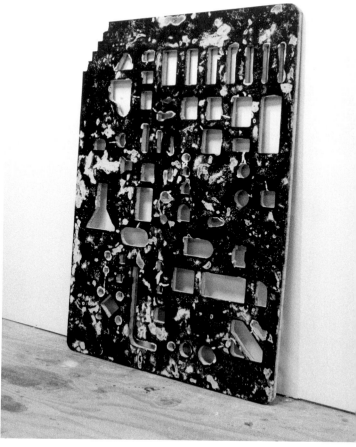

Home Furnishings, urethane, polyurethane adhesive, plywood, 121.9 x 173.3 x 2.5 cm, 2010
Every Thing Must Glow, plaster and steel, 274.32 x 152.4 cm, 2009 (opposite)

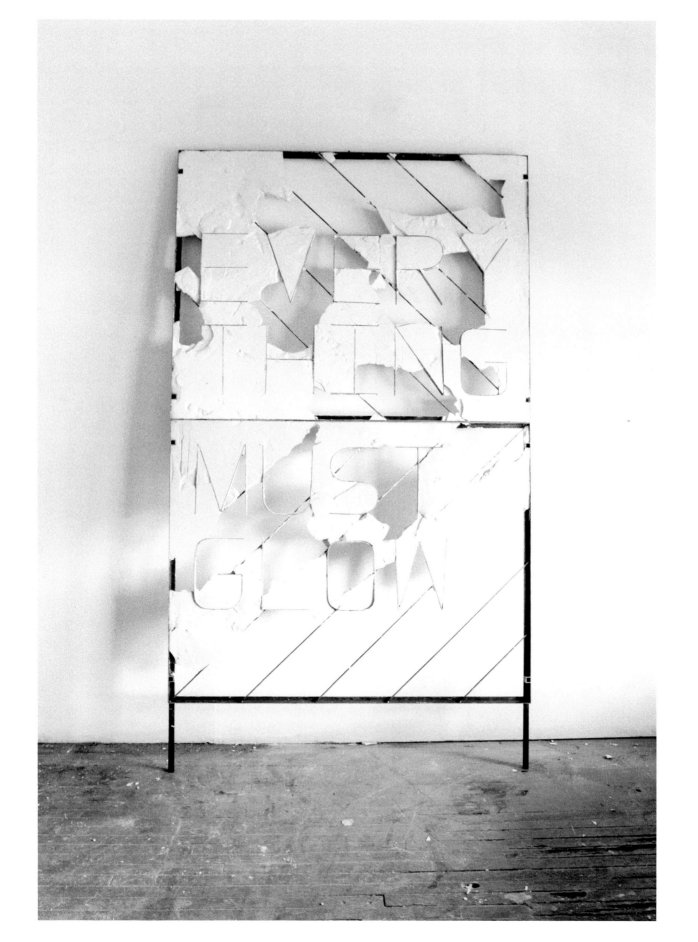

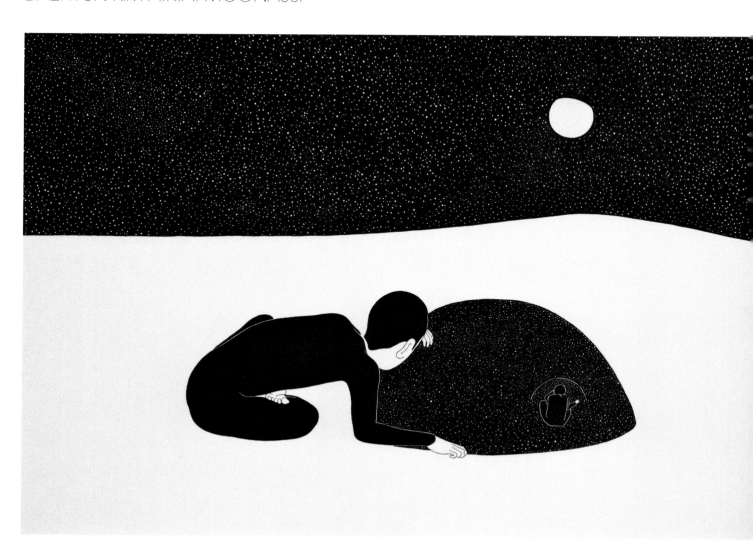

Example of Seeing Seeing, marker and pen on paper, 29.5x42cm, 2010

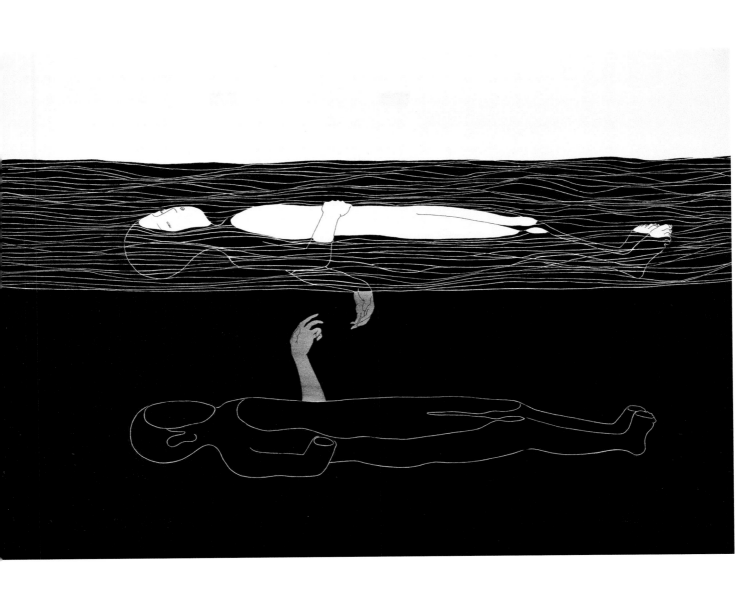

Sinking of You, marker and pen on paper, 29.5×42 cm, 2010

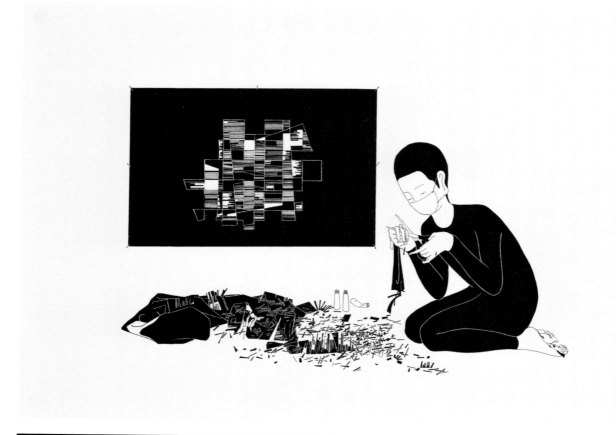

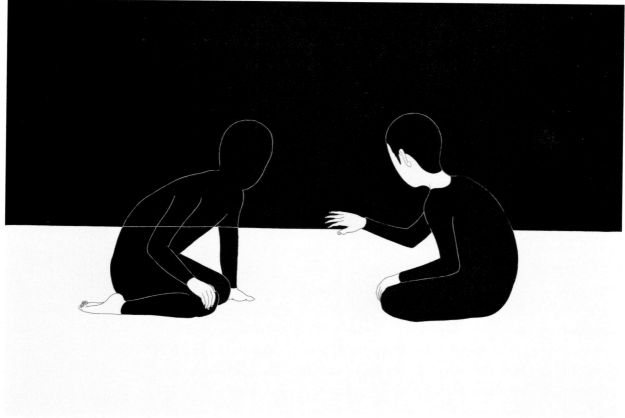

An Abstract Romanticist, marker and pen on paper, 29.5x42cm, 2010 (top)
Draw a Curtain, marker and pen on paper, 29.5x42cm, 2010 (bottom)

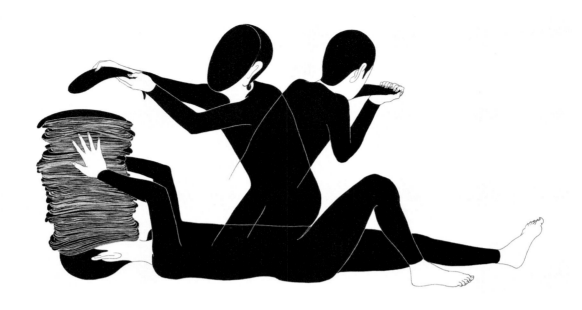

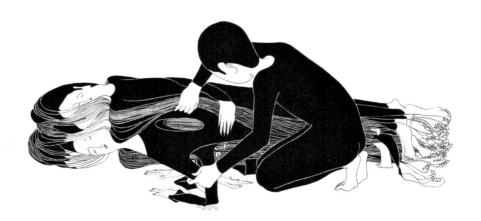

Faces That I Have to See Before I Sleep, marker and pen on paper, 29.5x42cm, 2010 (top)
The Moment That I Loved You, marker and pen on paper, 29.5x42cm, 2010 (bottom)

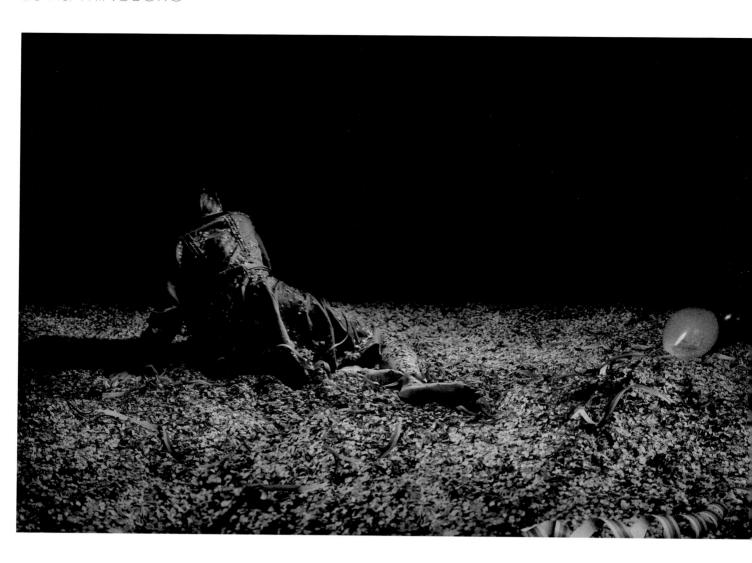

Inversion of the Realm, C-print, 180 x 125 cm, 2008
Piñata, C-print, 79 x 110 cm, 2008 (opposite)

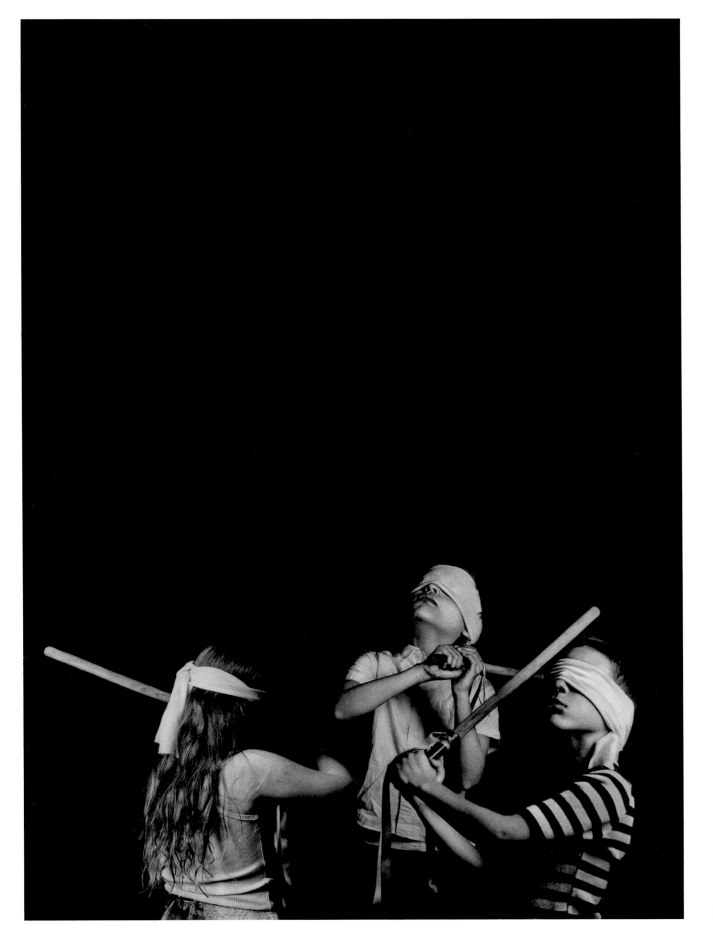

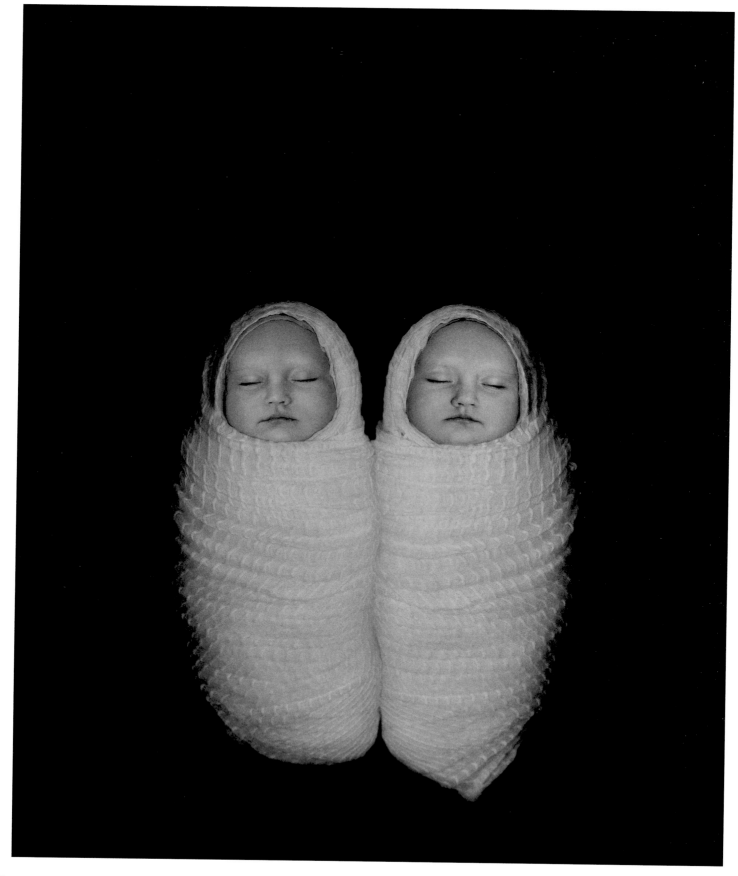

Cocoons, C-print, 57 x 73 cm, 2007

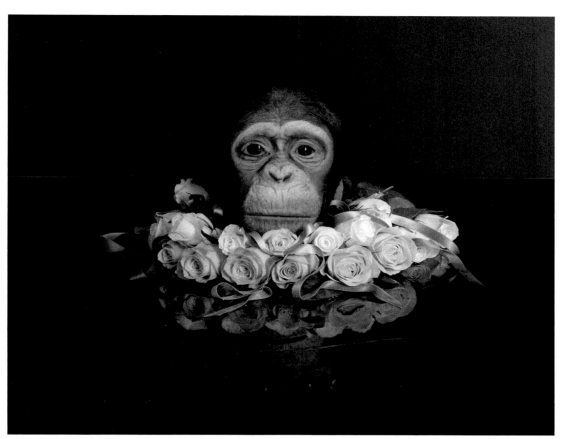

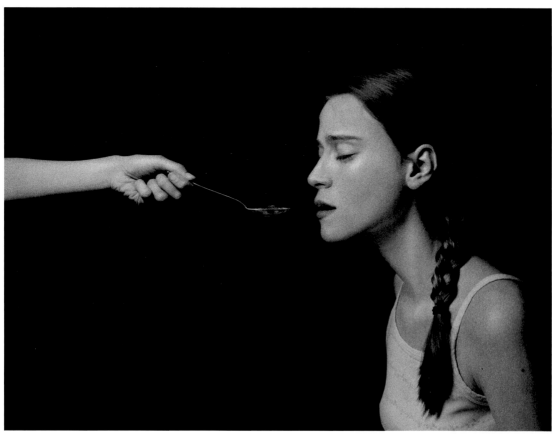

In Memoriam, C-print, 75×60 cm, 2009 (top)
Solitary Act I – Compulsion, C-print, 92×73 cm, 2007 (bottom)

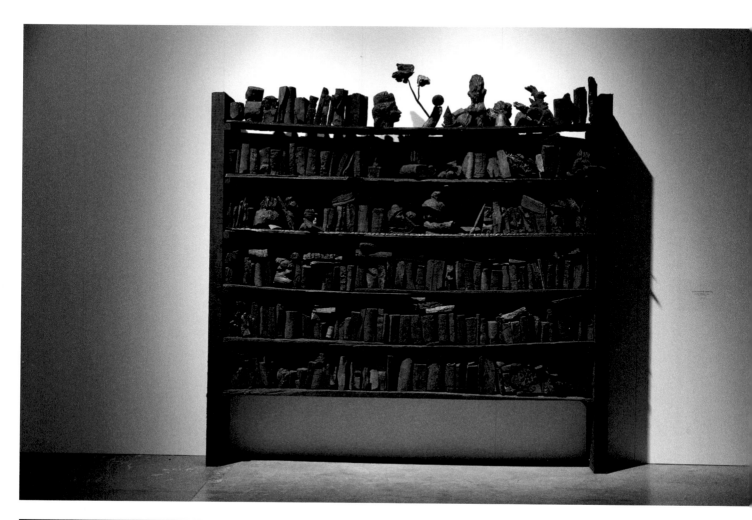

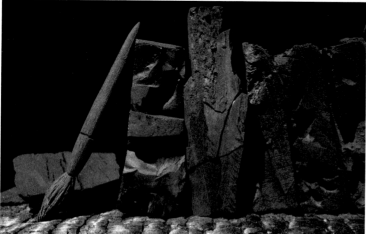
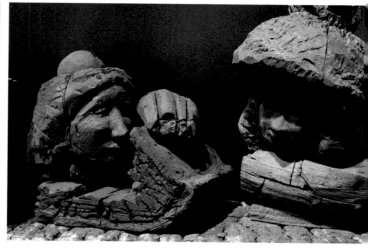

Human Library, charcoal and wood, 200x150x40cm, 2009.

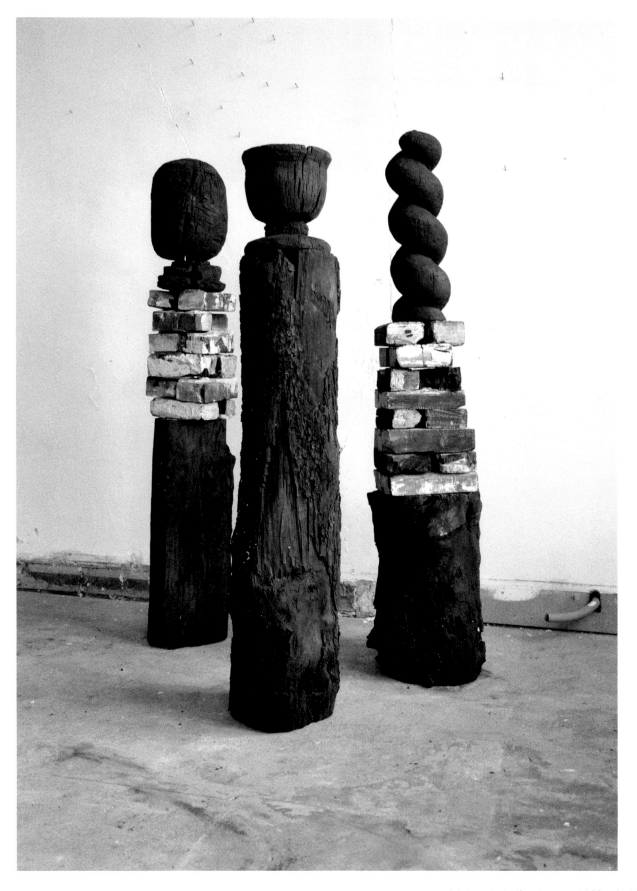

Melancholy (3), charcoal, 120x40x25cm, 2010

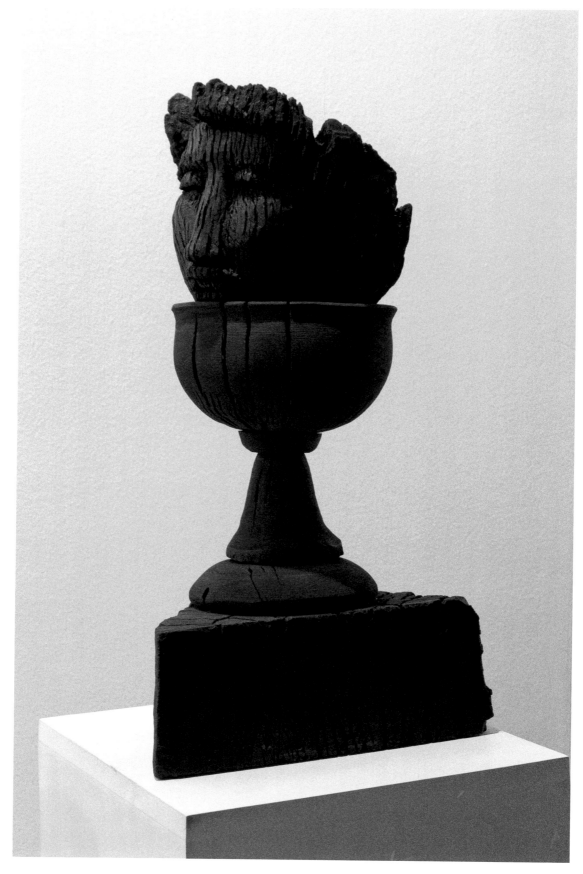

Pura Sangre, charcoal, 60 x 35 x 35 cm, 2010

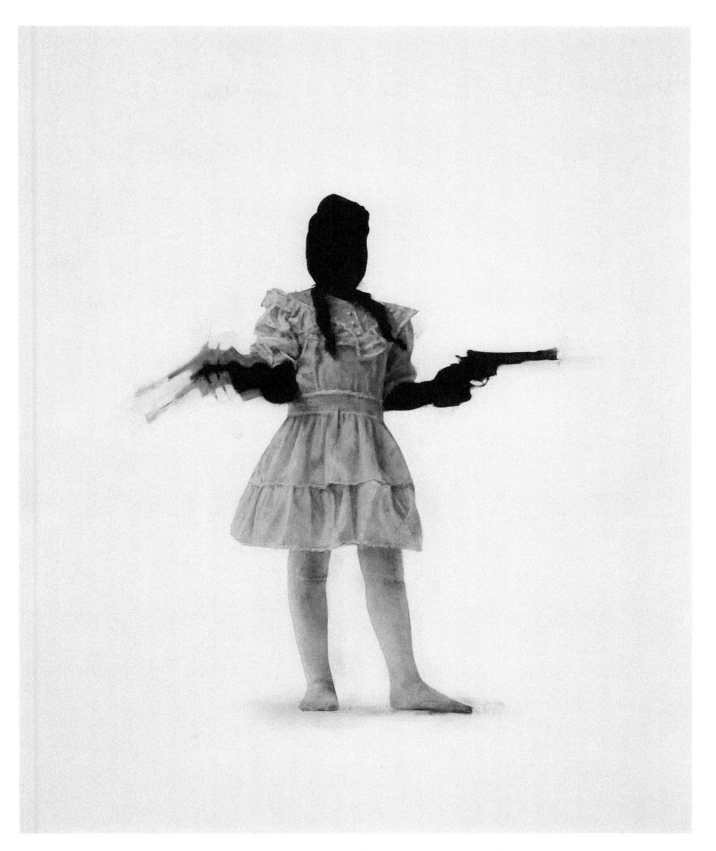

Drawing No. 2 from the video "Small Dramas & Little Nothings," Conté and acrylic on mylar, 35.5 x 28 cm, 2009

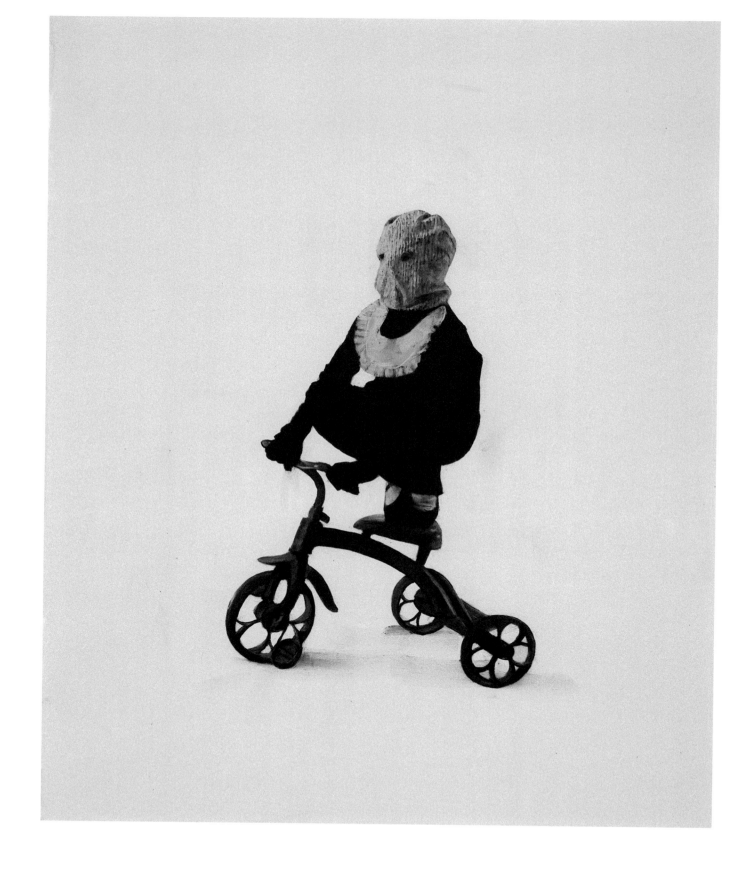

Drawing No. 3 from the video "Small Dramas & Little Nothings." Conté and acrylic on mylar, 35.5 x 28 cm, 2009

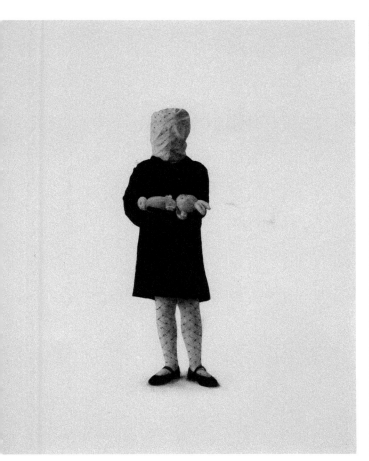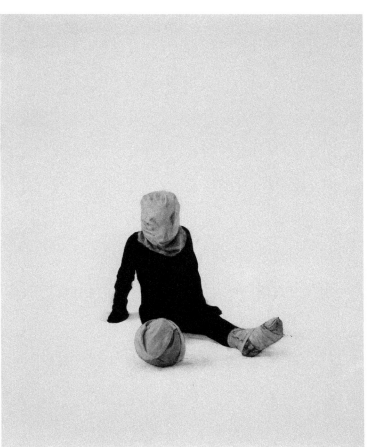

Drawing No. 1 from the video "Small Dramas & Little Nothings," Conté and acrylic on mylar, 35.5 x 28 cm, 2009 (left)
Drawing No. 4 from the video "Small Dramas & Little Nothings," Conté and acrylic on mylar, 35.5 x 28 cm, 2009 (right)

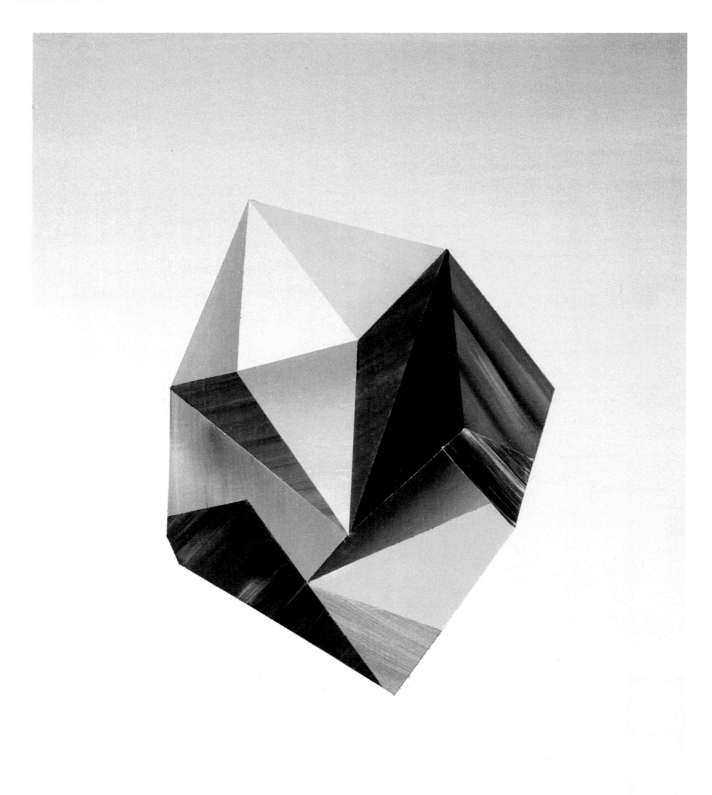

Landscape Painting 6 (Sunset), acrylic on wood panel, 28 x 35.5 cm, 2010

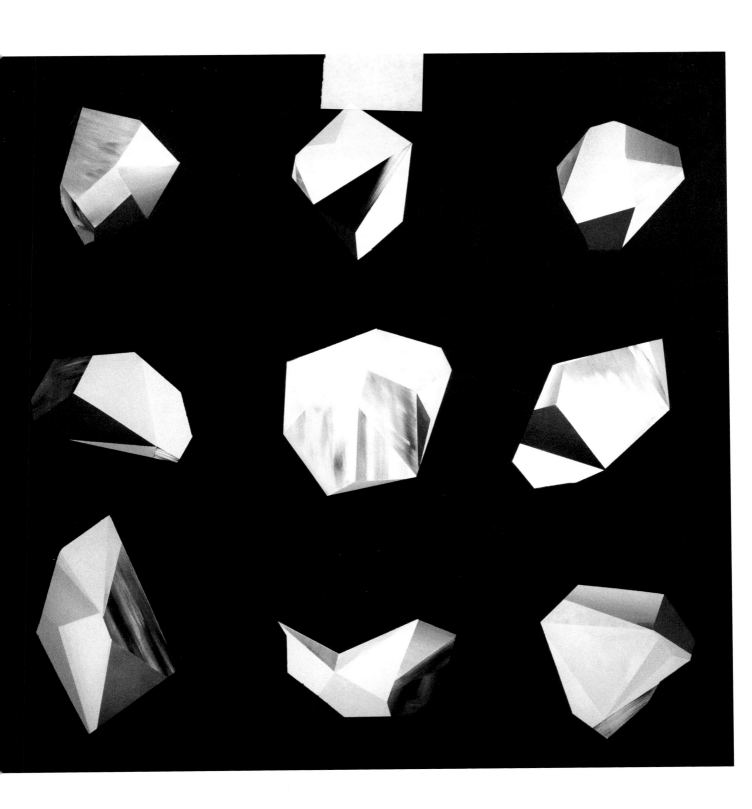

New Nature Systems 9, acrylic on wood panel, 91.5x91.5cm, 2010

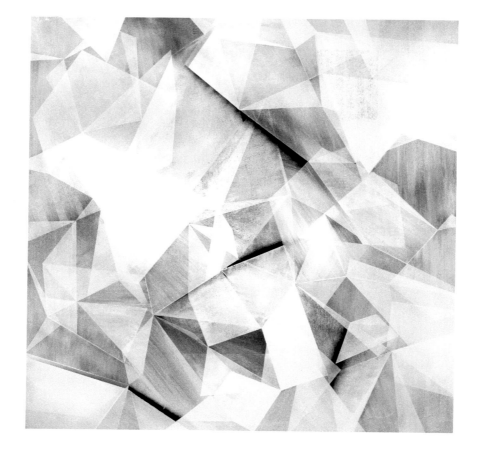

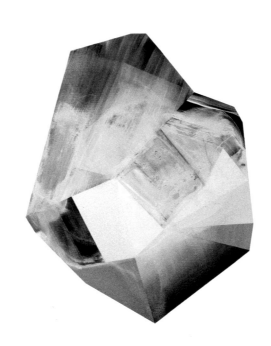

New Nature Systems 8, acrylic on wood panel, 91.5x91.5 cm, 2010 (top)
Landscape Painting 1, acrylic on wood panel, 50.8x67 cm, 2010 (bottom)

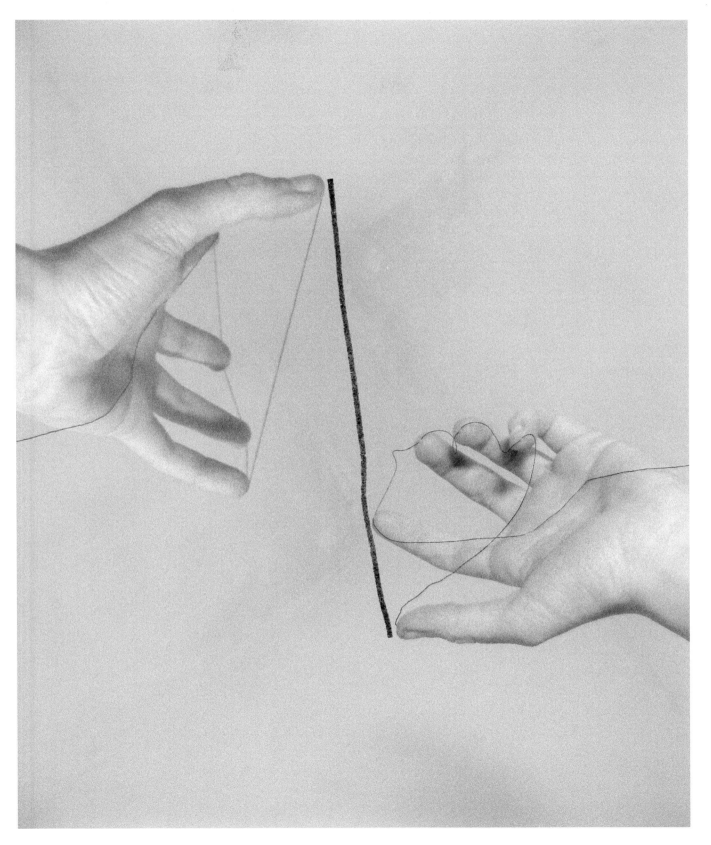

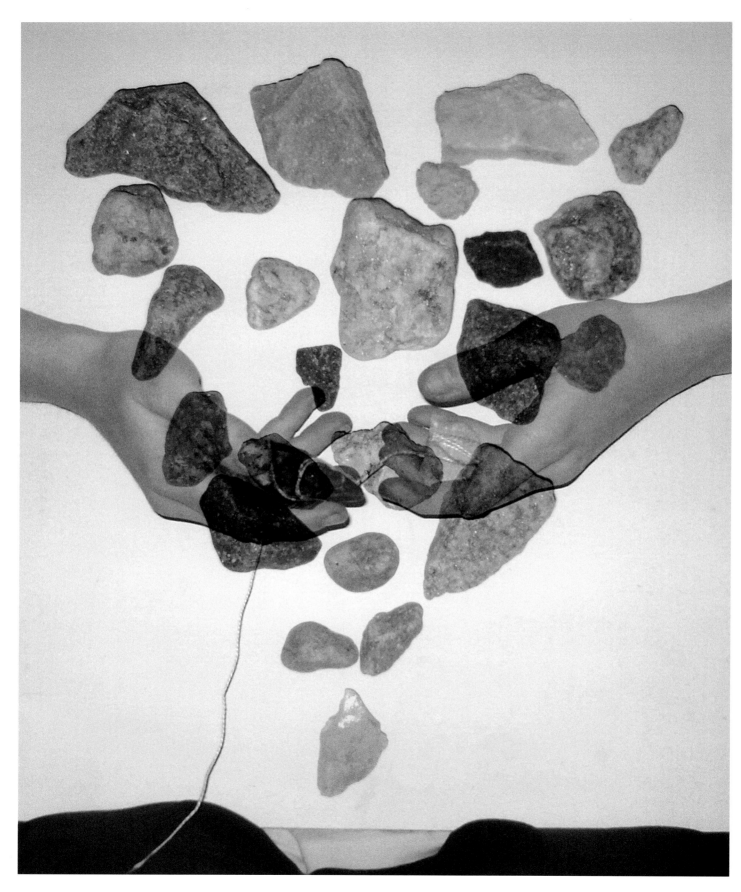

Soltar, digital print, 21x26 cm, 2008

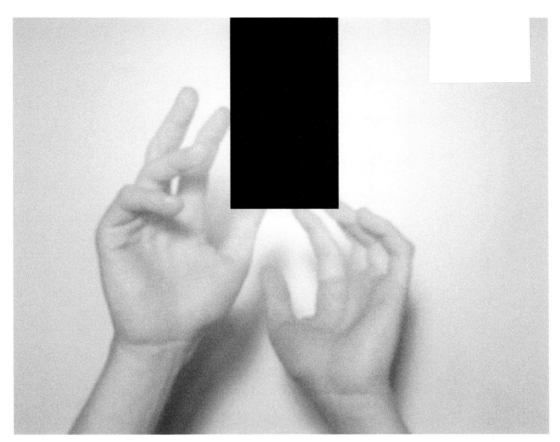

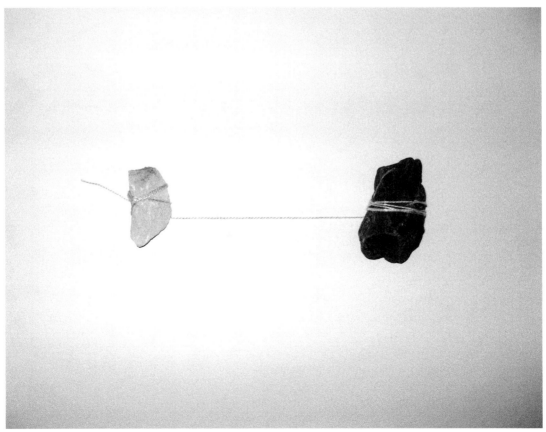

Puerta, digital print, 21 x 26 cm, 2008 (top)
Atados, digital print, 21 x 26 cm, 2008 (bottom)

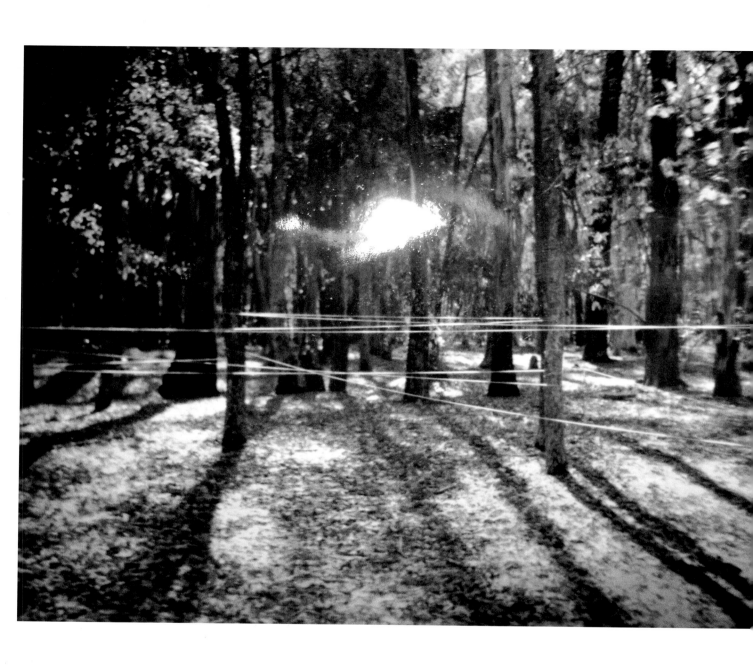

Bosque, analog photograph, 21 x 26 cm, 2008

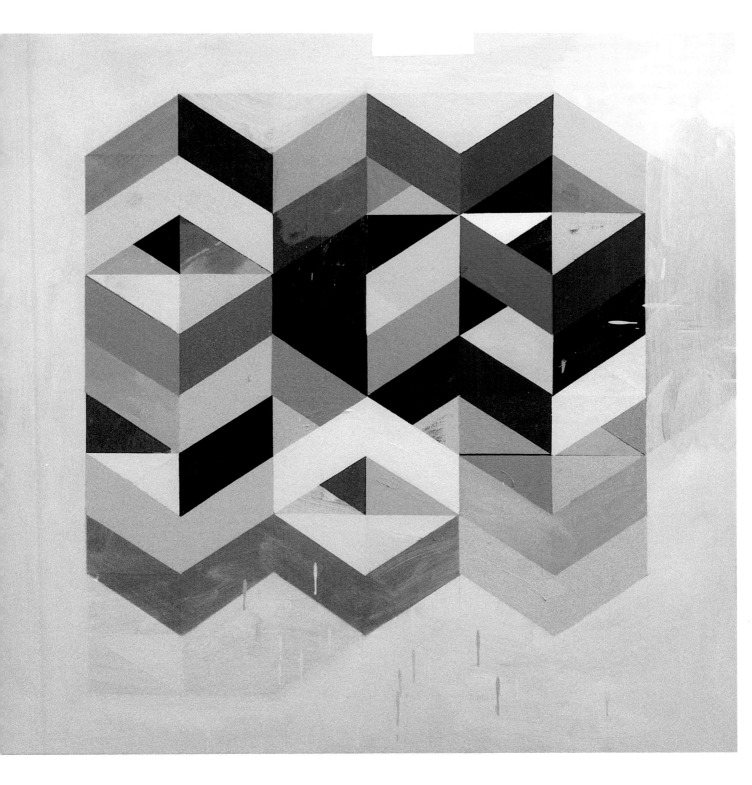

Reconfigured Grid Painting No.1, oil on canvas, 122x122cm, 2008

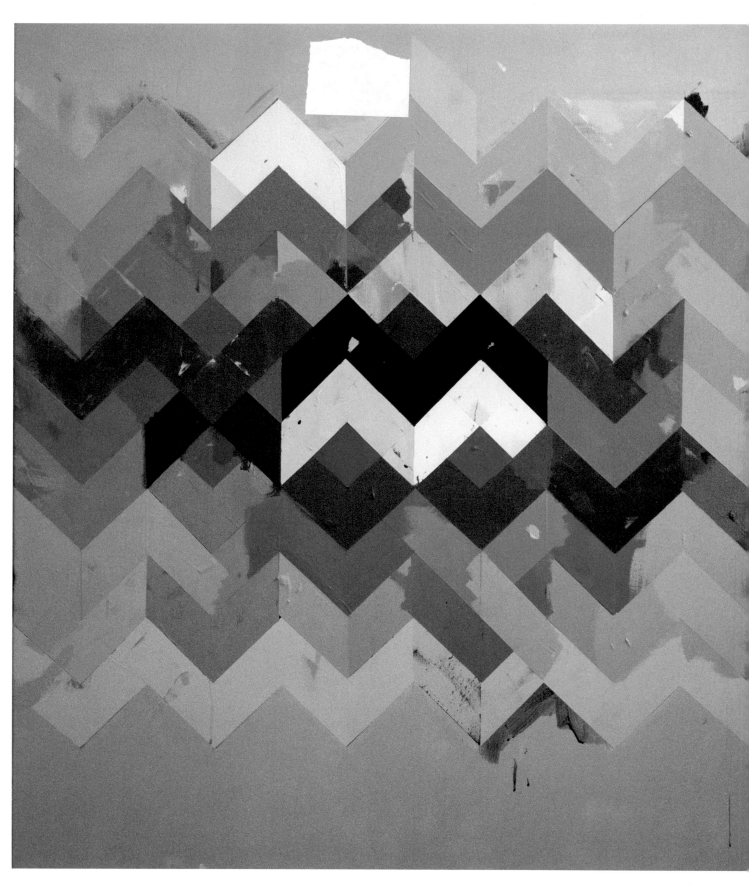

Reconfigured Grid Painting No.10, acrylic on canvas, 132x119.4cm, 2010

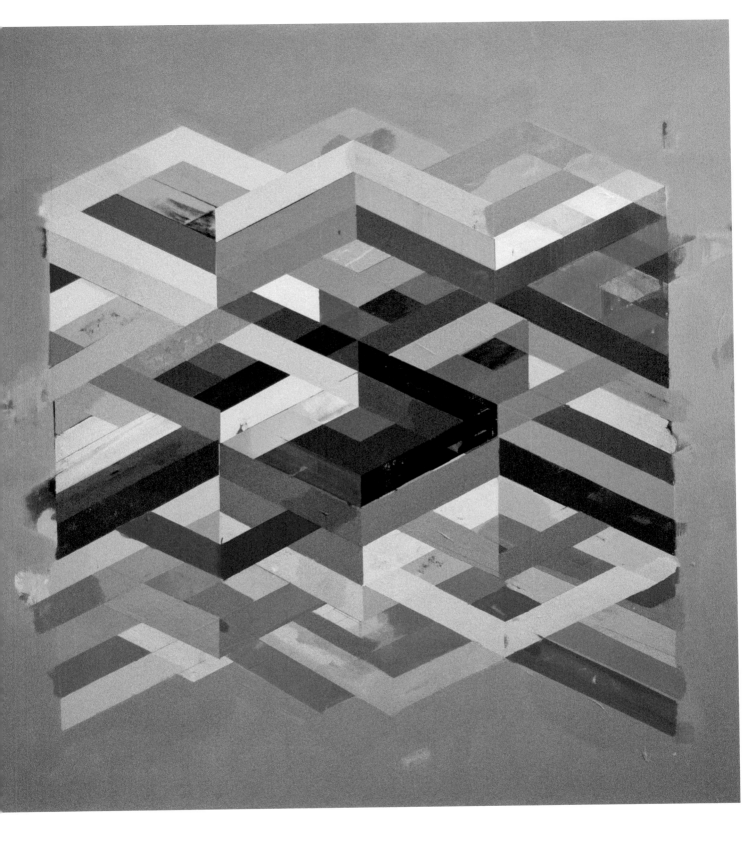

Reconfigured Grid Painting No. 8, acrylic on canvas, 119.4×109.2 cm, 2009

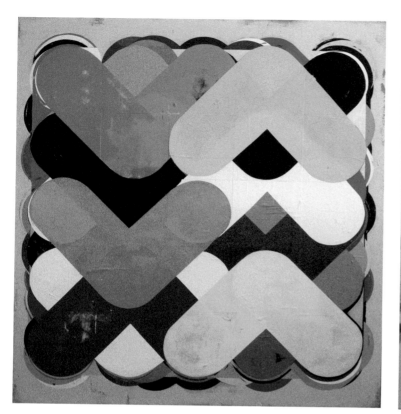
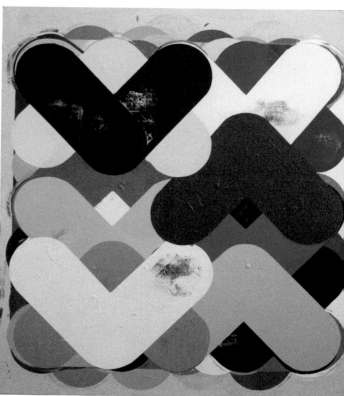

Reconfigured Grid Painting No.12, acrylic on canvas, 48×44cm, 2010 (left)
Reconfigured Grid Painting No.11, acrylic on canvas, 48×44cm, 2010 (right)

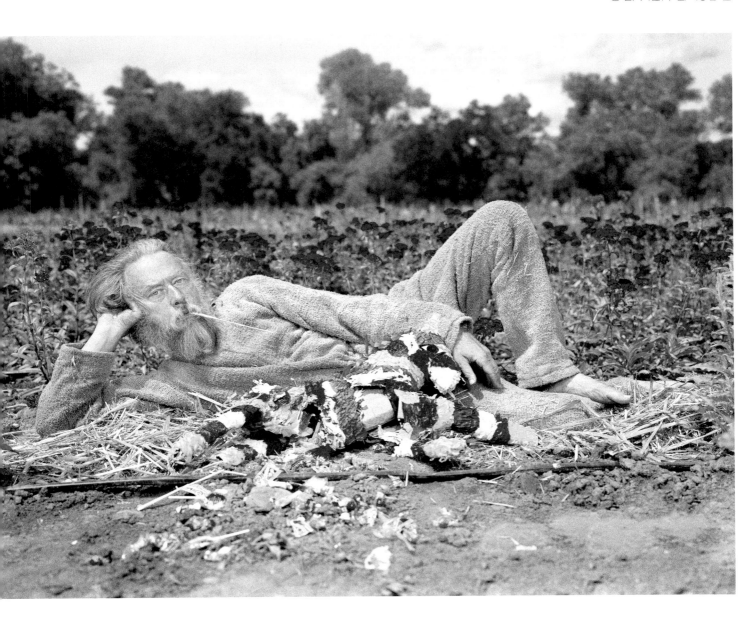

El Viejo from the "Mas Música Mexicana" series, C-print, 127.63 x 153.03 cm

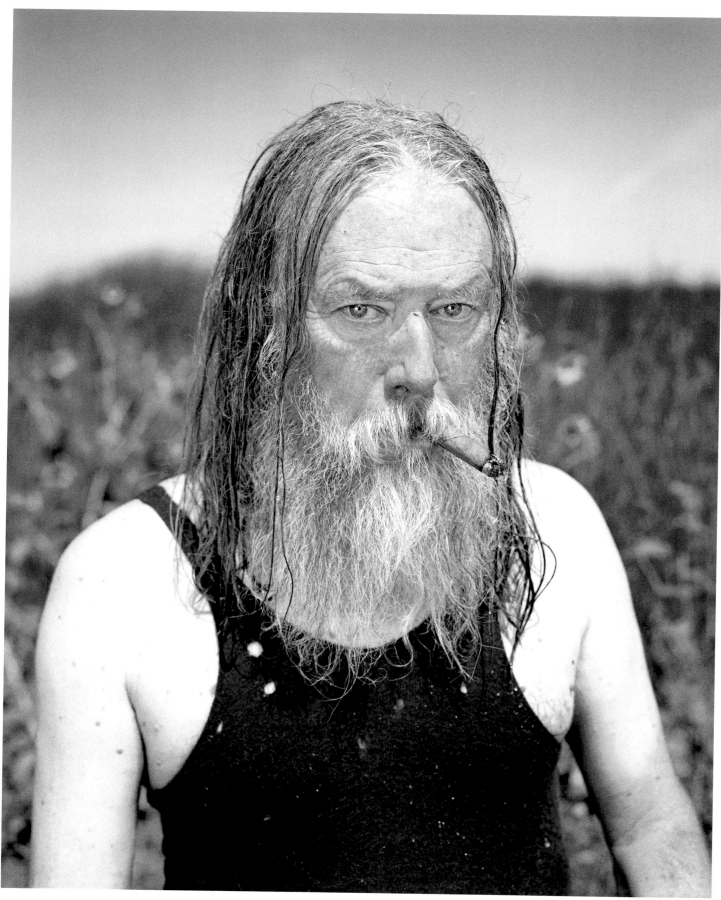

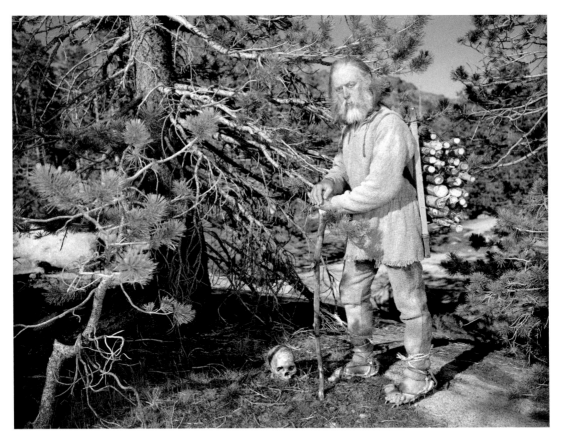

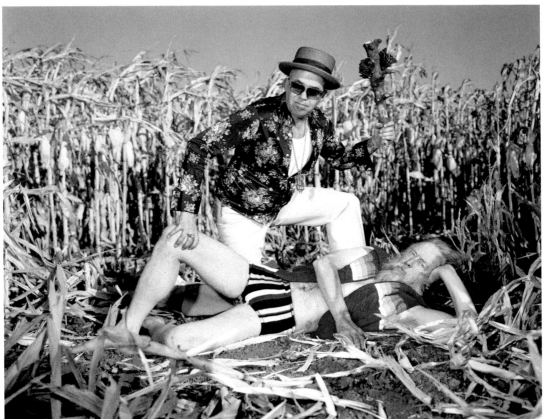

Holzfällers? from the "Lifestyle" series, C-print, 127.63 x 153.03 cm (top)
The Wrongerer from the "Lifestyle" series, C-print, 127.63 x 153.03 cm (bottom)
Henry from the "Cavendish" series, C-print, 51.43 x 161.59 cm (opposite)

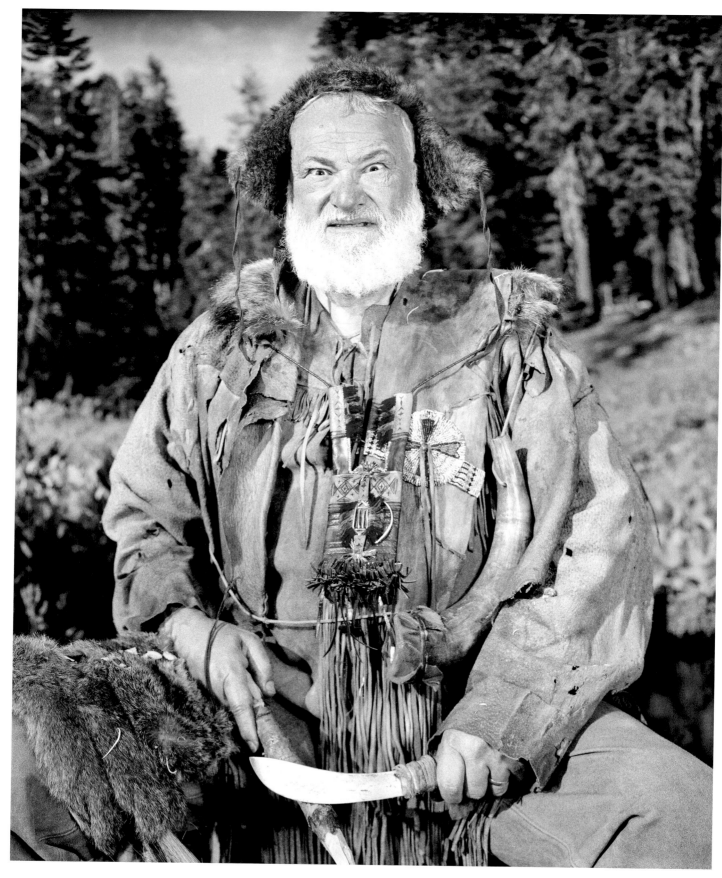

What's So Funny About...Love, Death and Misunderstandings, C-print, 127.63 x 153.03 cm

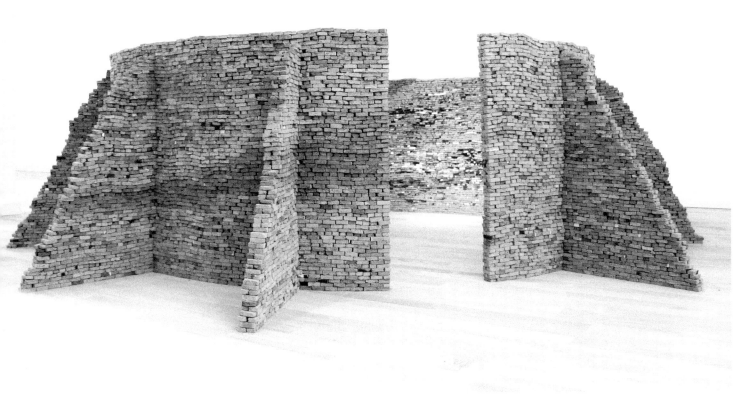

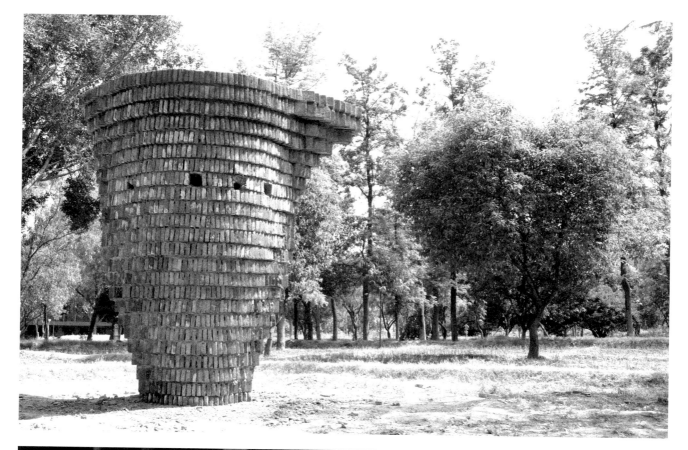

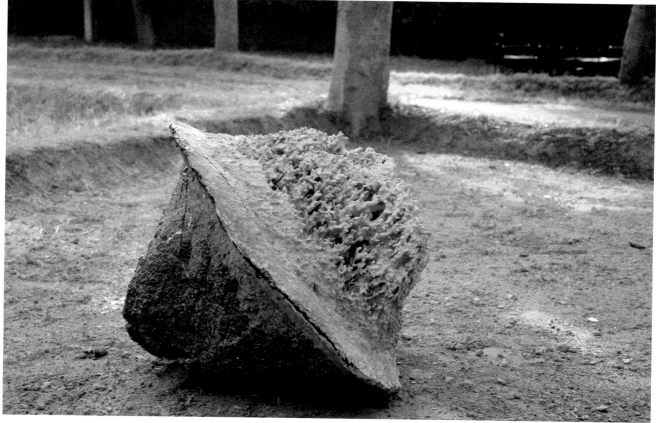

Skyqutb, brick, 300 x 120 x 240 cm, 2005 (top)
Inverted Anthill, wax, plaster, pigment, 70 x 70 x 55 cm, 2005 (bottom)

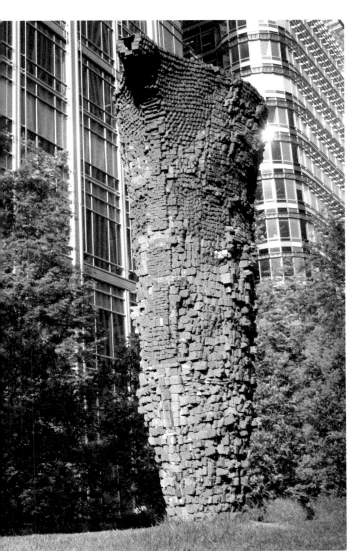

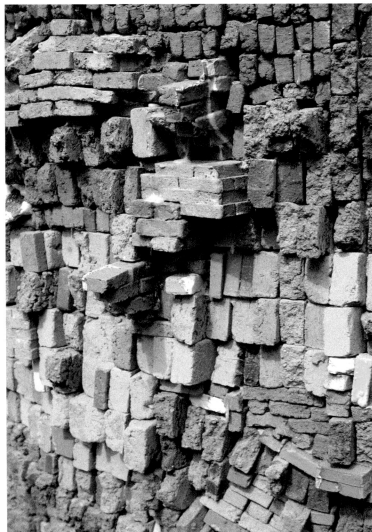

Jug, fired clay, paint, cement, 225×120×70cm, 2008

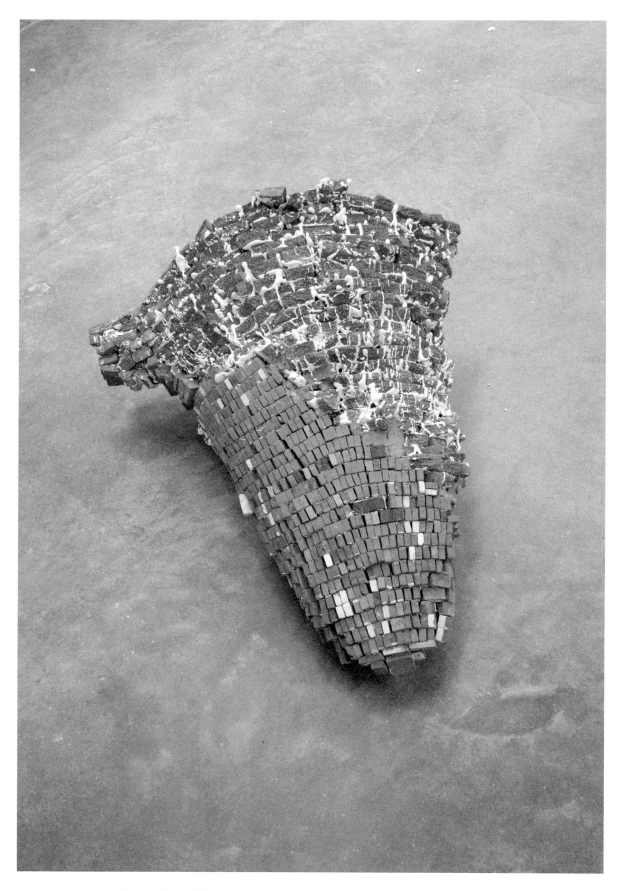

Reformation, fired clay, paint, stain, 78 x 60 x 80 cm, 2006

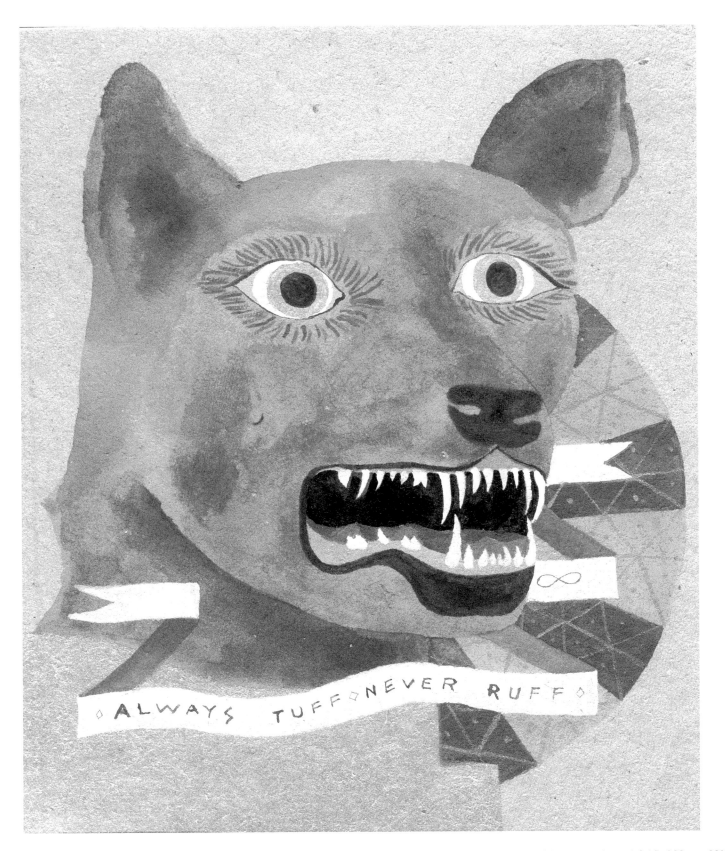

Tuff Dog, gouache, watercolor and ink on grey board, 14.5 x 180 cm, 2010

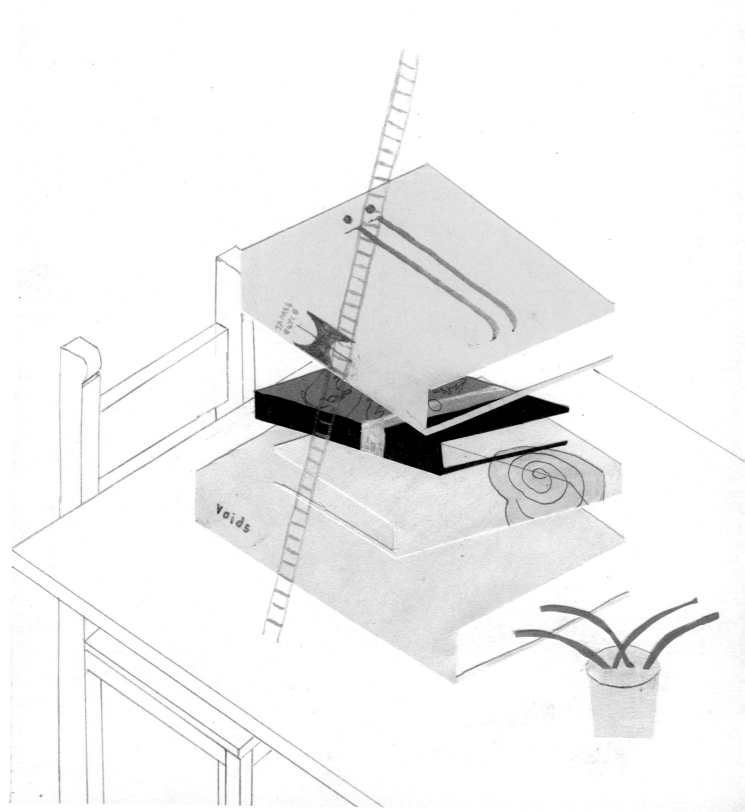

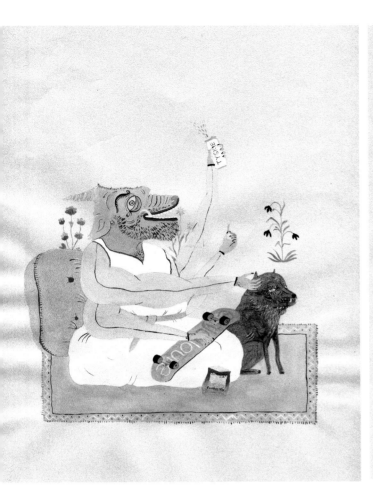

H. Buddy, gouache, watercolor and ink on Japanese paper, 21.6x27.9 cm, 2010 (left)
Skating Curbs, gouache, watercolor ard ink on Japanese paper, 21.6x27.9 cm, 2010 (right)
Pile, gouache, watercolor and ink on paper, 14.5x18 cm, 2010 (opposite)

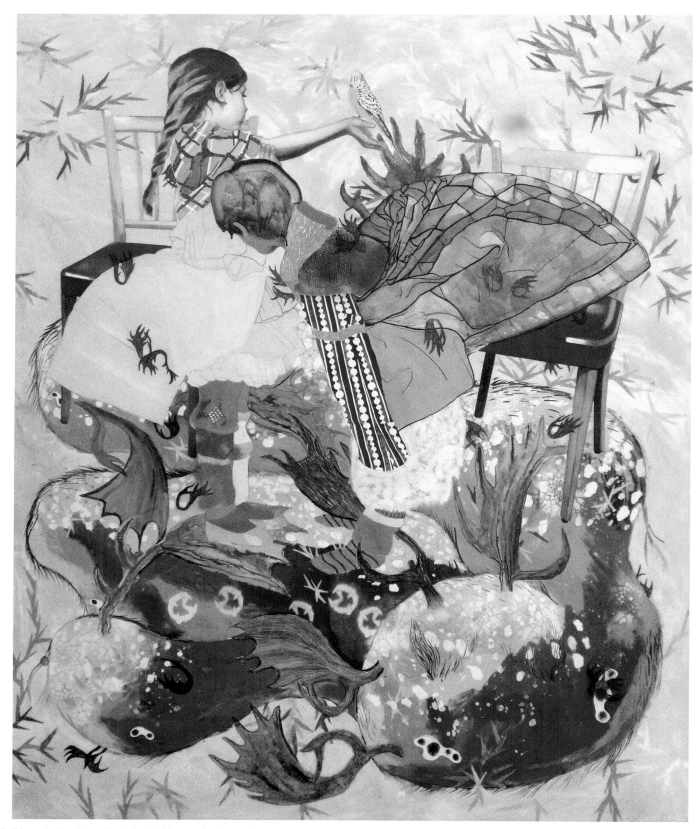

Plastic Vampire Teeth on the Marble Floor, mixed media behind polyester film, 121 × 151 cm, 2010
Bats Everywhere, mixed media behind polyester film, 121 × 151 cm, 2010 (opposite)

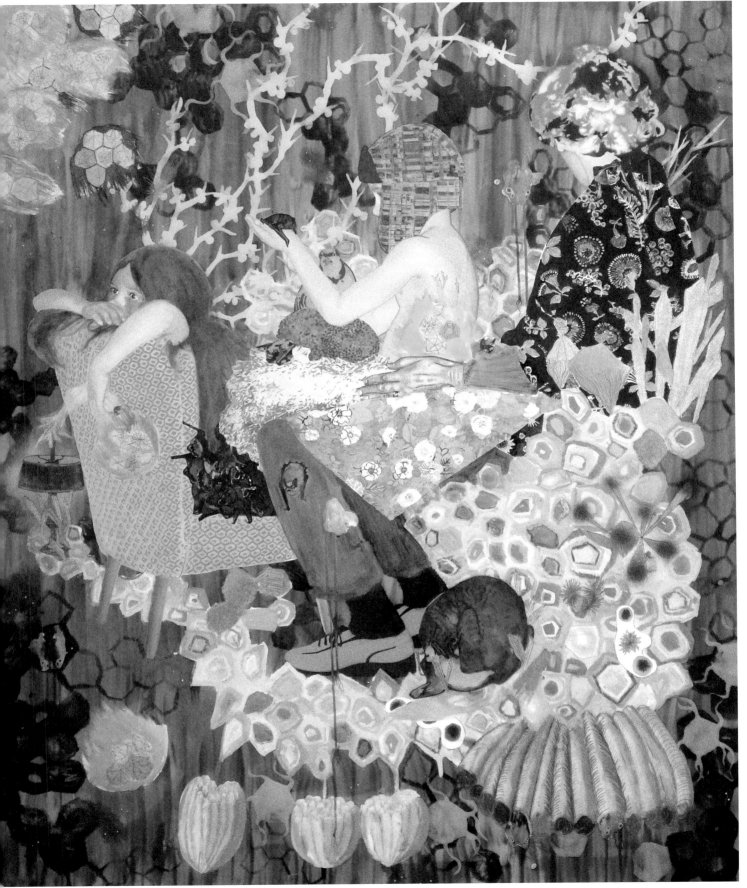

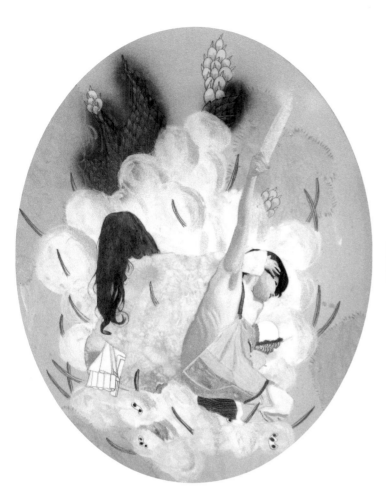
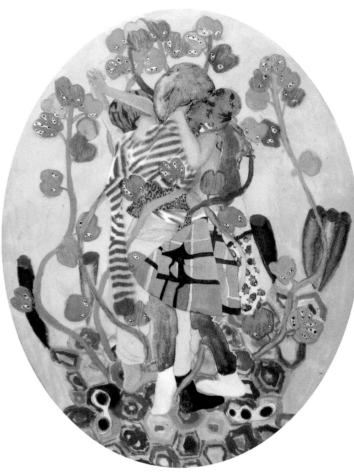

Peaceful Diamonds, mixed media behind polyester film, 45×60cm, 2010 (left)
A Fragile Green Forest, mixed media behind polyester film, 45×60cm, 2010 (right)

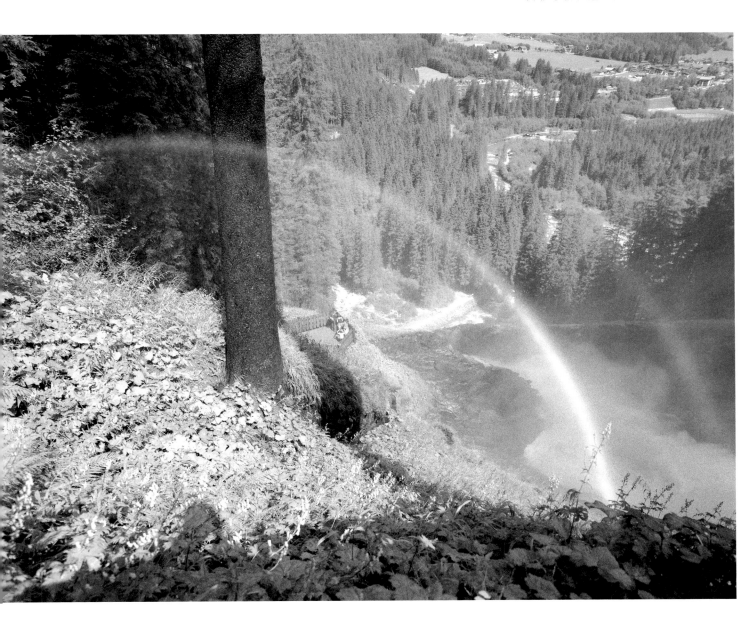

Alpenrose II, digital C-print, 80x100cm, 2009

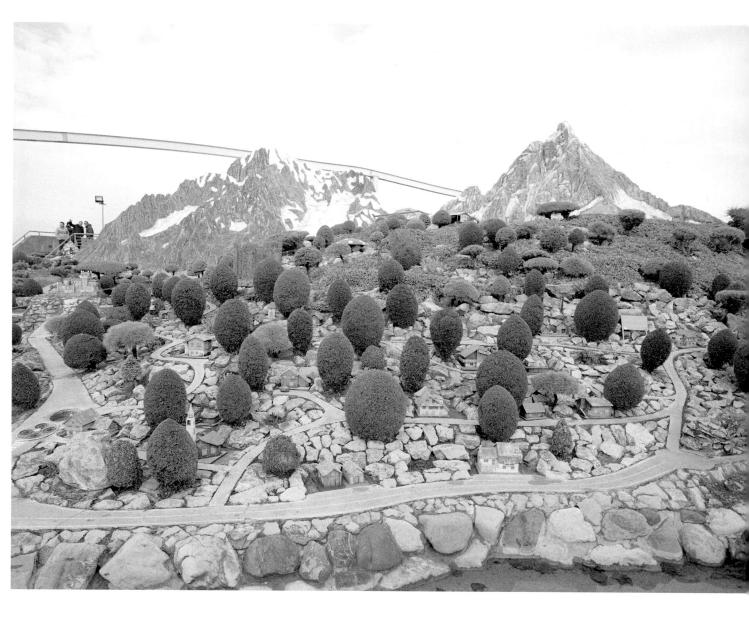

Cervino I, digital C-print, 80×100 cm, 2010

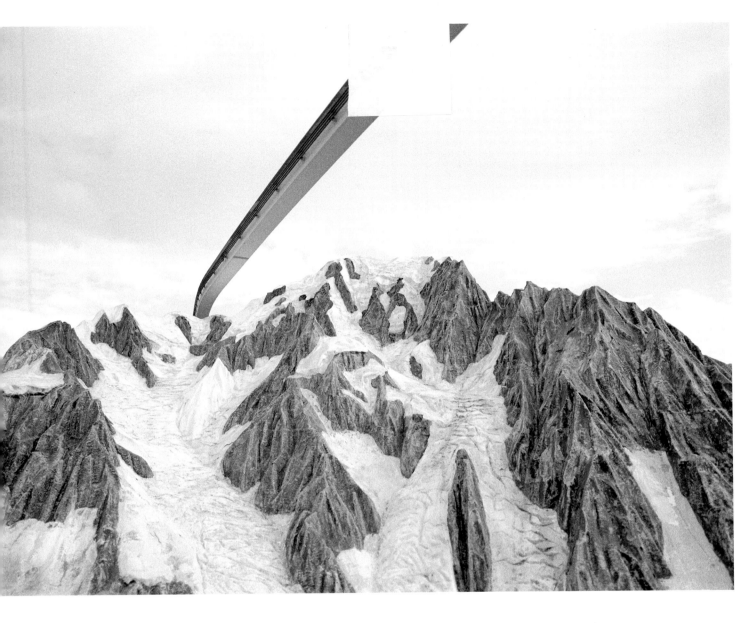

Cervino II, digital C-print, 80x100cm, 2010

Alpenrose III, digital C-print, 80×100 cm, 2009 (top)
Alpenrose I, digital C-print, 80×100 cm, 2009 (bottom)

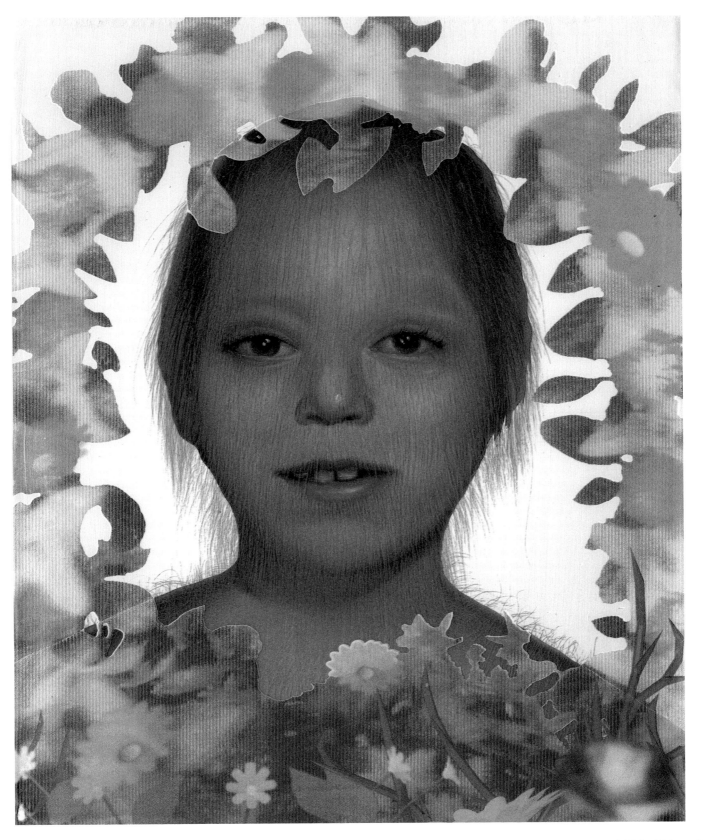

Girl With Floral Frame, oil, resin, acrylic, and silkscreen on panel, 50.8 x 40.6 cm, 2009

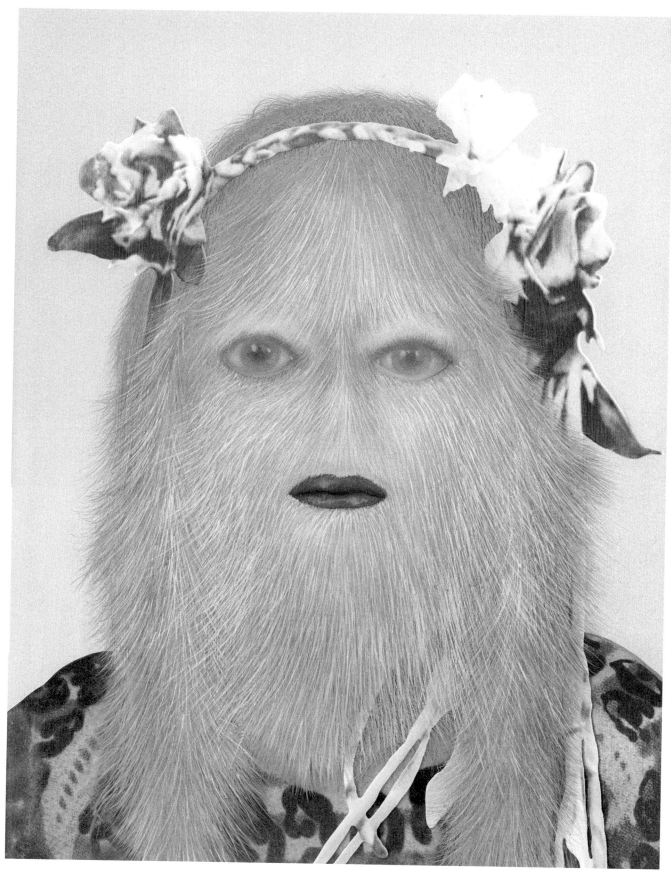

Girl With Floral Headband, oil, resin, acrylic, and silkscreen on panel, 50.8×40.6cm, 2010

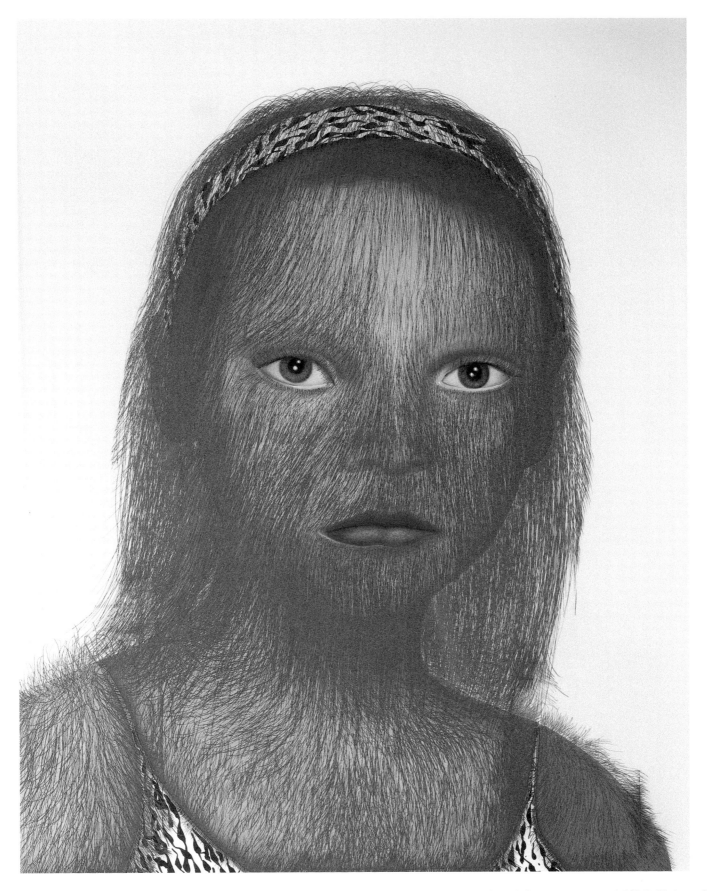

Youth With Zebra Tank, oil, airbrush, enamel, and silkscreen on panel, 121.9x91.4cm, 2010

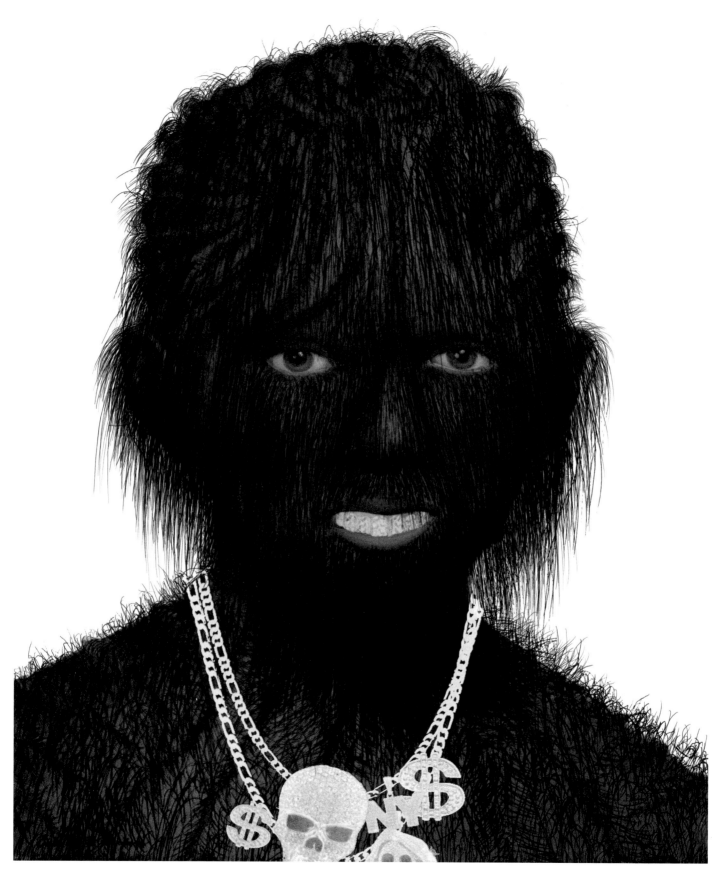

Shirtless Youth With Enhanced Smile and Jewelry, oil, resin, acrylic, and silkscreen on panel, 50.8x40.6cm, 2009

112

Untitled (Screen Block Tower), graphite, gouache, acrylic, colored pencil on masonite, 76x76cm, 2010

Untitled (Potted Plant), graphite, gouache, acrylic, colored pencil on masonite, 76×76cm, 2010

NSPK, graphite, colored pencil, acrylic, enamel on paper, 33×48 cm, 2010 (top)
Untitled, graphite, ink, acrylic, colored pencil on paper, 58.4×73.6 cm, 2010 (bottom)

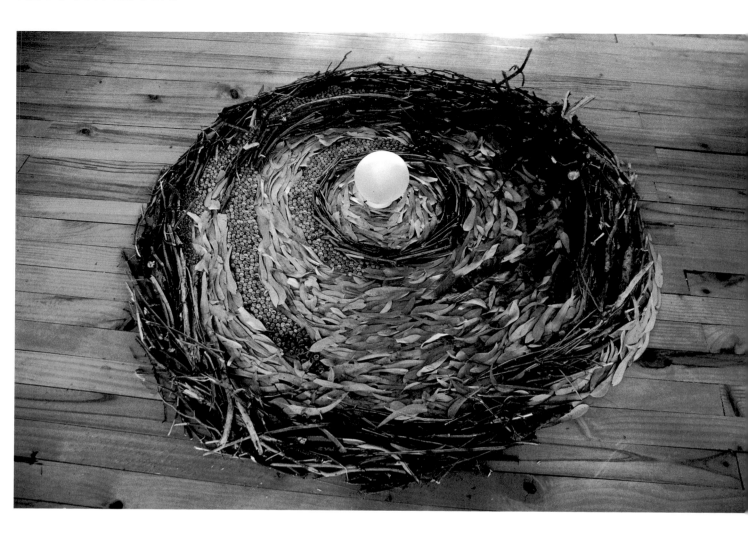

Nido de Luz, leaves, branches, seeds, light, 2009
Hormiguero, ashes, leaves, branches, soil, acrylic paint, 2008 (opposite)

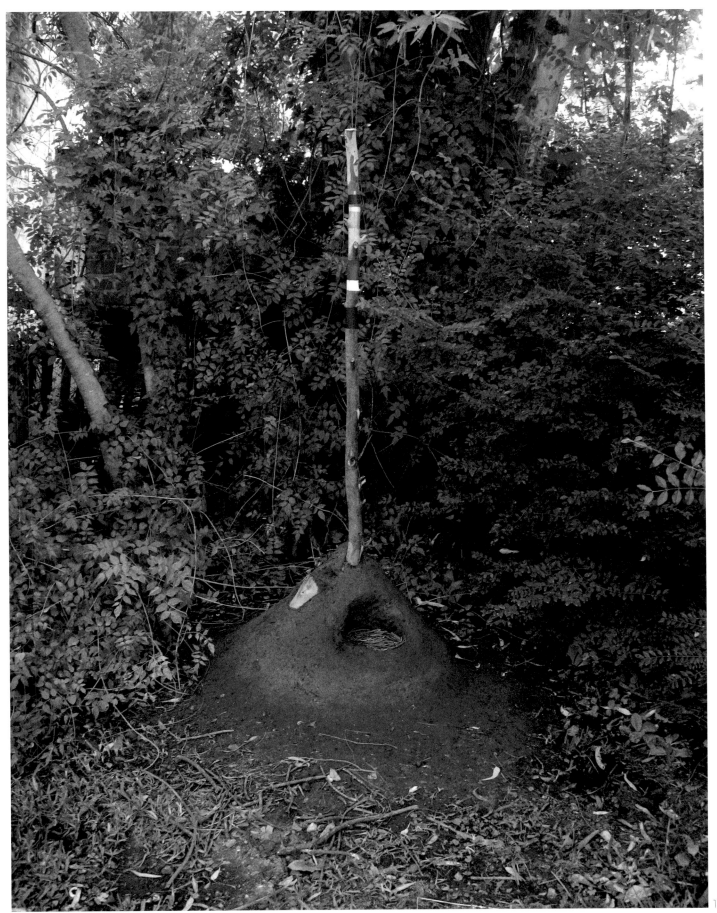

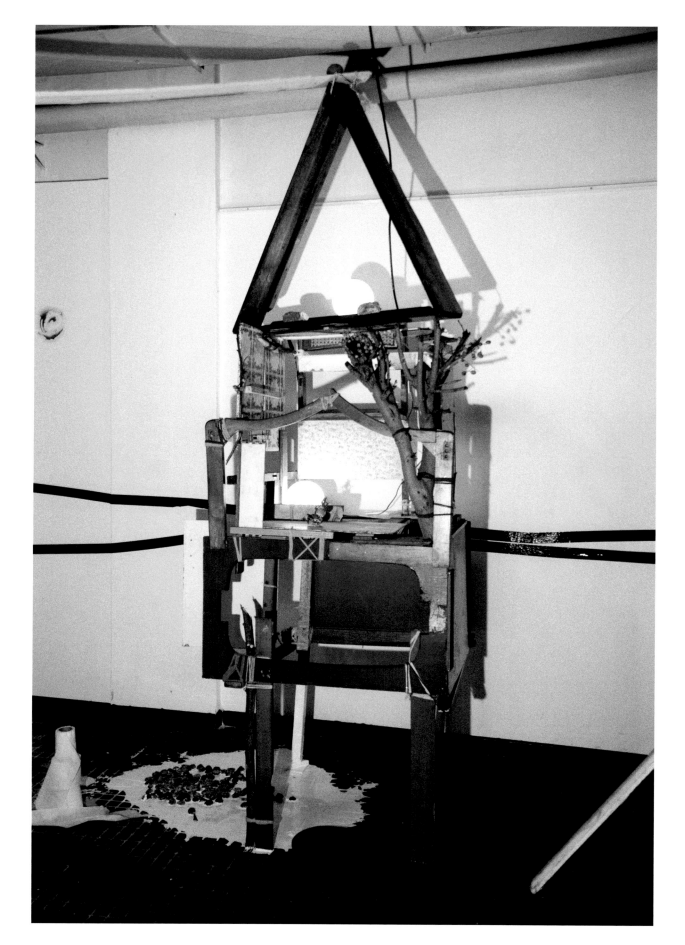

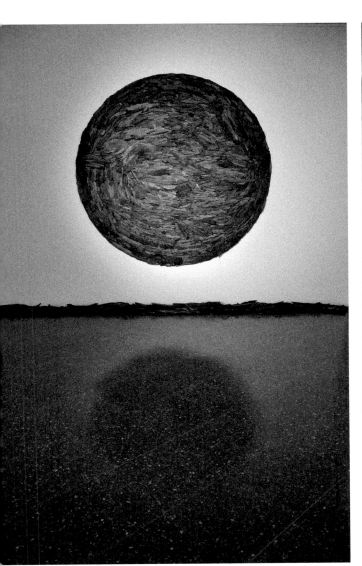

Mañana, bark, 2010
Santuario, found wood/furniture, branches, oranges, threads, light, 2009 (opposite)

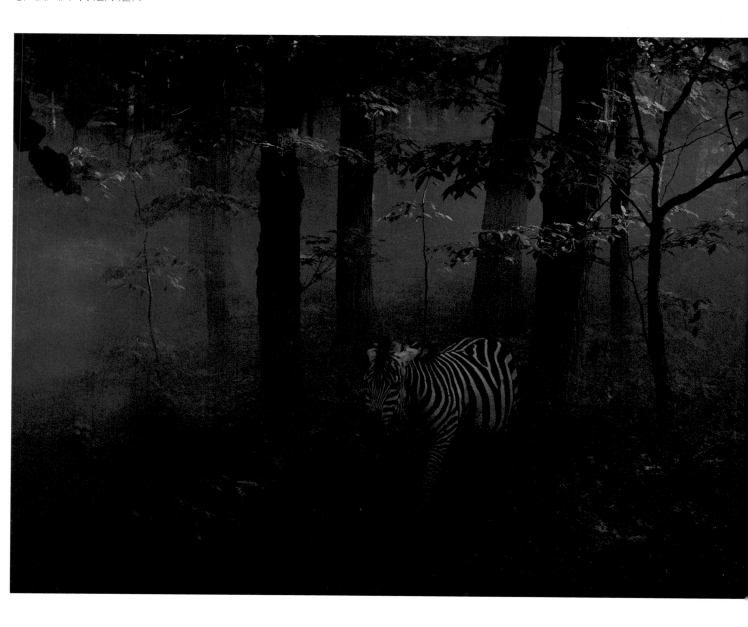

Zebra for J.C., photograph, archival print, varying sizes, 2009

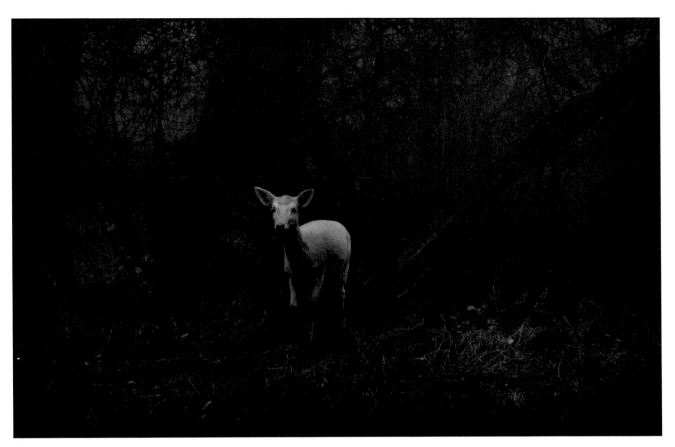

White Deer, Foggy Mountain, archival print, varying sizes, 2010 (top)
Fairless Flowers, archival print, varying sizes, 2009 (bottom)

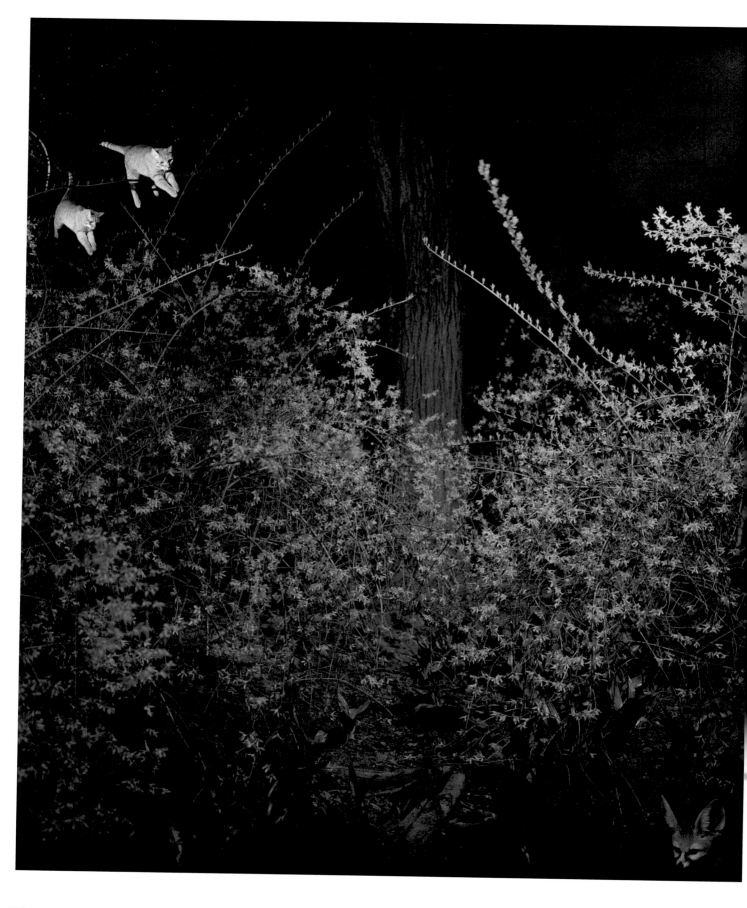

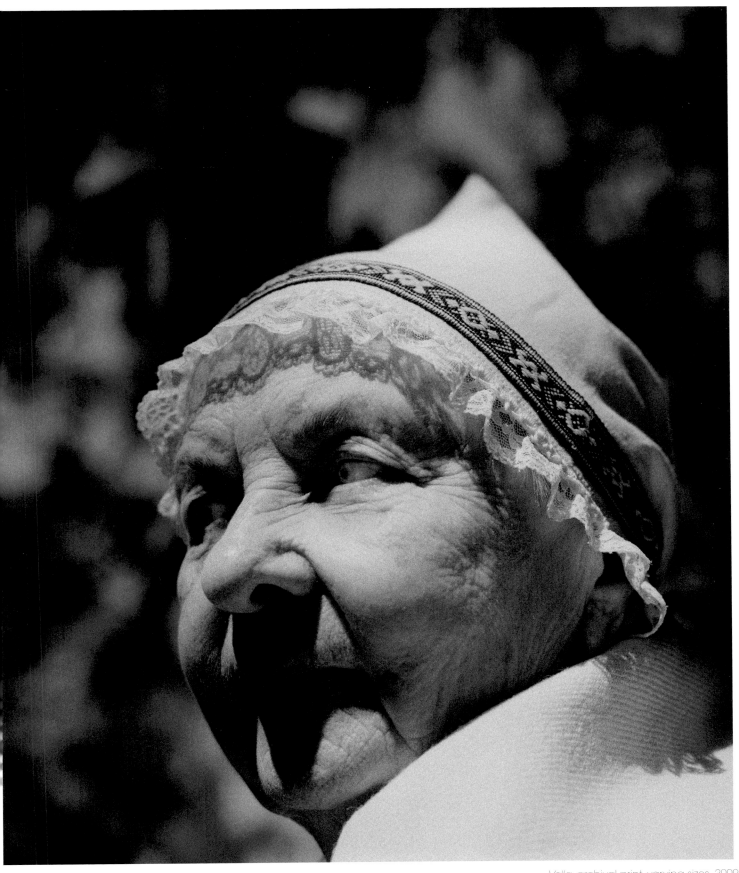

Vella, archival print, varying sizes, 2009
Untitled (Fliers and Fox), archival print, varying sizes, 2008 (opposite)

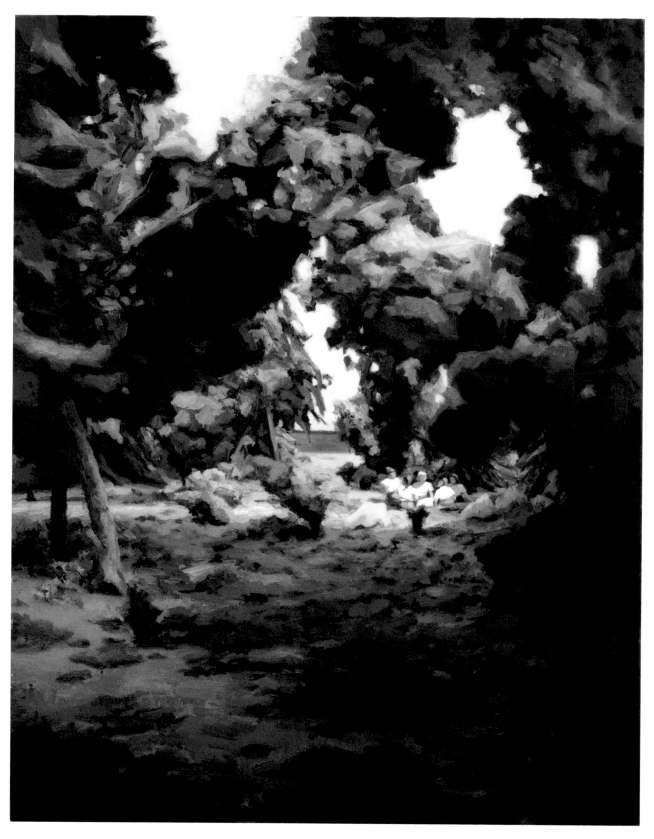

Faking It, oil on panel, 23x30.5cm, 2009

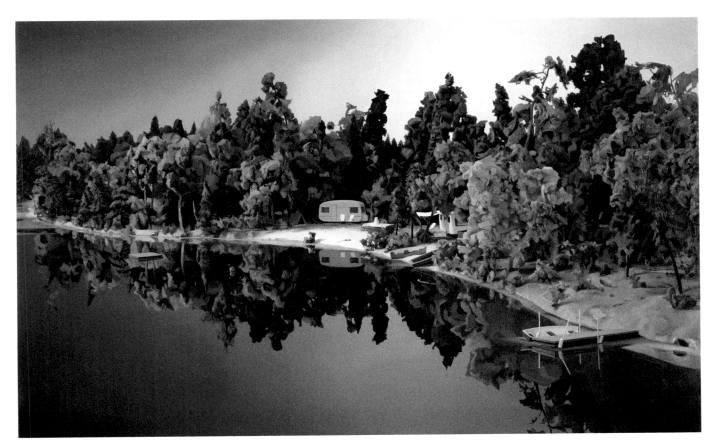

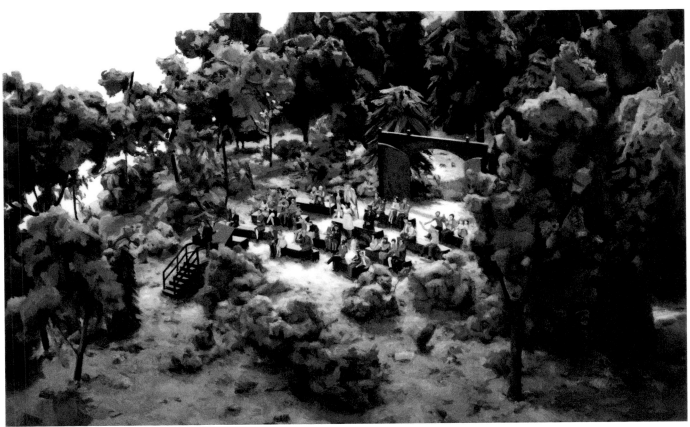

Heat, oil on panel, 61 x 96.5 cm, 2009 (top)
Heaven Help Us, oil on panel, 25.5 x 41 cm, 2009 (bottom)

125

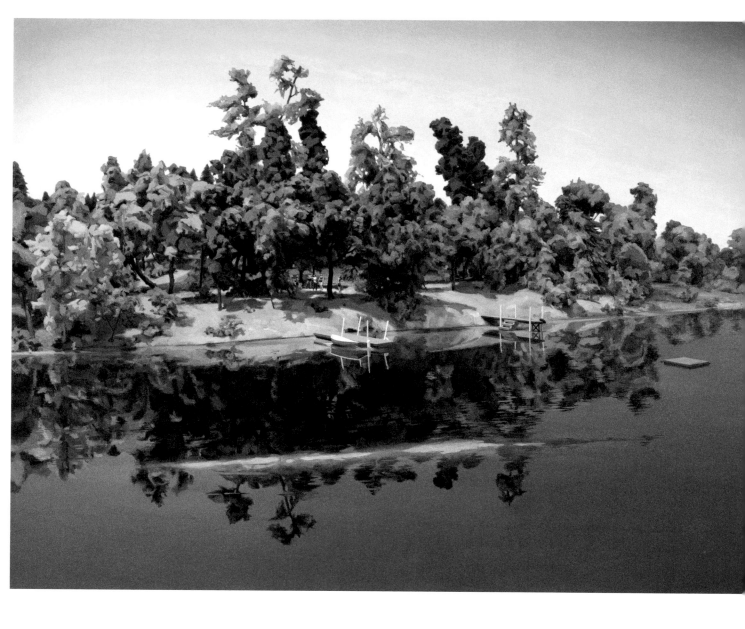

A Change of Scenery, oil on panel, 61 x 76.5 cm, 2009

Untitled, analog photograph, 2010

Untitled, analog photograph, 2010

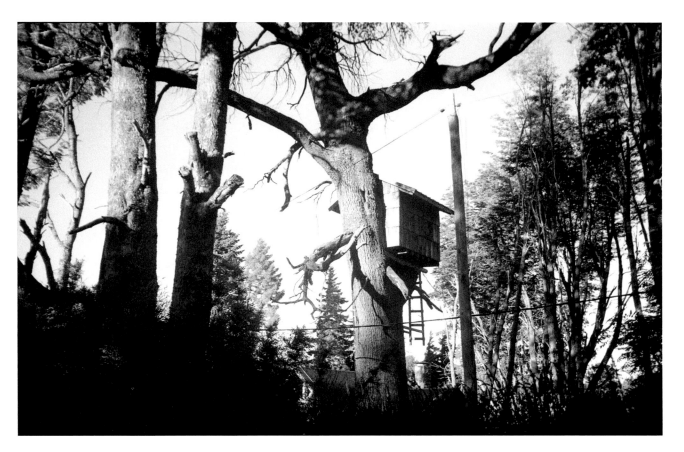

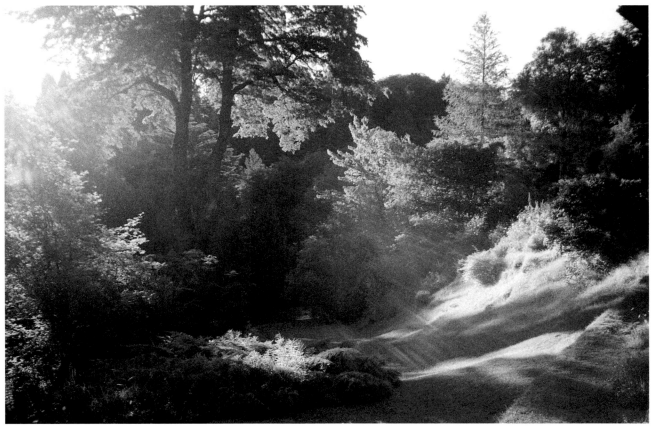

Untitled, analog photograph, 2010 (top)
Untitled, analog photograph, 2010 (bottom)

Untitled, analog photograph, 2010

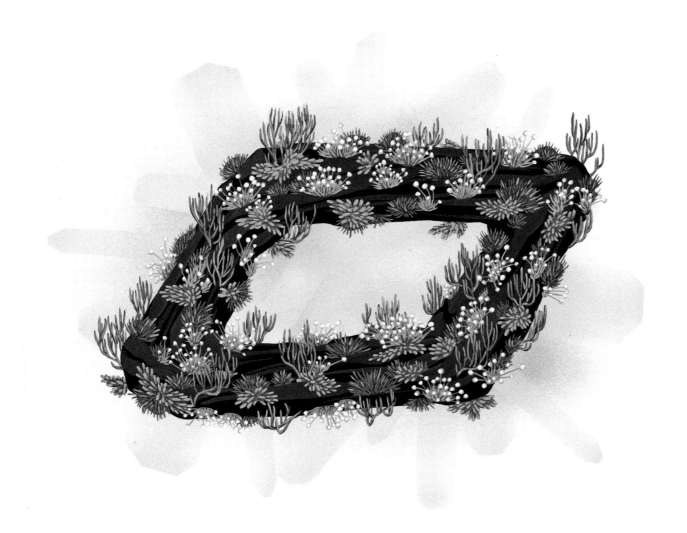

Desert 1, gouache and acrylic on paper, 41x51 cm, 2010

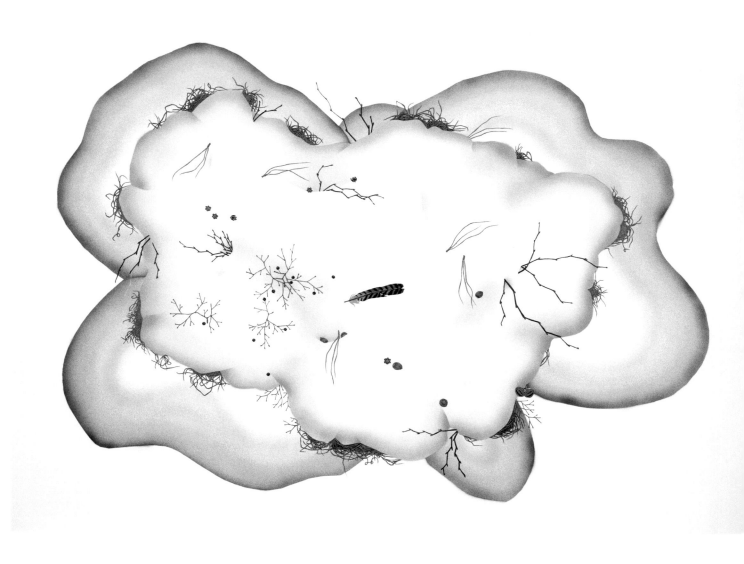

Fairy Ring, gouache and acrylic on paper, 122 x 183 cm, 2010

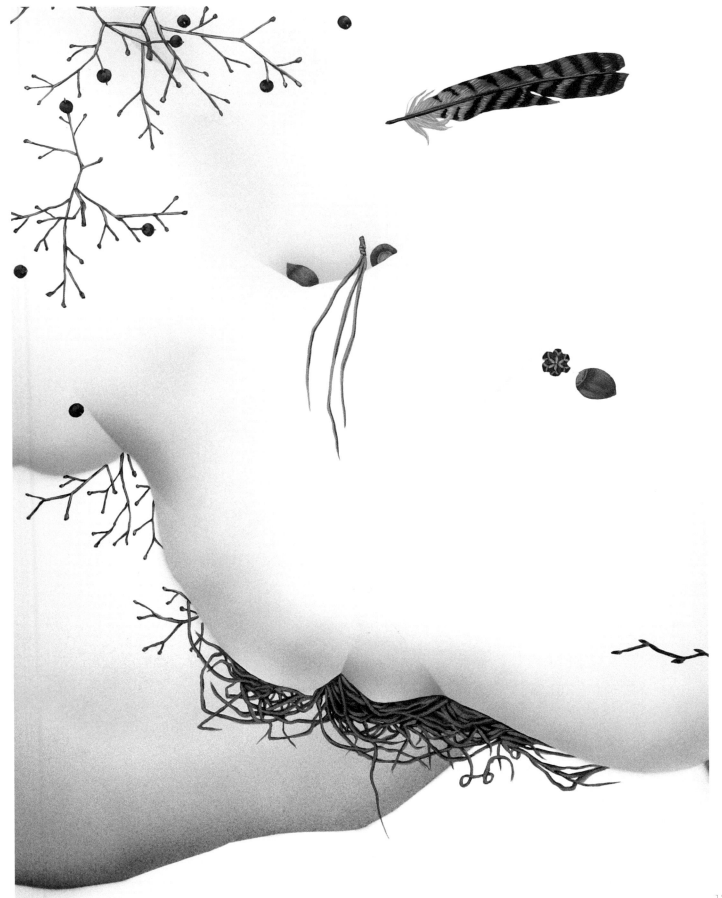

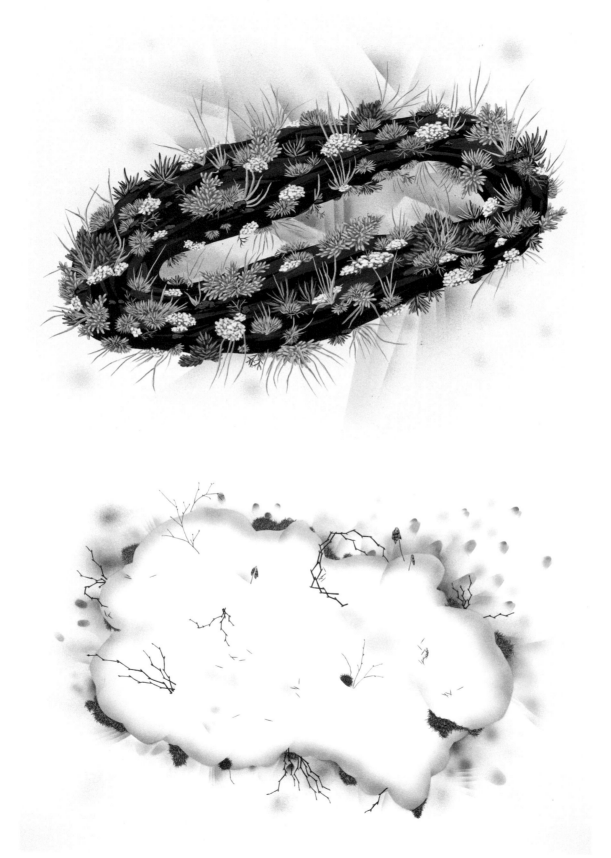

Desert 1, gouache and acrylic on paper, 41x51 cm, 2010 (top)
Snowdrop, gouache and acrylic on paper, 122x183 cm, 2010 (bottom)

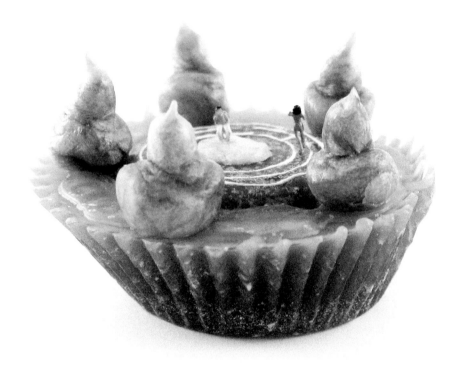

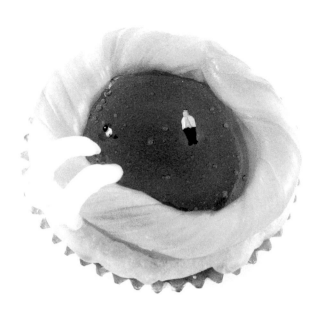
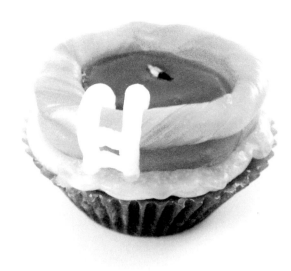
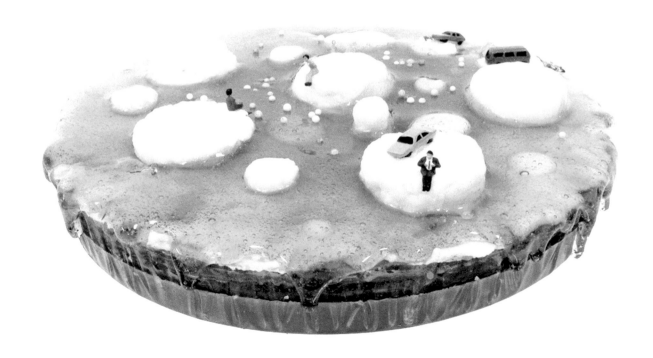

Cup Cake Swimming Pool, wax, 8 x 8 x 8 cm, 2009 (top)
Glacier Pie, wax, 8 x 8 x 8 cm, 2009 (bottom)

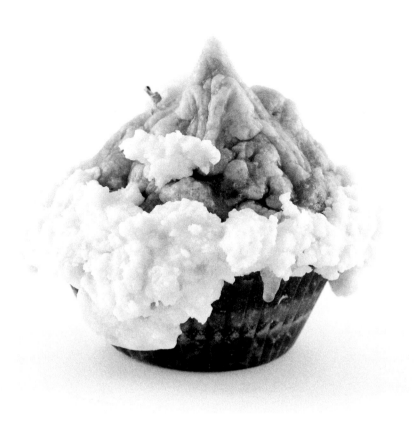

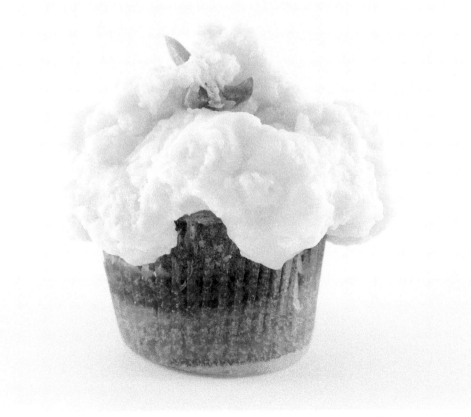

Cup Cake Mountain, wax, 8x8x8cm, 2009 (top)
Cup Cake Cloud, wax, 8x8x8cm, 2009 (bottom)

137

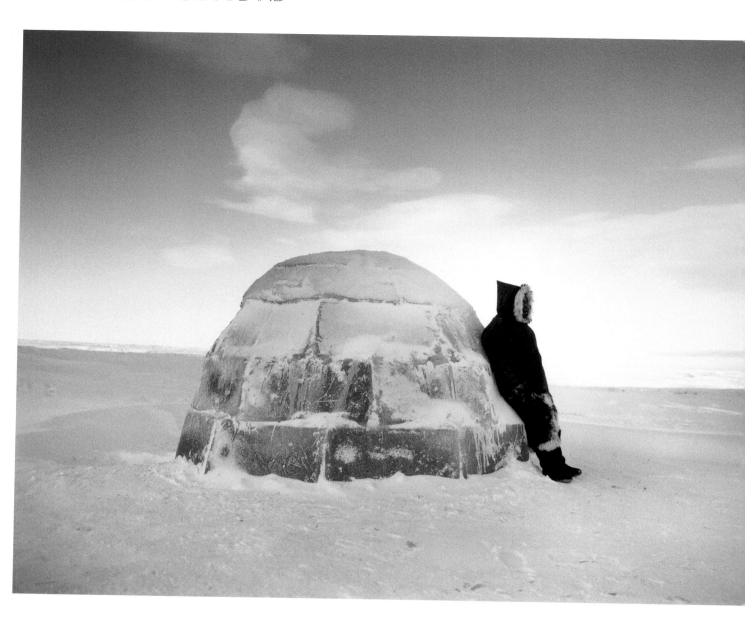

Lemonade Igloo from the "My White Night" series, C-print, 120×150 cm, 2007

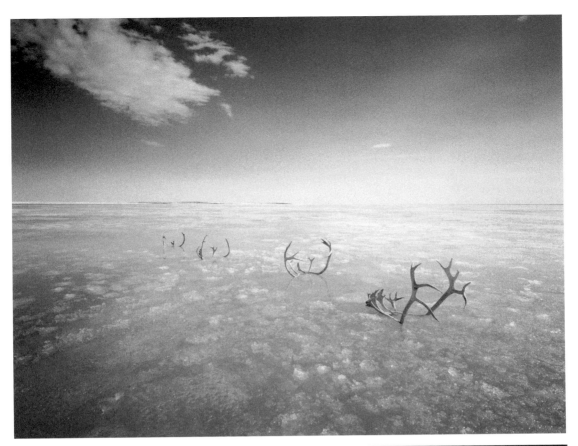

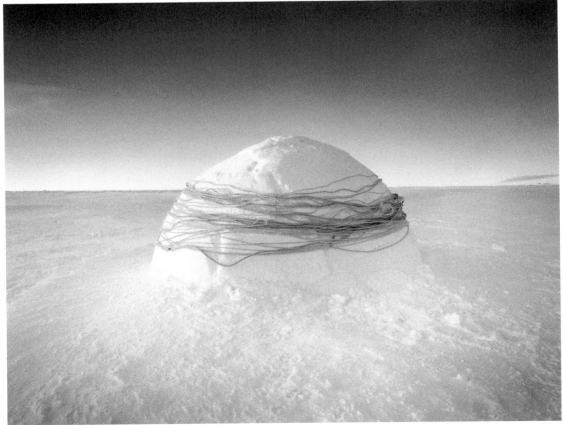

Journey from the "My White Night" series, C-print, 120×150cm, 2007 (top)
Wrapped from the "My White Night" series, C-print, 120×150cm, 2008 (bottom)

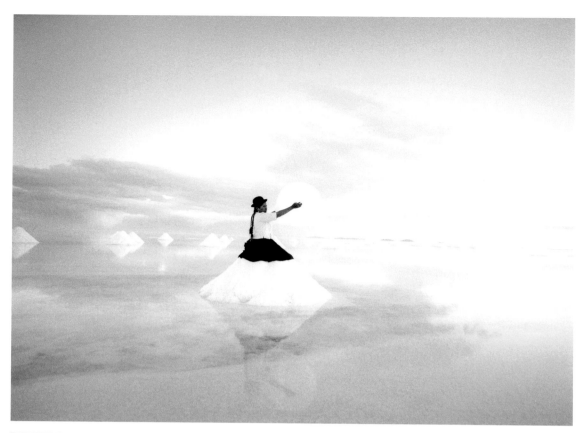

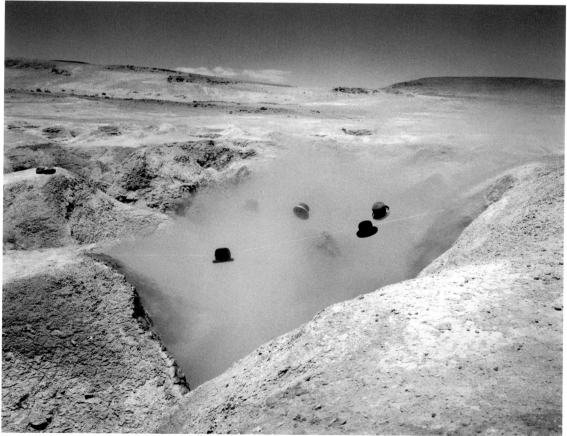

Out of Continuum from the "Soft Horizons" series, C-print, 120x150 cm, 2007 (top)
Harvest Time from the "Soft Horizons" series, C-print, 120x150 cm, 2006 (bottom)

140

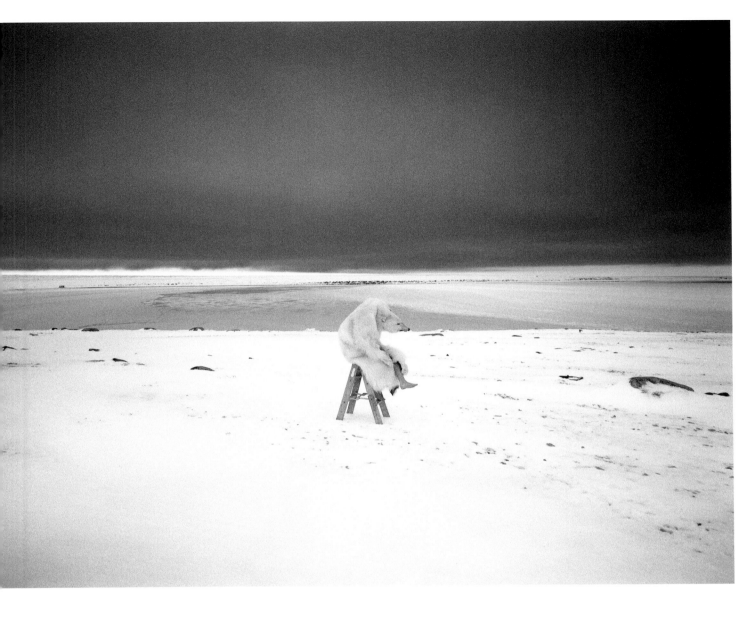

Polar Bear from the "My White Night" series, C-print, 120x150cm, 2007

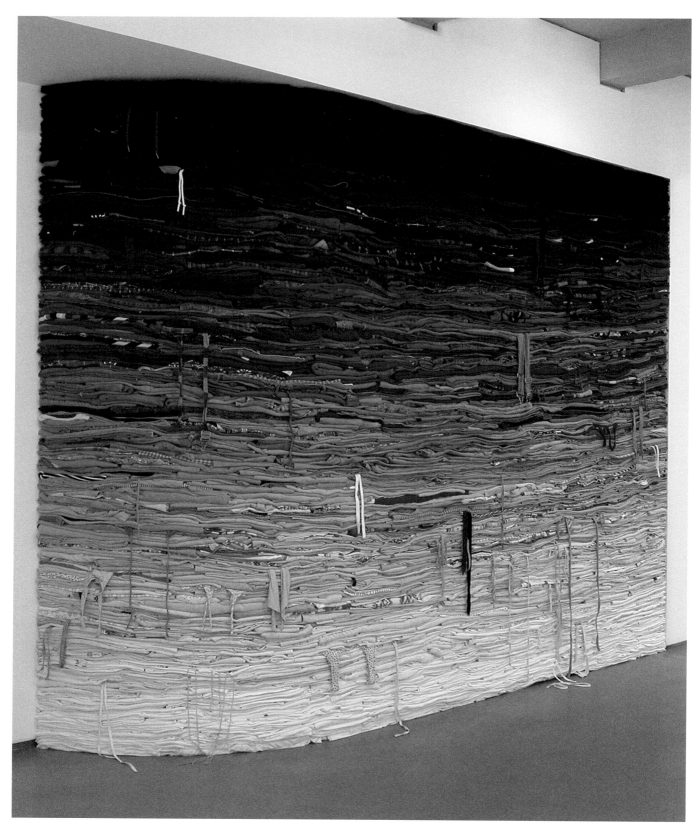

Filter, folded second-hand clothing, wood and steel, 259 x 335 x 30.5 cm, 2009

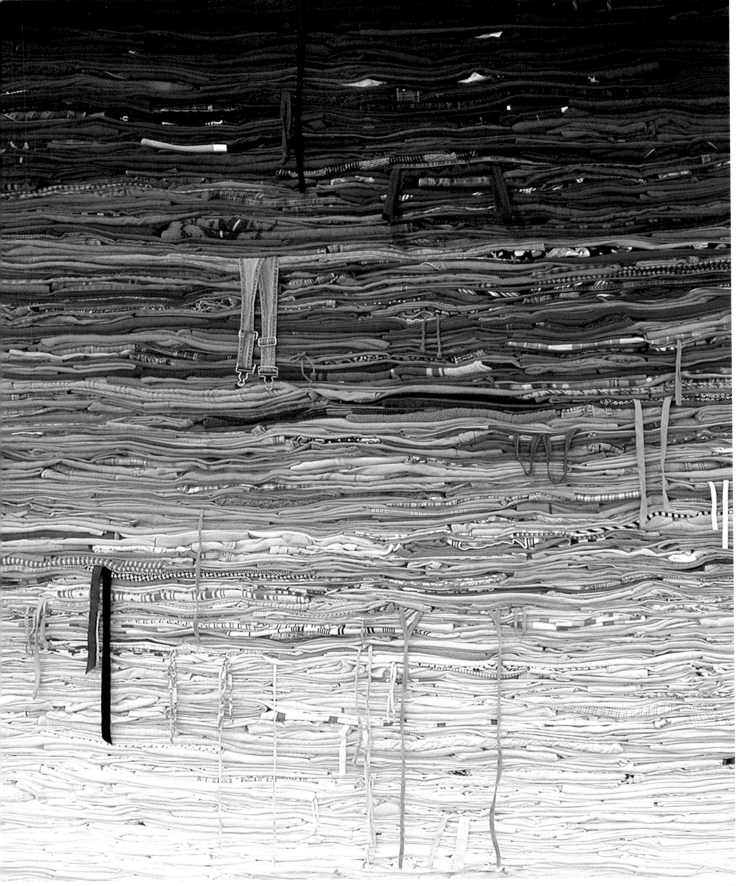

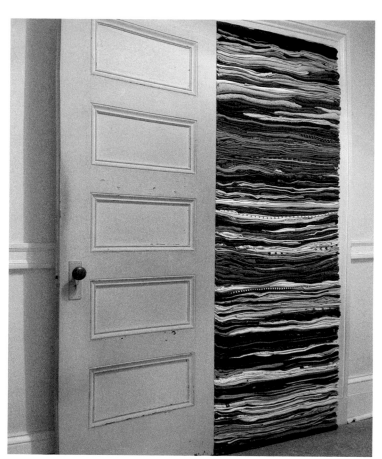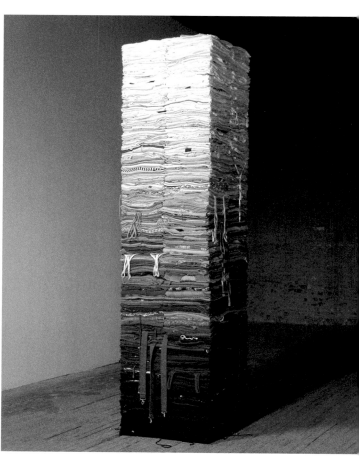

Silence, folded second-hand clothing, massonite, 61 x 208.3 x 30.5 (left)
Compression, folded second-hand clothing, wood and steel, 20.3 x 60.9 x 60.9 cm, 2007 (right)

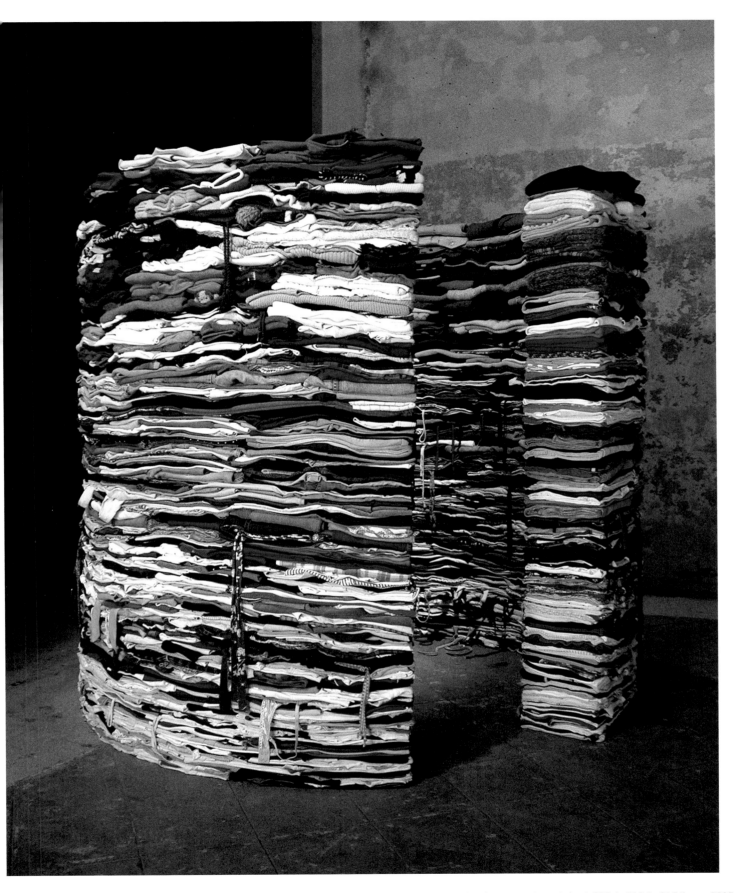

Grasp, folded second-hand clothing, wood and steel, 200.6x213.3x213.3cm, 2005

TAKASHI IWASAKI

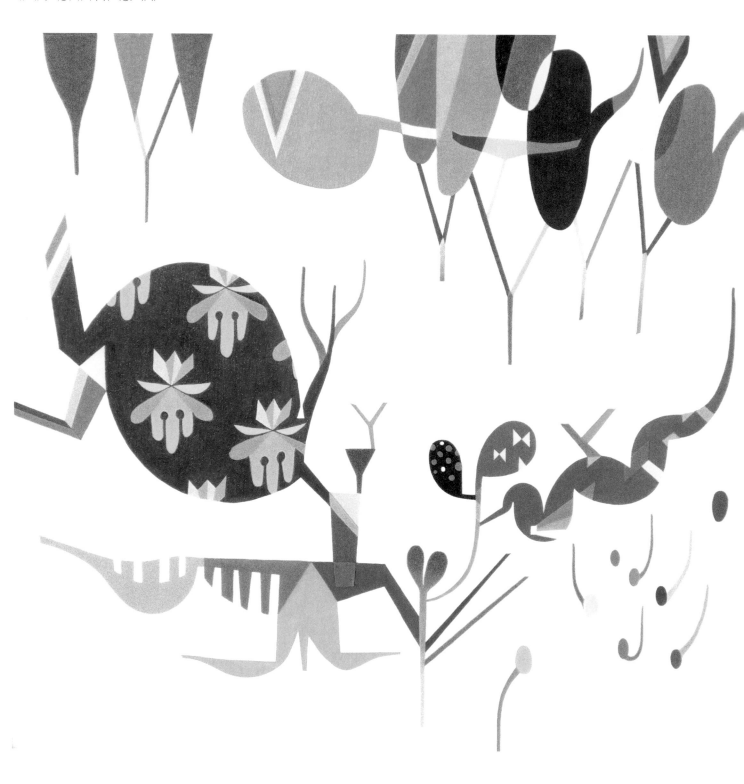

Teiteigroiku, acrylic on canvas, 51×51 cm, 2009

146

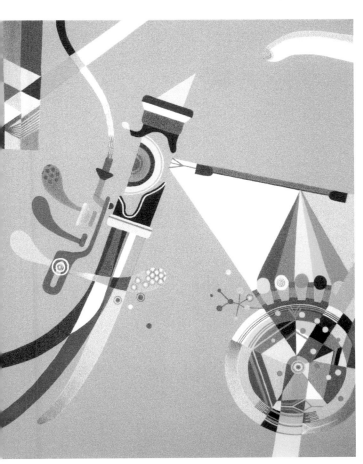
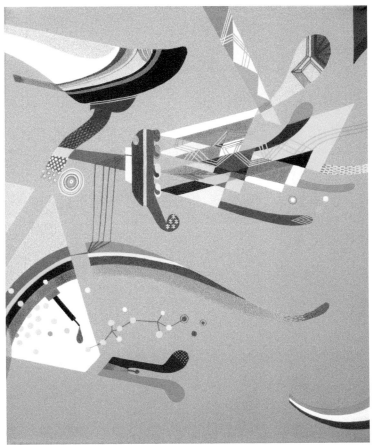

Natcyfixiemae, acrylic on canvas, 35.5×28 cm, 2010 (left)
Natcyfixieushiro, acrylic on canvas, 35.5×28 cm, 2010 (right)

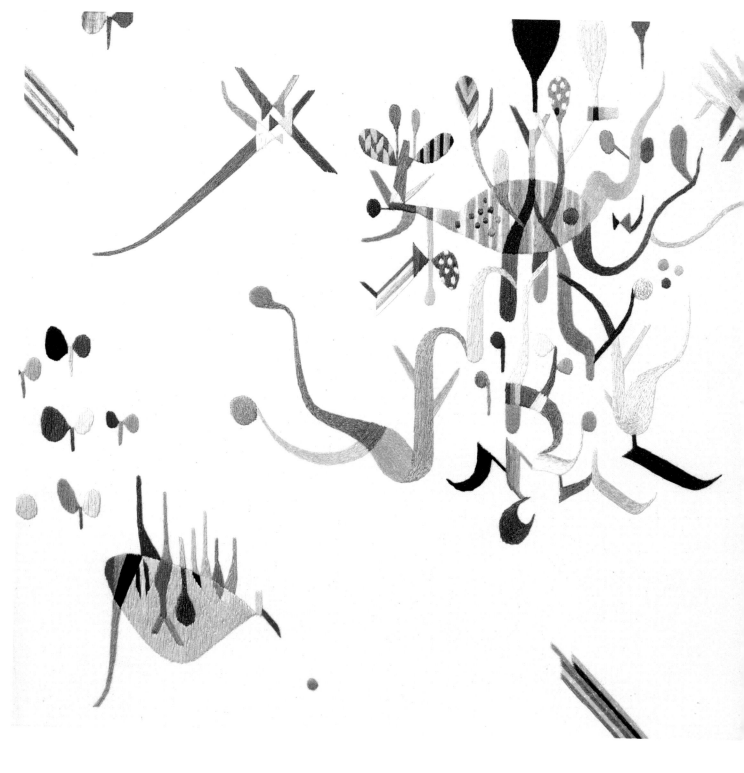

Chiroruhouten, hand-embroidered fabric, 35.5×35.5cm, 2010

148

Negadegrow, hand-embroidered fabric, 25.5 x 25.5 cm, 2010

Untitled from the "My African Dream" series, color photograph, 90 x 90 cm, 2006 – 2010

Untitled from the "My African Dream" series, color photograph, 90×90 cm, 2006–2010

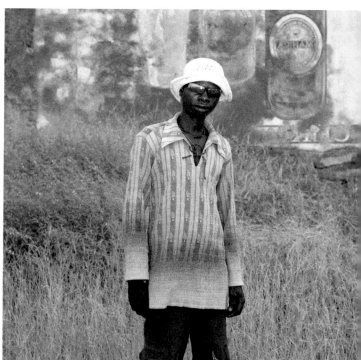

Untitled from the "My African Dream" series, color photograph, 90×90 cm, 2006–2010 (left)
Untitled from the "My African Dream" series, color photograph, 90×90 cm, 2006–2010 (right)

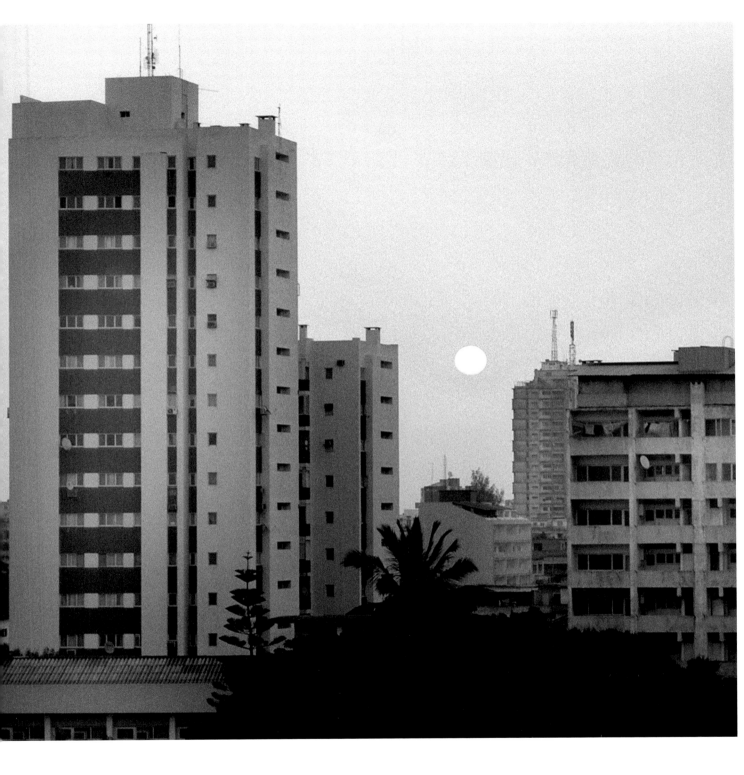

Untitled from the "My African Dream" series, color photograph, 90×90 cm, 2006–2010

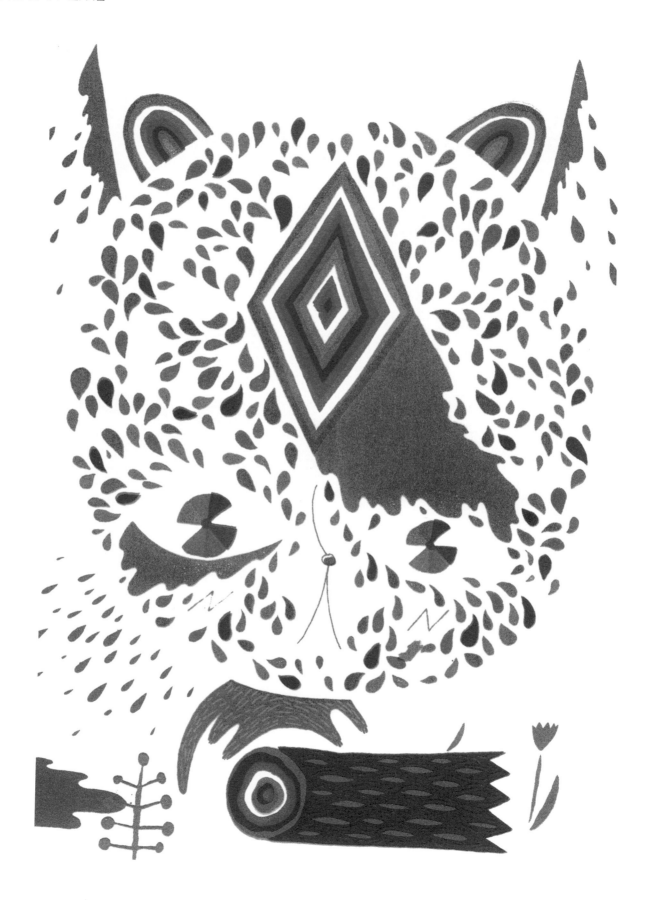

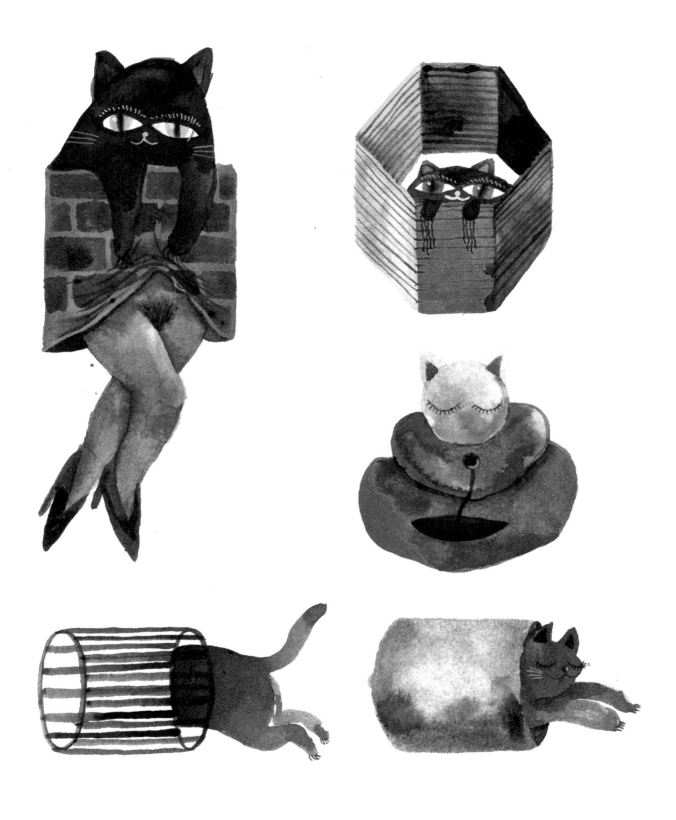

Things, inks, 22.9x30.5cm, 2010
Leap, silkscreen (3 layers), 22.9x30.5cm, 2008 (opposite)

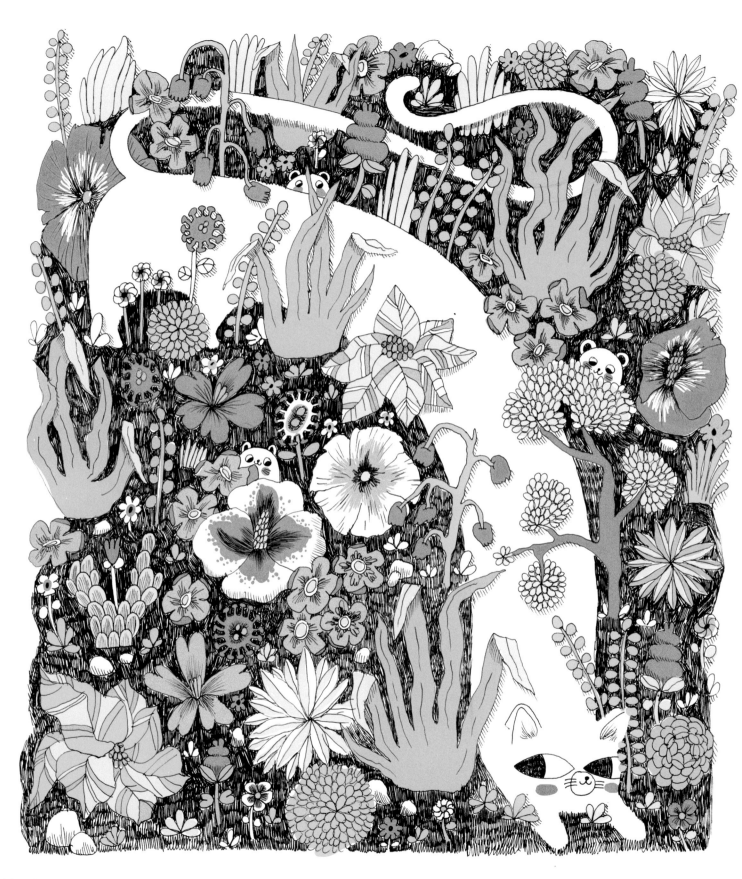

Mewr Mama, pen and digital, 20.3 x 28 cm, 2010

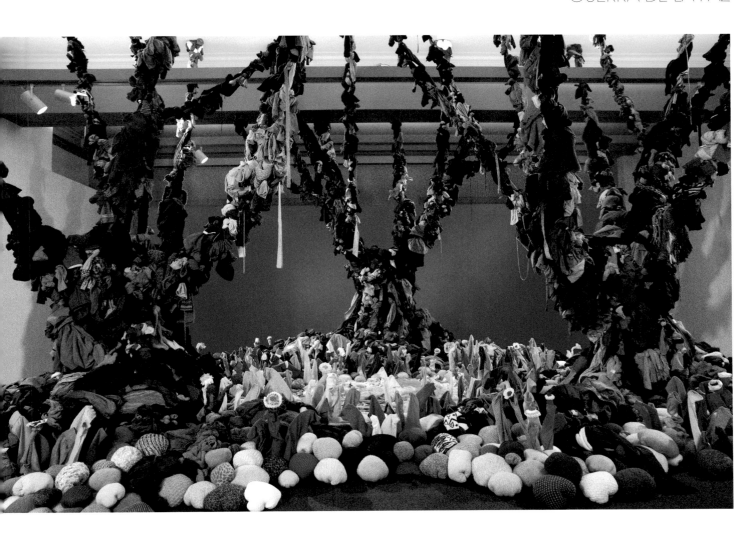

Oasis, mixed-media, site-specific sculptural installation, found garments, ceiling brackets, wire, wood, 450x910x760cm, 2006

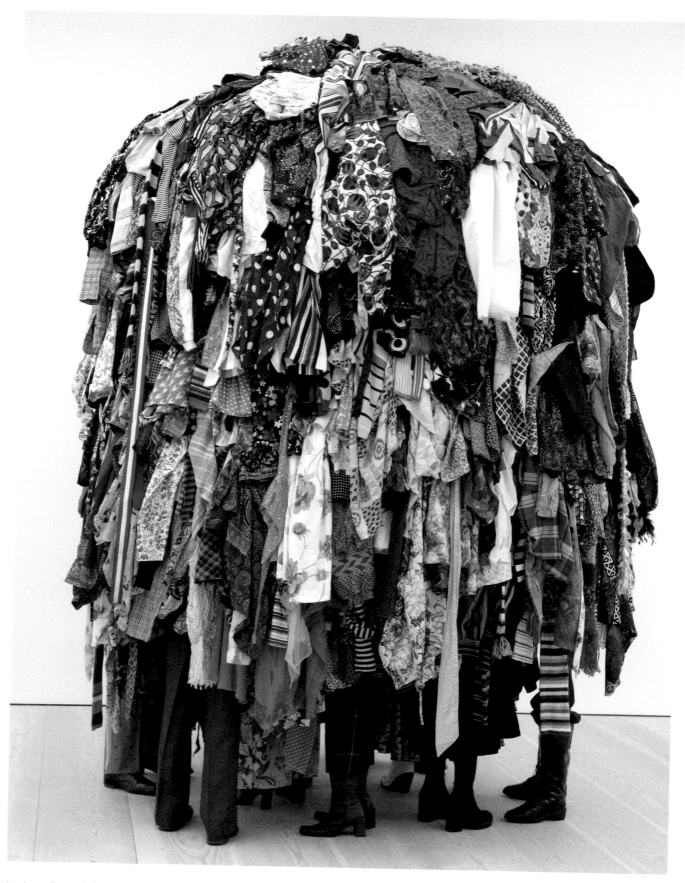

Nine, mixed-media sculptural installation, found garments, footwear, wood, 365 × 244 × 244 cm, 2007

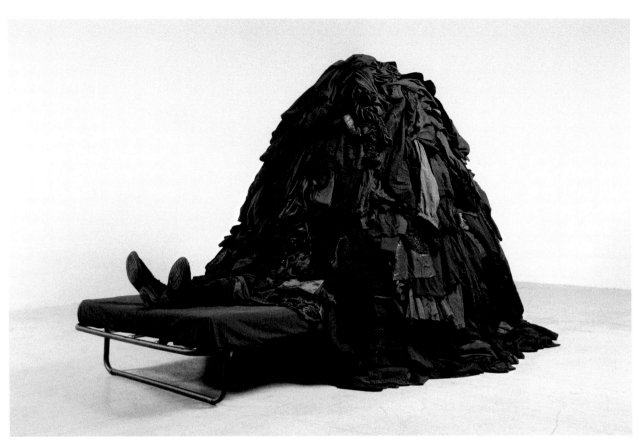

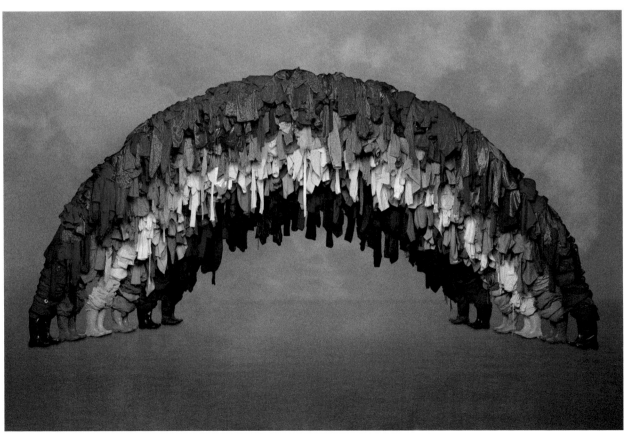

Mort, fold-out bed, black garments, wood, 180 x 300 x 240 cm, 2010 (top)
Indradhanush, found garments, rain boots, steel modular armature, 300 x 600 x 250 cm, 2008 (bottom)

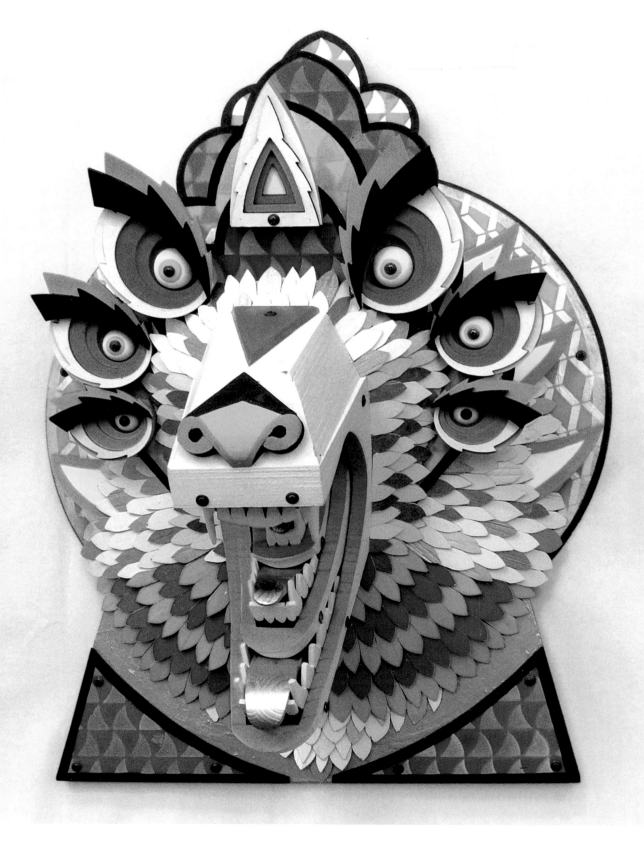

As Good As Any God, wood, paint, nails, 86.3 x 50.8 x 35.5 cm, 2009

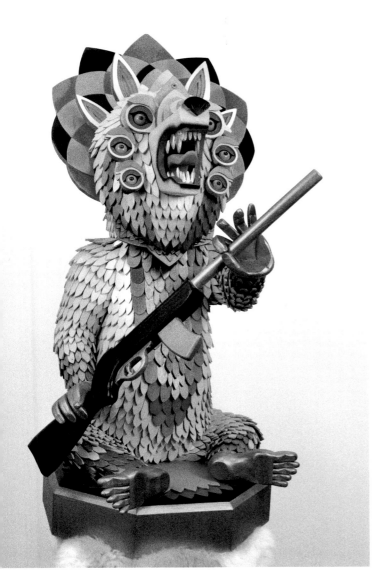

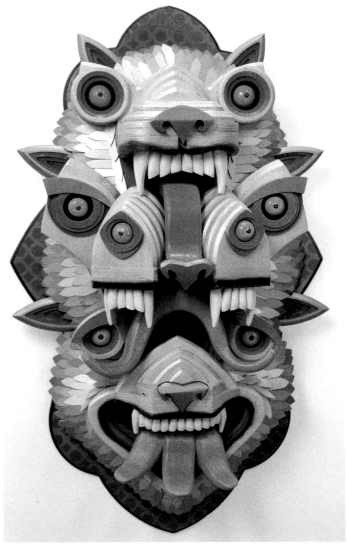

The Time & The Way, wood, paint, nails, 50.8x50.8x111.7cm, 2010 (left)
Dare Nothing, Hope for Nothing, wood, paint, nails, 101.6x61x38.1cm, 2010 (right)

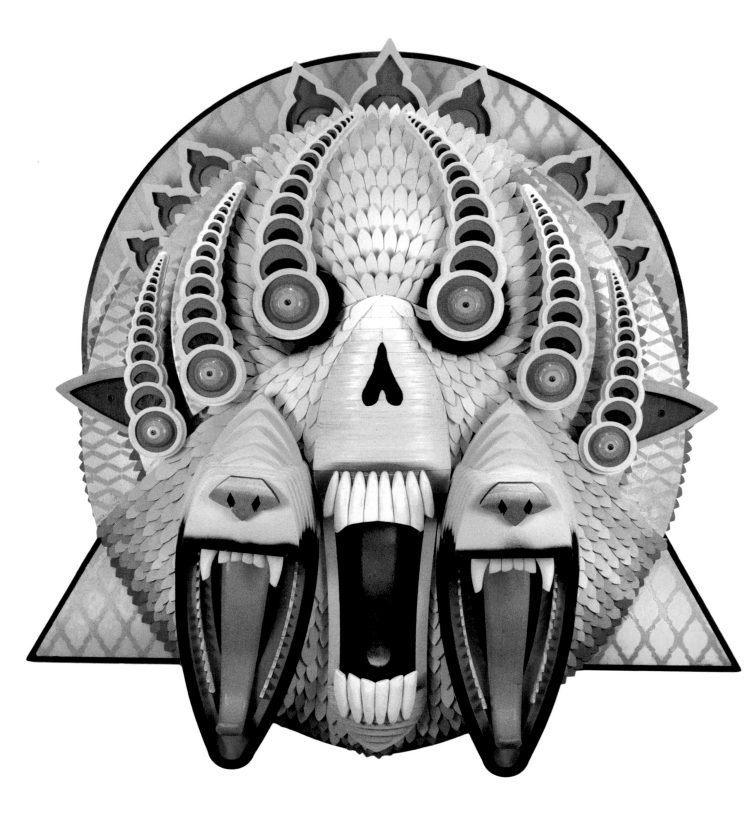

In the Teeth of Stupefying Odds, wood, paint, nails, 121.9 x 121.9 x 38.1 cm

162

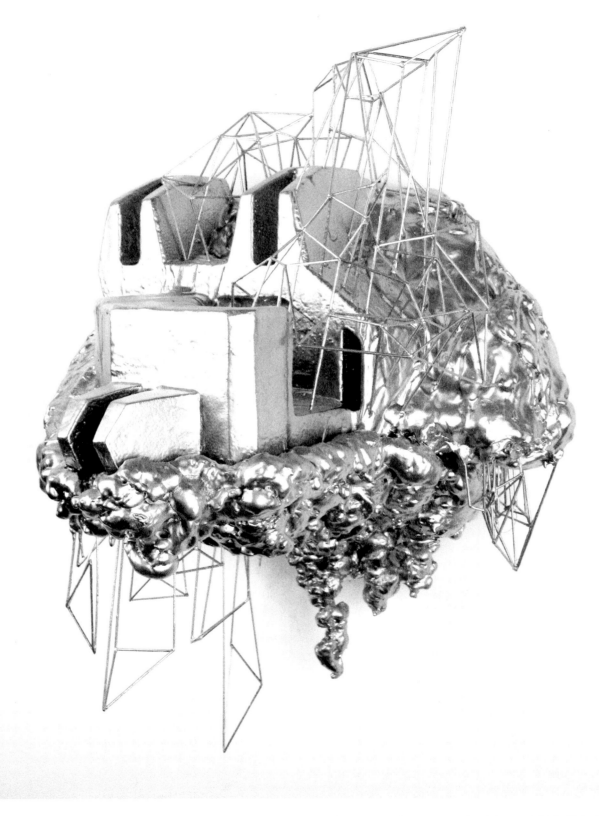

Bling, styrofoam, spray foam, enamel paint, wood, 86.3x53.3x55.8cm, 2008

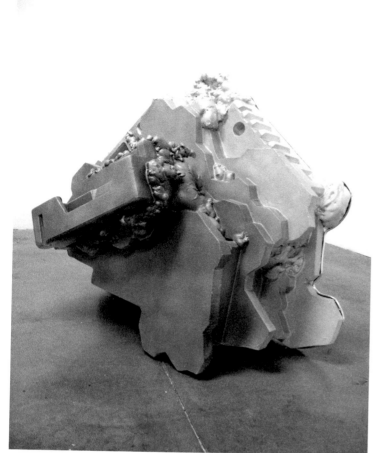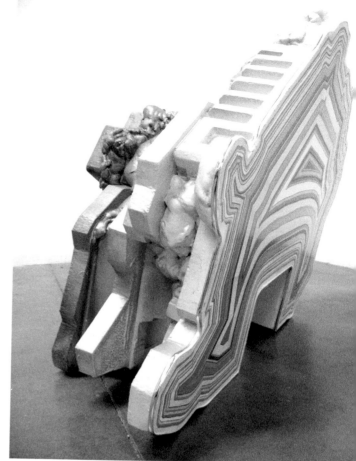

Smog Geode, styrofoam, foam core, spray foam, latex paint, chrome piping, ink, 78.7 x 96.5 x 50.8 cm, 2008

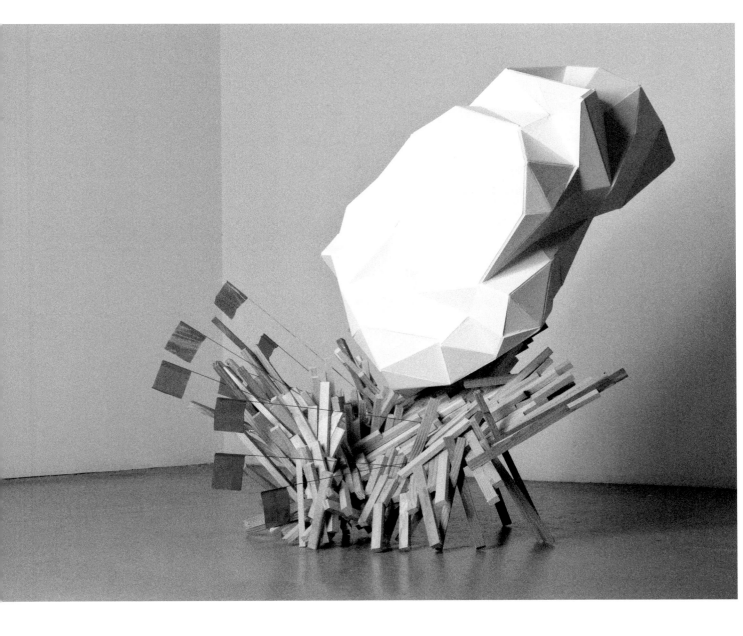

Flag, styrofoam, foam core, latex paint, wood, marker flags, 91.4x106.6x68.6cm, 2008

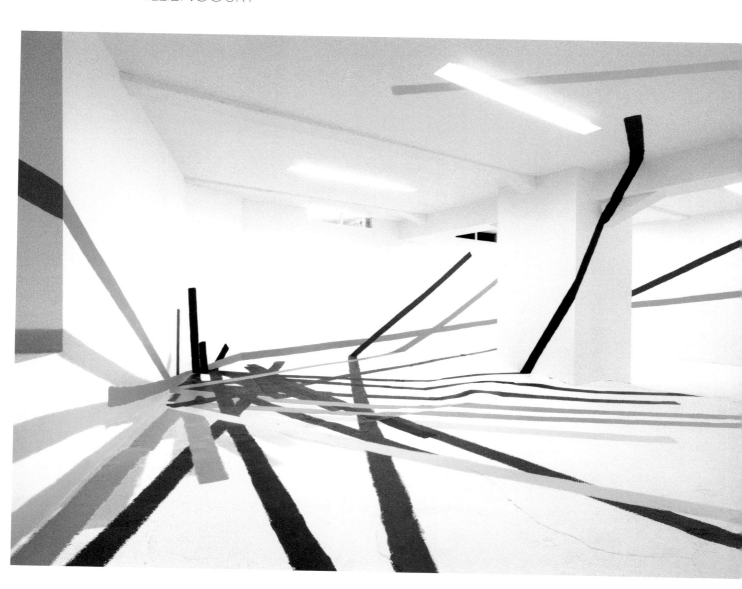

Occupation à 6, acrylic paint on floor, walls, columns, and window, 2008

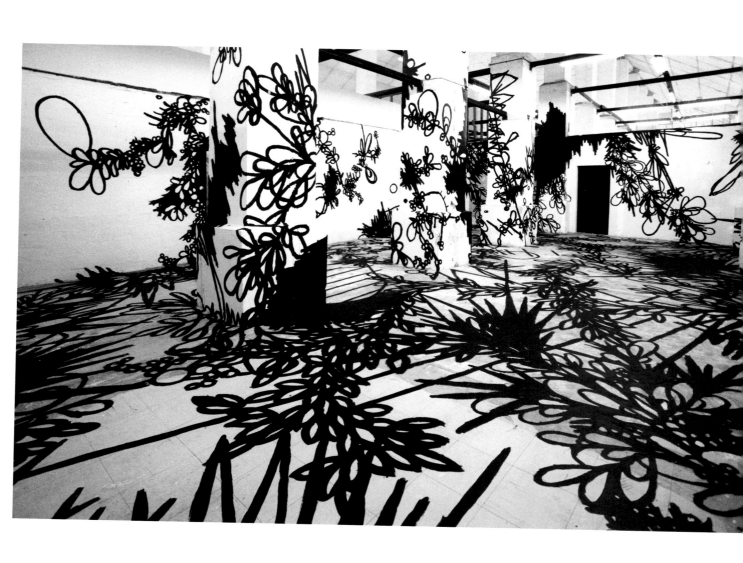

Occupation Bleue, acrylic paint on floor, walls, and columns, 2006

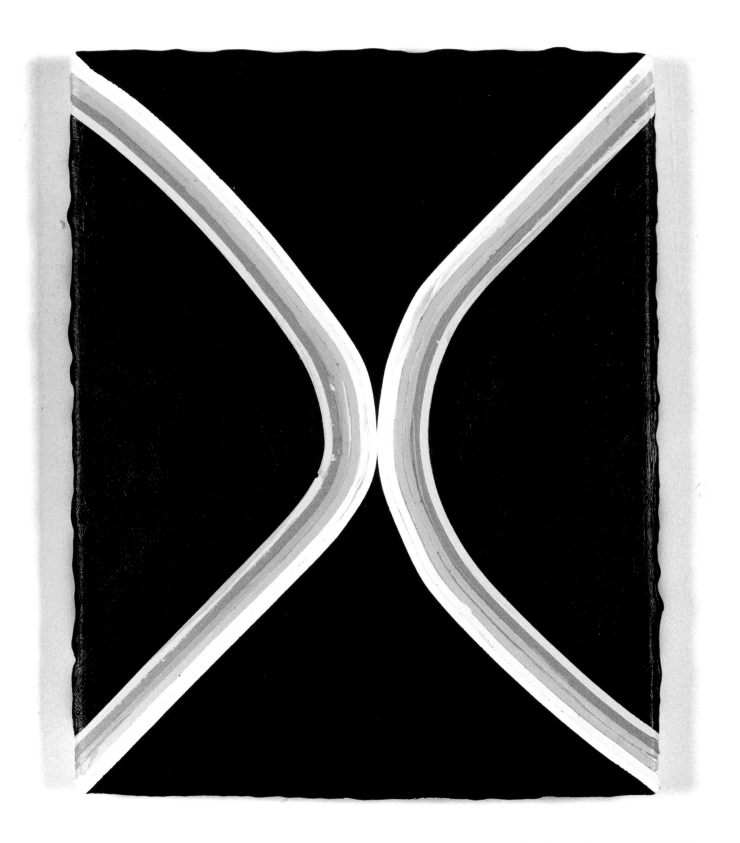

The Kiss, acrylic on panel, 20.3 x 28 cm, 2010

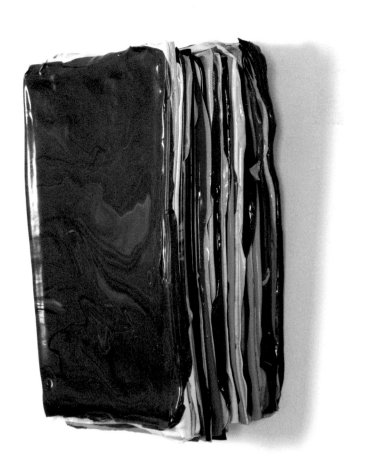
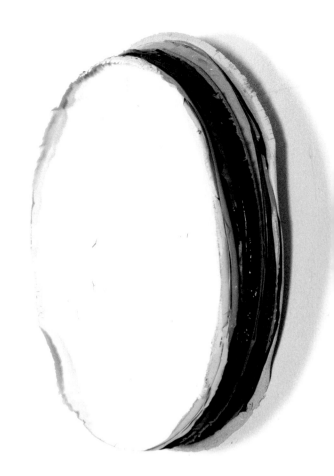

Wall Stack (folded), acrylic paint stacked and folded, 25.4 x 17.8 x 20.3 cm, 2010 (left)
Wall Stack (circle), acrylic paint, 25.4 x 10 cm, 2010 (right)

Wall Stack (blue/green), acrylic on panel, 28x35.5cm, 2010

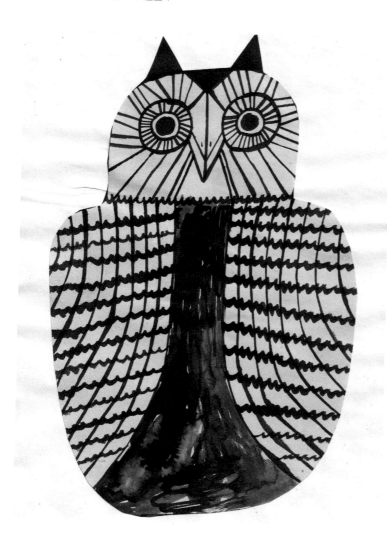

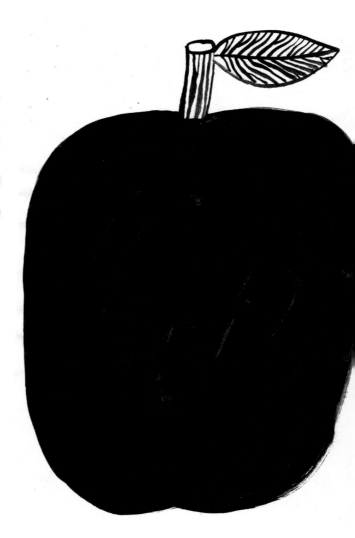

Owl, black ink on colored paper, 21 x 29 cm, 2010 (left)
Apple, black ink on colored paper, 21 x 29 cm, 2010 (right)
Mock Tudor House & Car, black ink on colored paper, 21 x 29 cm, 2010 (opposite)

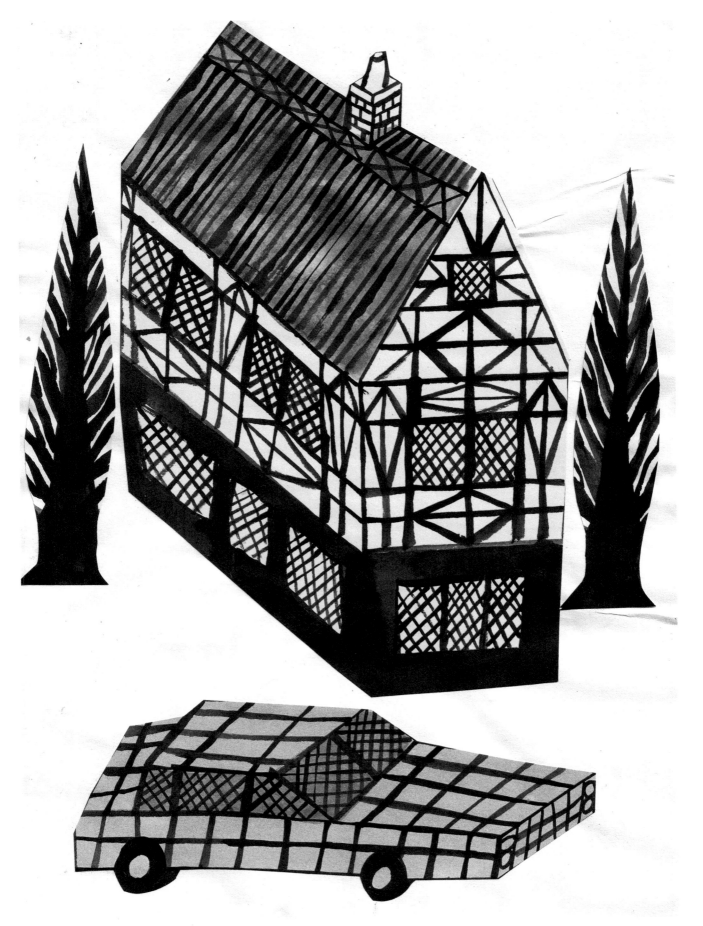

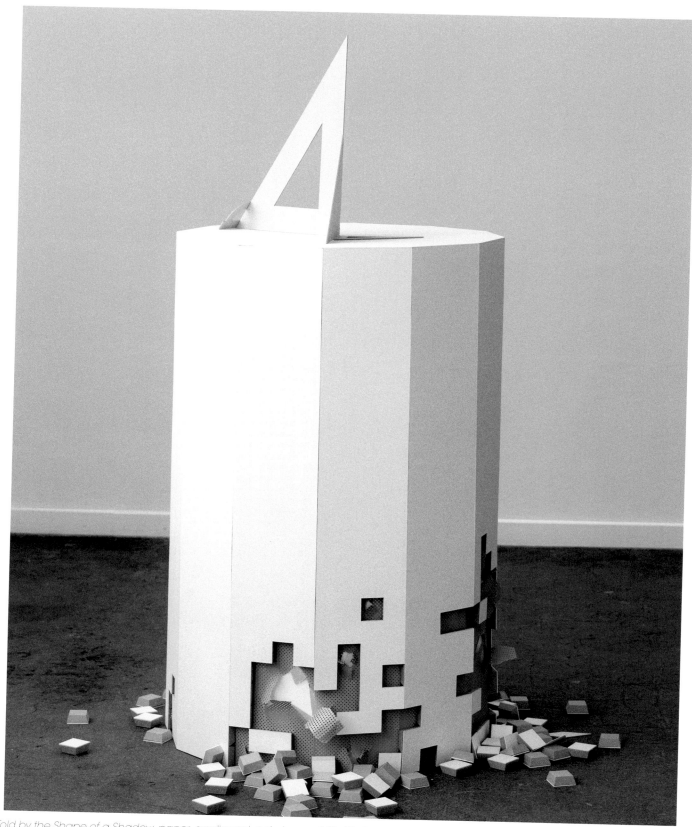

Time Told by the Shape of a Shadow, paper, cardboard, polystyrene, 145 x 80 x 80 cm, 2006
Nostalgic Construction (detail), paper, cardboard, polystyrene, aluminium, 285 x 110 x 40 cm, 2010 (opposite)

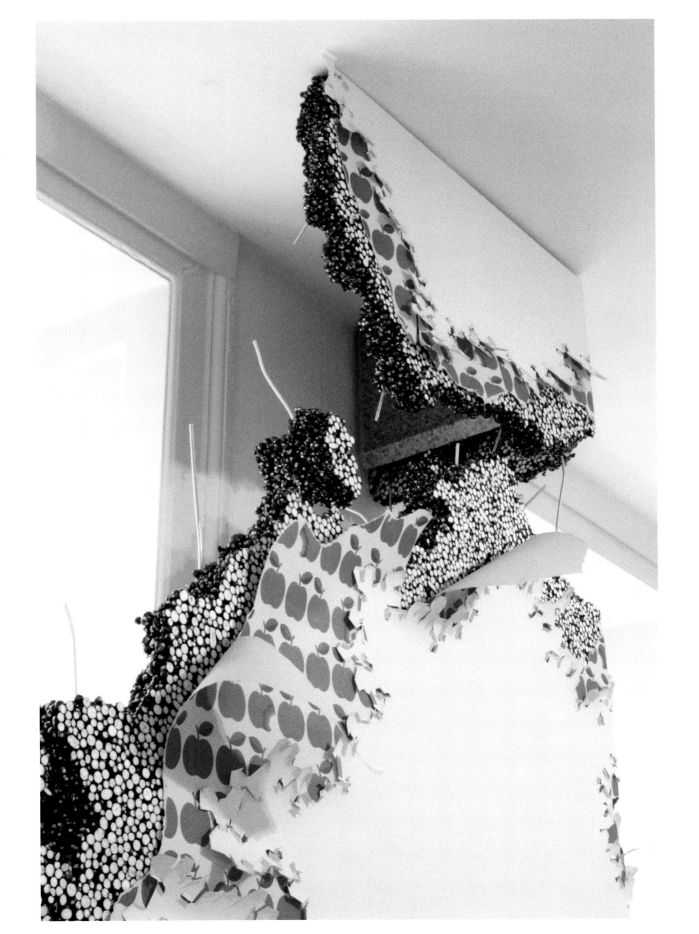

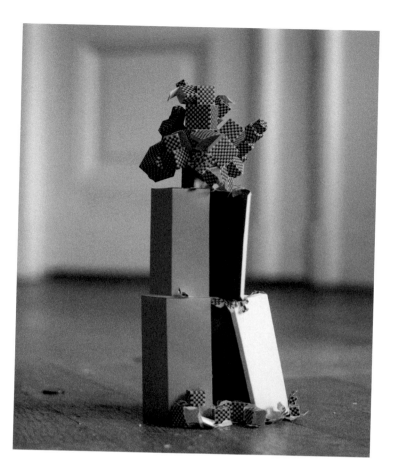

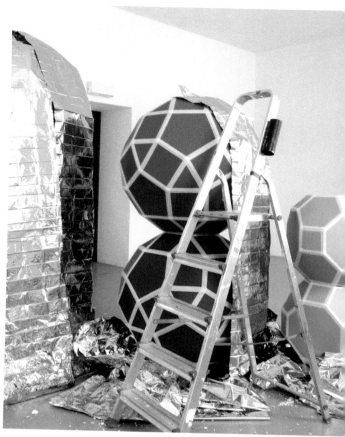

Unfinished Miniature, paper, 18x7x7cm, 2007 (left)
Detail of photograph from the series *3 Sculptures*, photographic print, 30x40cm, 2010 (right)

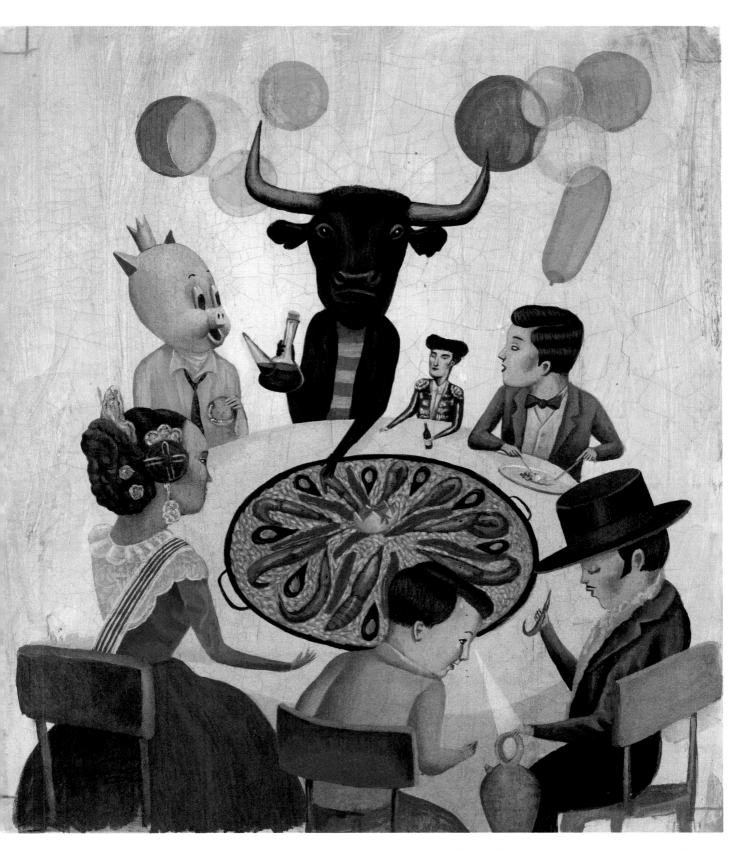

Cuadrilla Caníbal, acrylic and oil on canvas, 69x58cm, 2010

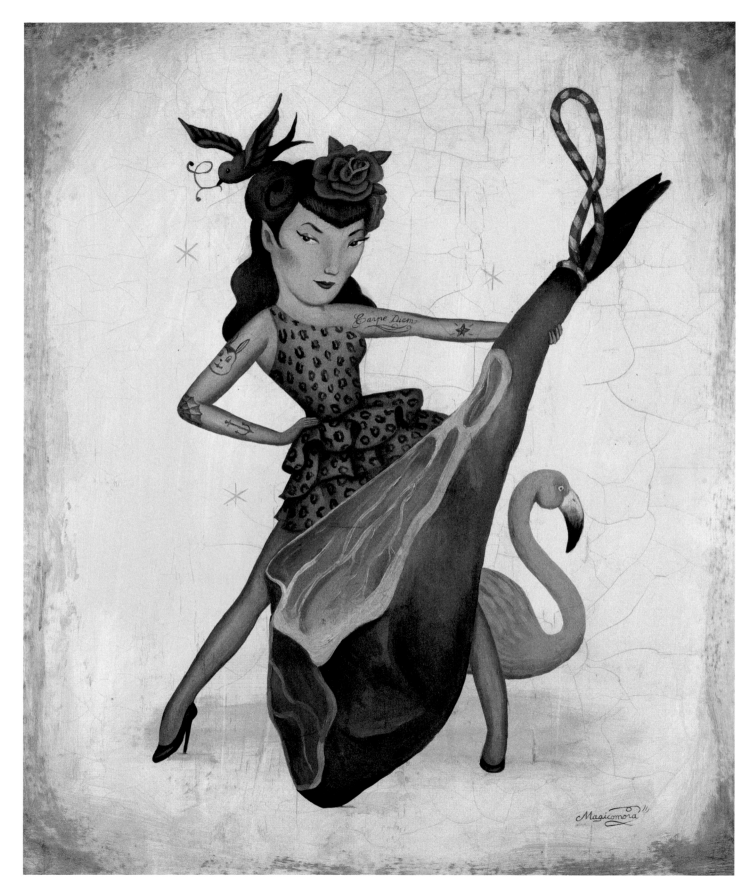

Jamona con Jamón, acrylic and oil on canvas, 73×92cm, 2010

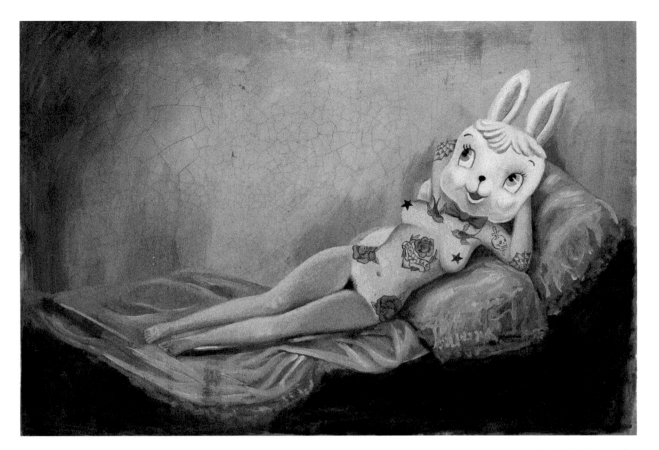

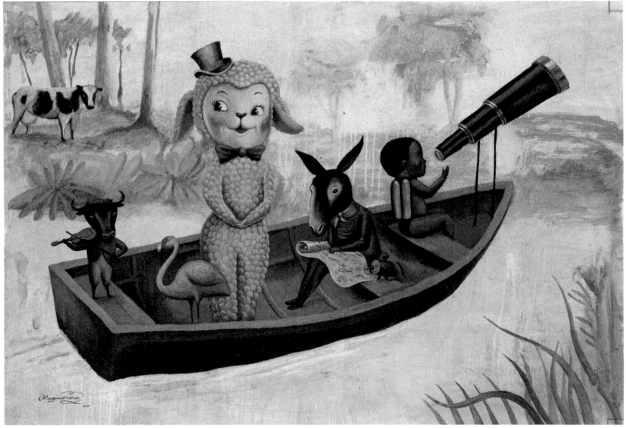

La Magia Desnuda, acrylic and oil on canvas, 92x63 cm, 2010 (top)
Semilla Negra, acrylic and oil on canvas, 116x81 cm, 2010 (bottom)

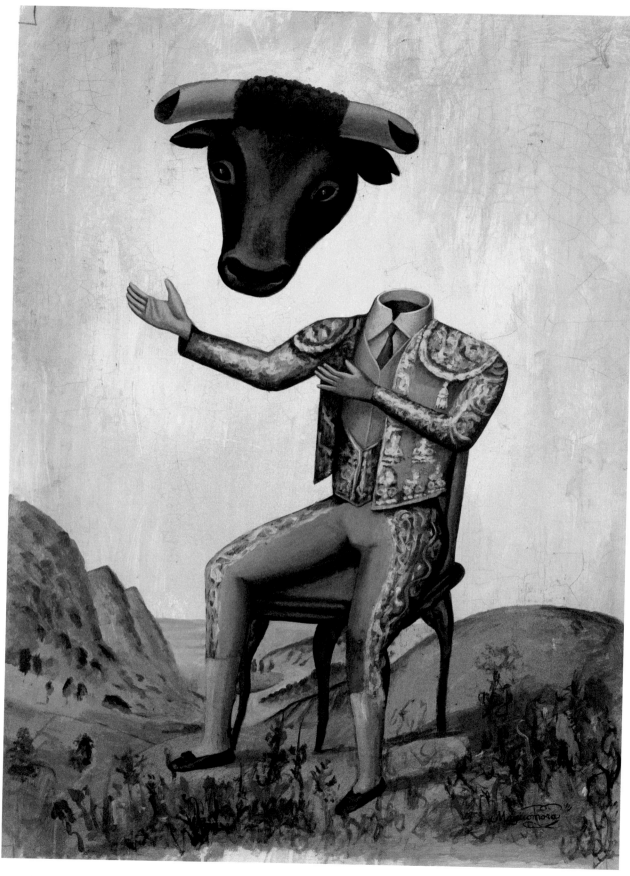

Tauromagia, acrylic and oil on canvas, 81 x 116 cm, 2010

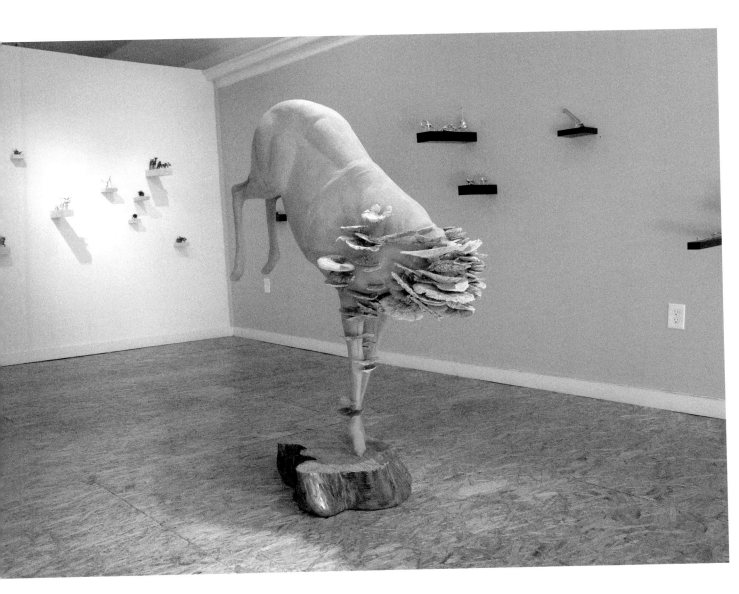

Mushroom Deer, taxidermy foam, resin, metal, wood, dried mushroom, paint, sand, 150 x 76 x 129 cm, 2010

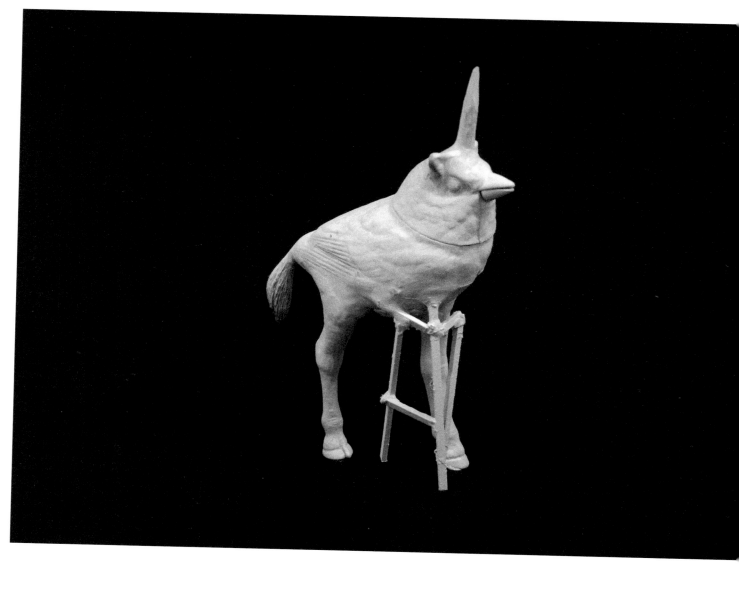

Scafflegiraffe, kinetic sculpture, motion sensor, toy, resin, wood, paint, 17x15x7cm, 2009

182

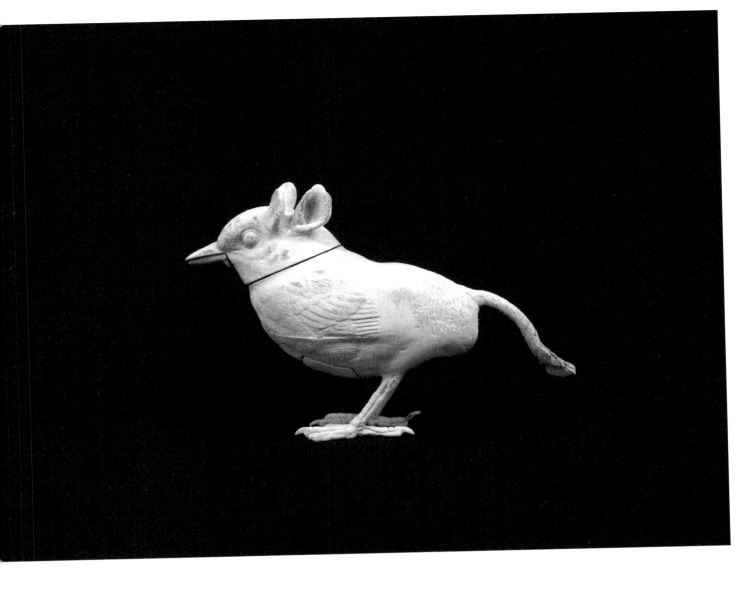

Rabbird, kinetic sculpture, motion sensor, toy, resin, rubber, metal, paint, 15x12x7cm, 200[?]

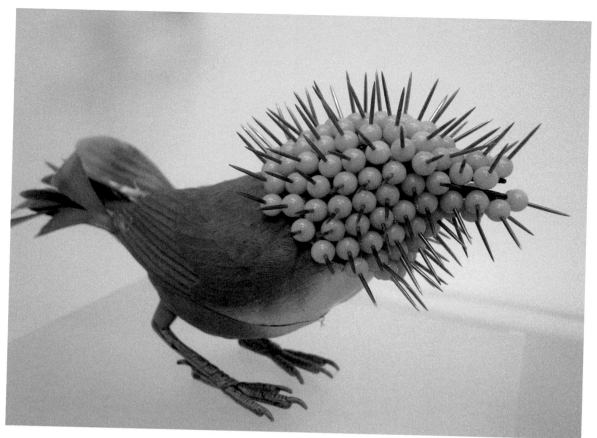

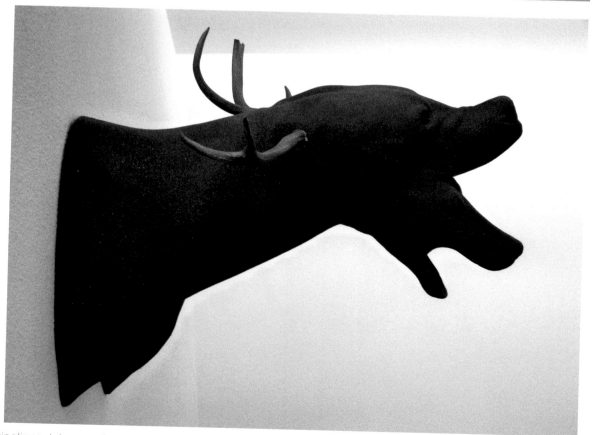

Green Pin Bird, kinetic sculpture, motion sensor, motor, batteries, toy, pushpins, artificial plants, paint, 18x20x28cm, 2006 (top)
Bearheads, foam, wood, metal, resin, antlers, paint, sand, 63x61x61cm, 2010 (bottom)

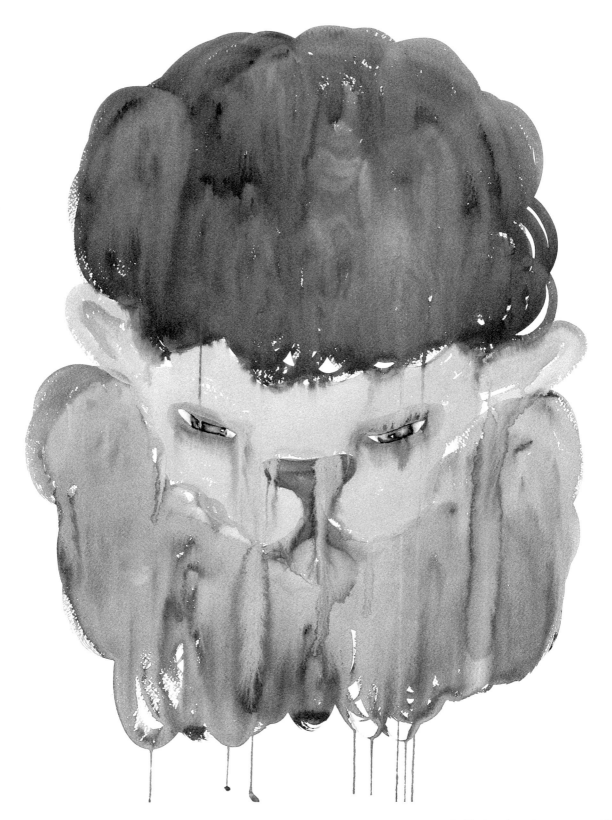

Untitled, watercolor on paper, 70x50cm, 2009

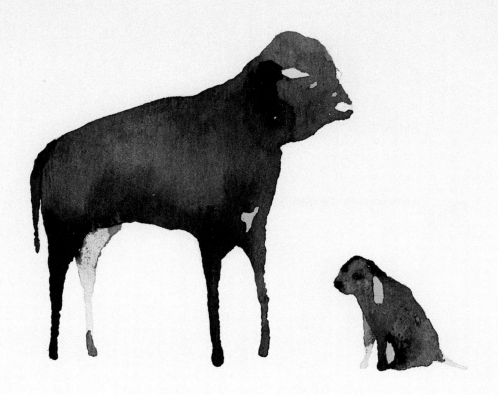

Untitled, watercolor on paper, 15×20 cm, 2005
Retrato de mis Padres, watercolor on paper, 55×40 cm, 2004 (opposite)

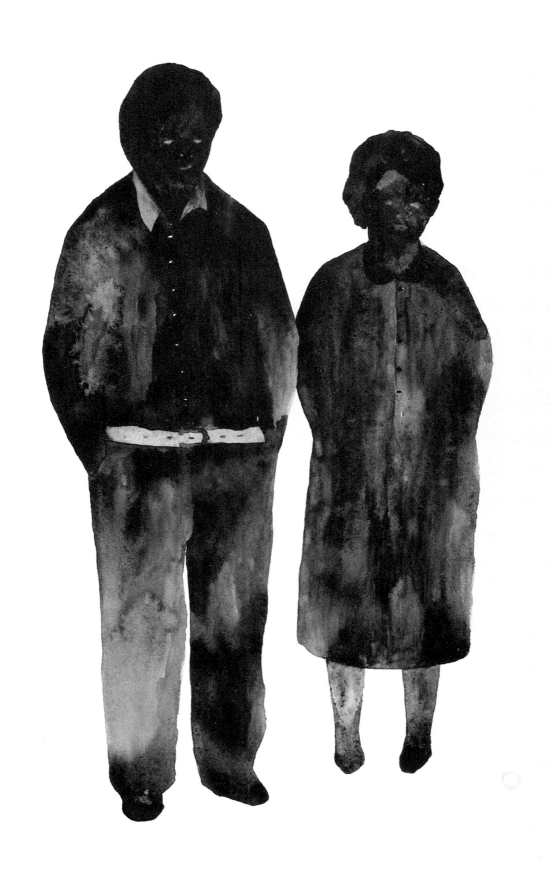

JACKSON EATON

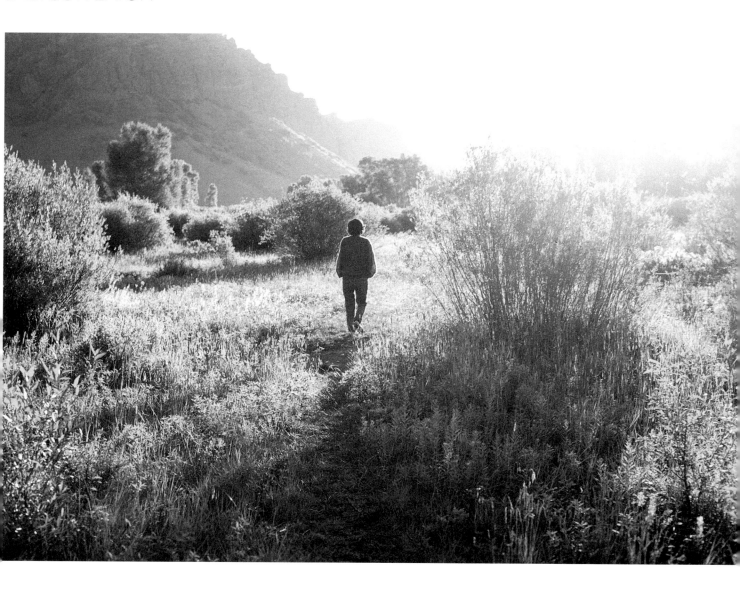

Untitled, inkjet print, 45.7 x 61 cm, 2009

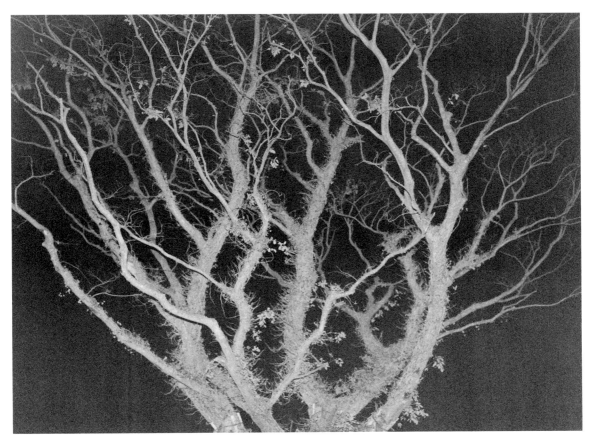

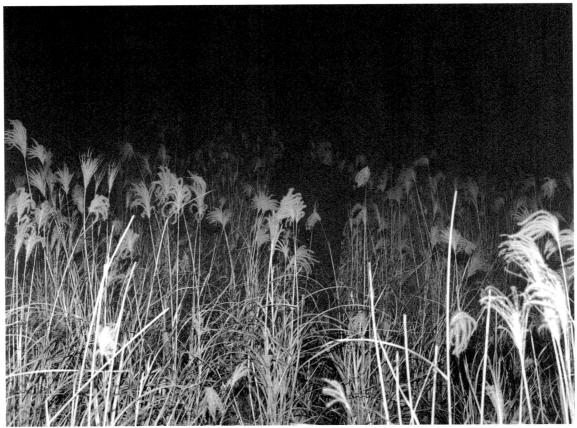

Untitled, inkjet print, 45.7 x 61 cm, 2008 (top
Untitled, inkjet print, 45.7 x 61 cm, 2008 (bottom

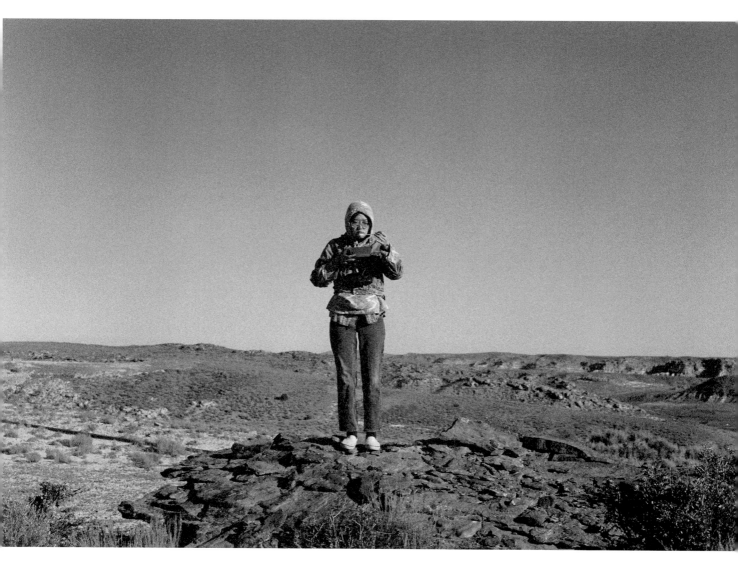

Intitled, inkjet print, 45.7 x 61 cm, 2009

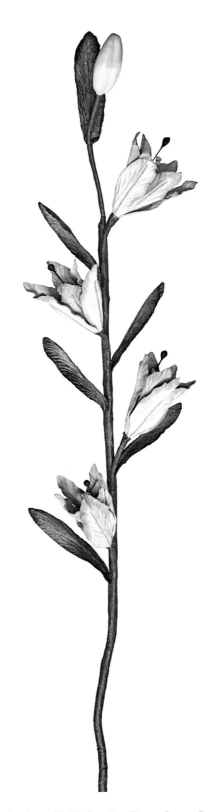

Tuberosa polianthes, $2.59, Creative Flower Shop, Queens, NY, archival pigment print, 76.2x101.6cm, 2009

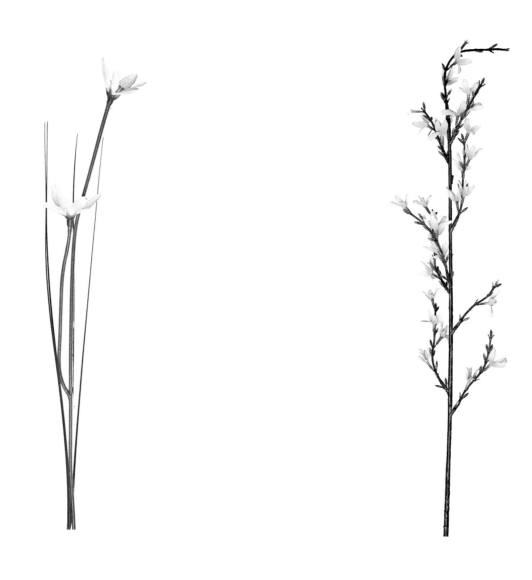

Potentilla fruticosa, $1.99, Flora Design, Manhattan, NY, archival pigment print, 76.2 x 101.6 cm, 2009 (left)
Dimorfoteca osteospermun, $1.99, Princess Silk Flowers Flower Shop, Manhattan, NY, archival pigment print, 76.2 x 101.6 cm, 2009 (right)

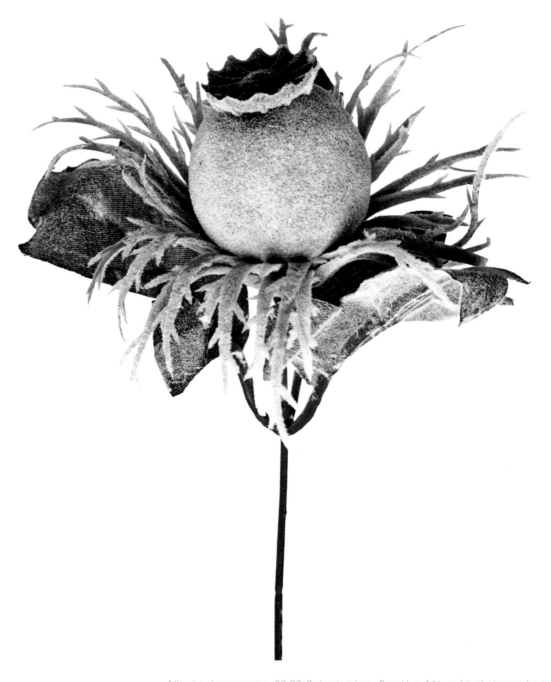

Nigella damascene, $3.99, Botanica Inc., Brooklyn, NY, archival pigment print, 76.2x101.6cm, 2009

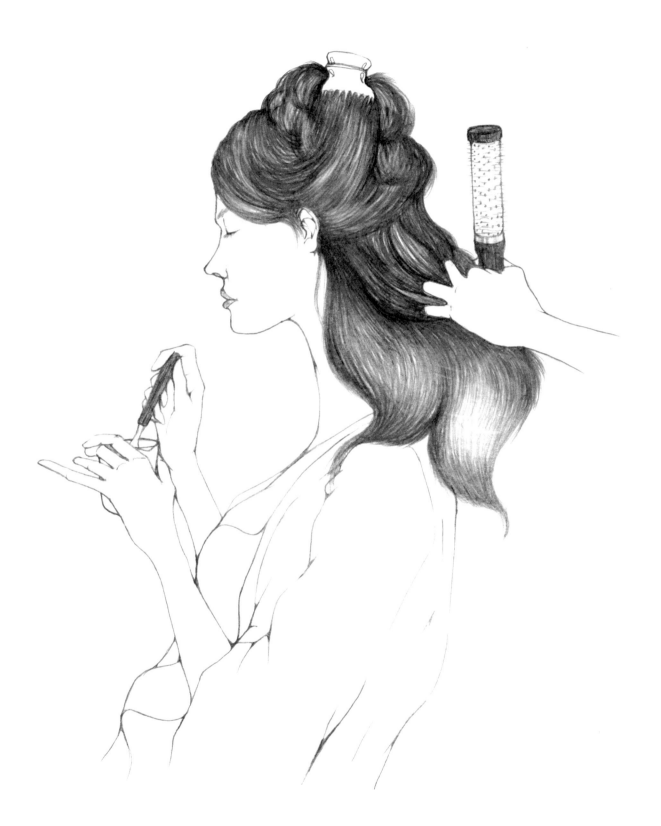

Combing, pencil on paper, 15 x 21 cm, 2009

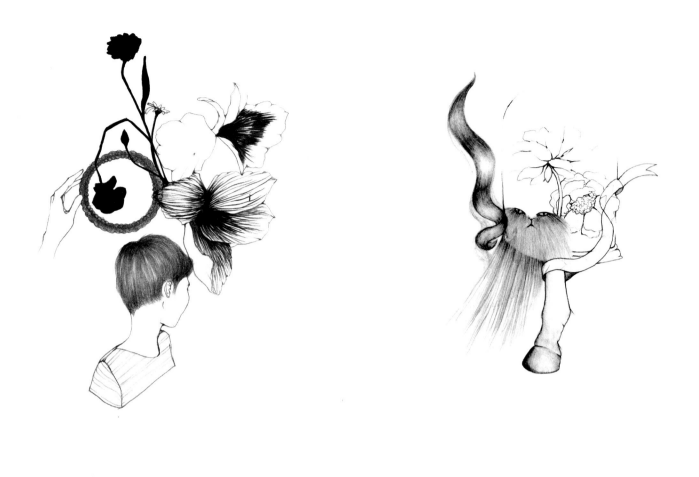

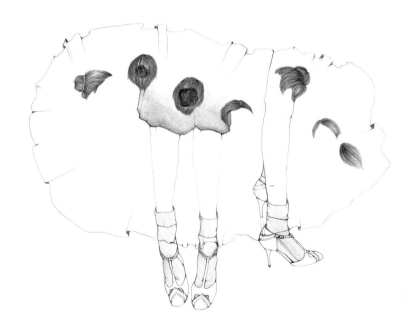

Mia, pencil, watercolor and acrylic on paper, 27 x 27 cm, 2009 (top left)
Persa, pencil on paper, 15 x 21 cm, 2008 (top right)
Ballerinas, pencil and watercolor on paper, 27 x 27 cm, 2009 (bottom)

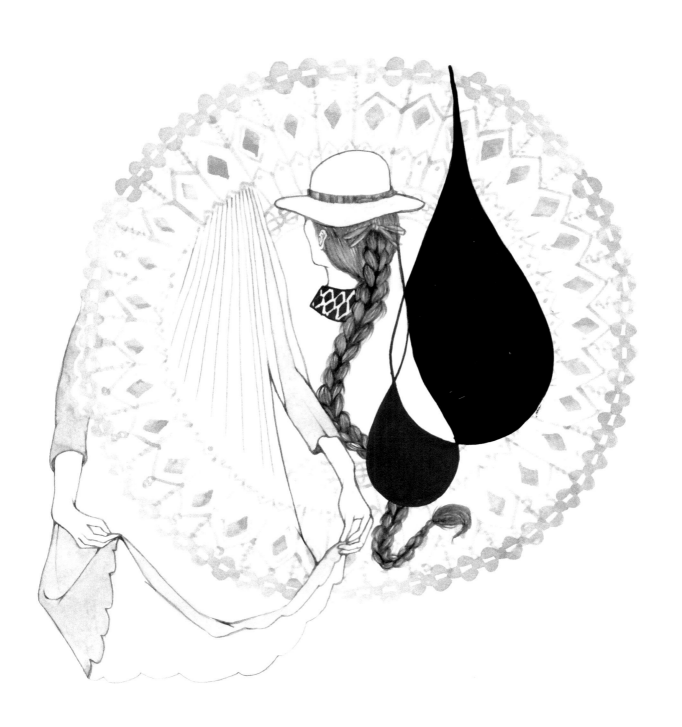

Coya, pencil on paper, 27 x 27 cm, 2009

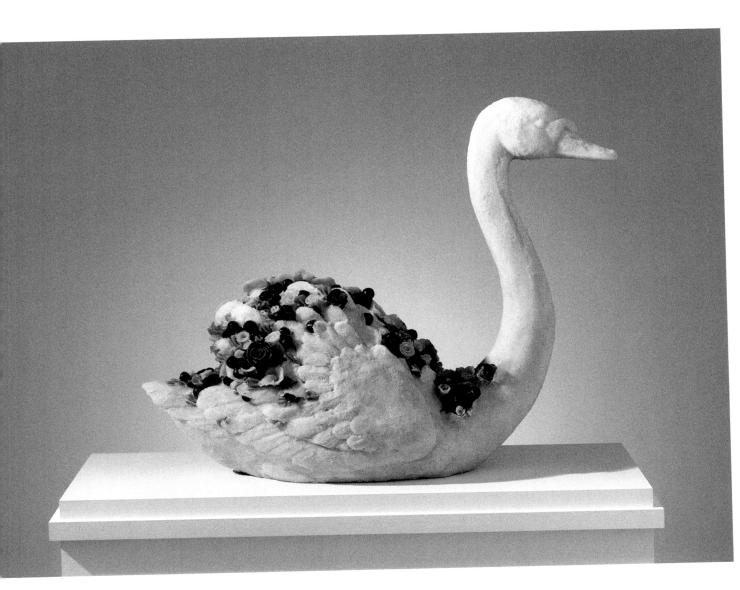

Pavlova, polyester resin and wax, 80x35x65cm, 200[

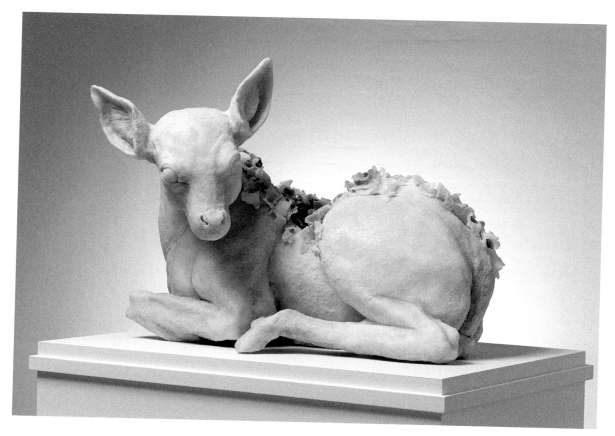

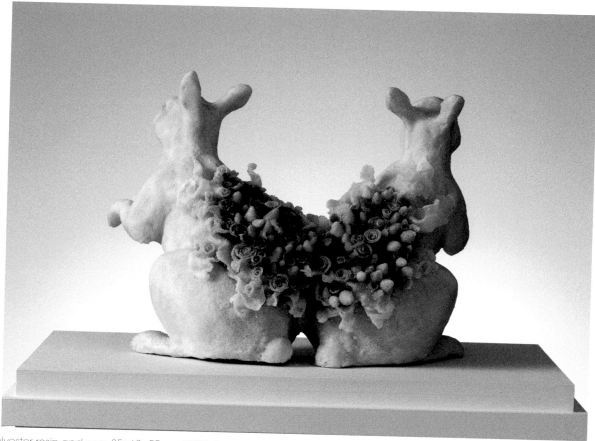

ambarella, polyester resin and wax, 85×63×55 cm, 2007 (top)
unny Ripple, polyester resin and wax, 50×38×30 cm, 2008 (bottom)

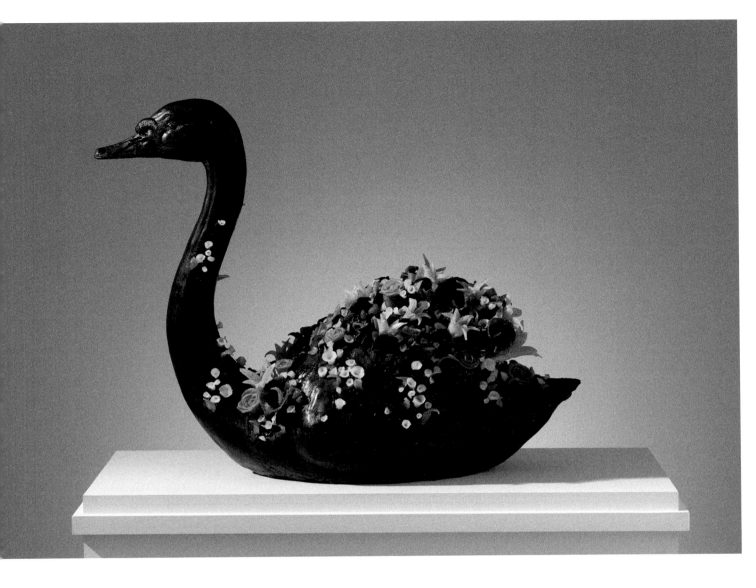

nswept Floor from the "Afterhours" series, LightJet-print on fiberboard, 110x140cm, 2008

Nimbus No.1, LightJet-print on Dibond, 130x170cm, 2005 (top)
Nimbus No.2, LightJet-print on Dibond, 130x170cm, 2005 (bottom)

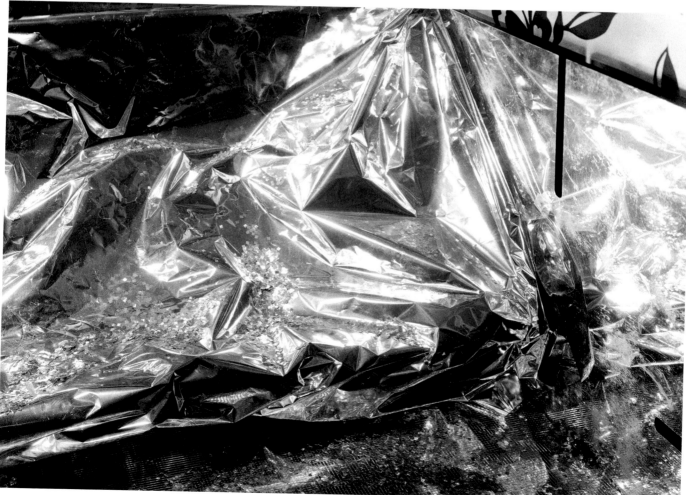

Galaxy No. 3, LightJet-print, 40×40cm, 2010 (top left)
Galaxy No. 4, LightJet-print, 40×40cm, 2010 (top right)
Shop Window from the "Afterhours" series, LightJet-print on fiberboard, 60×70cm, 2008 (bottom)

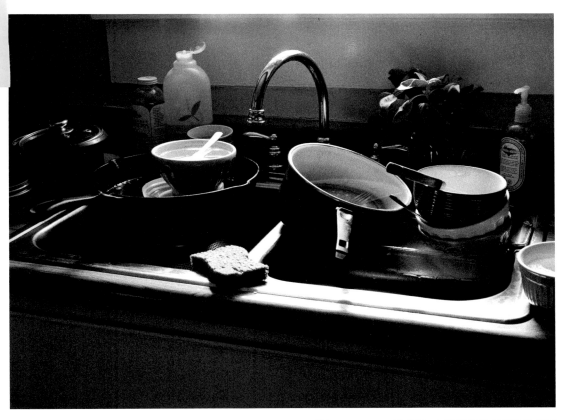

Always Dishes, 2008 (top)
Blanket (bottom)

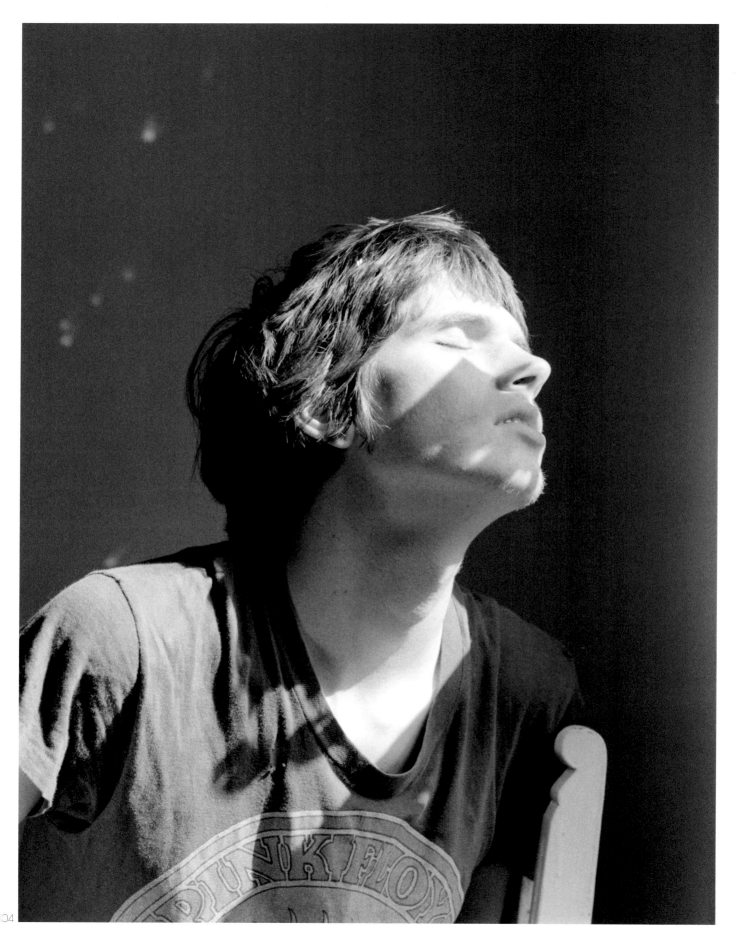

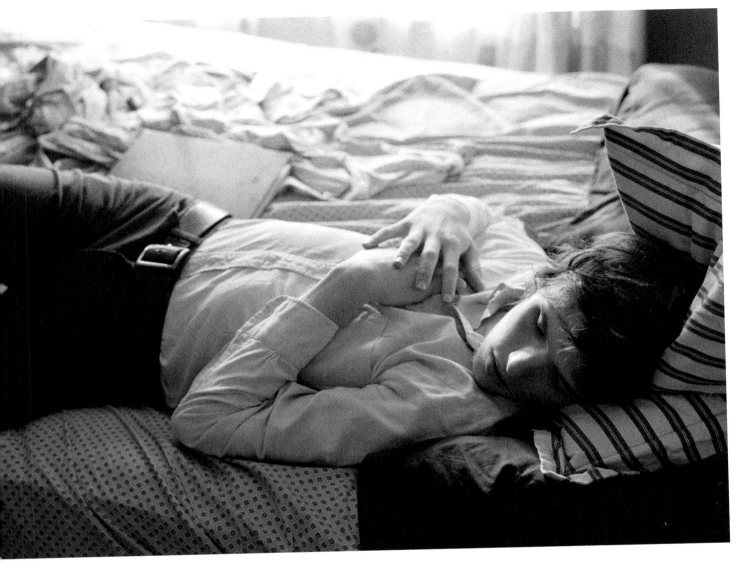

Dylan Sleeping No. 1, 200
Dylan Triangle, 2008 (opposite

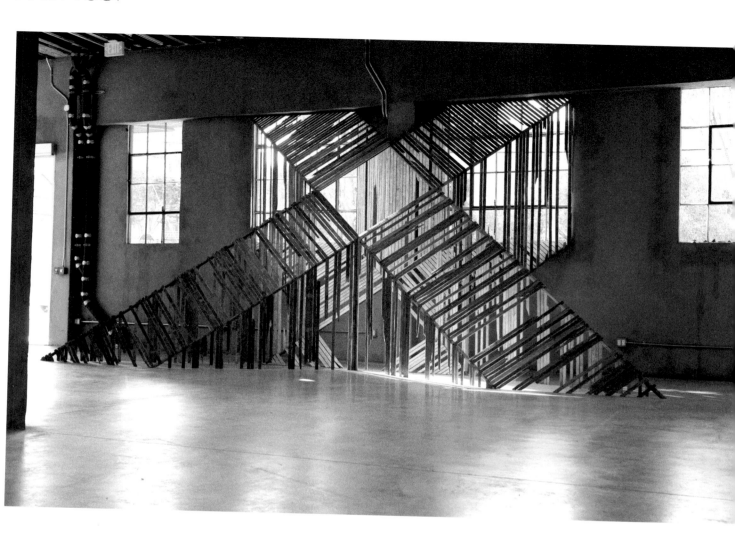

Gray Area, salvaged wood, 732 x 335 x 244 cm, 2010

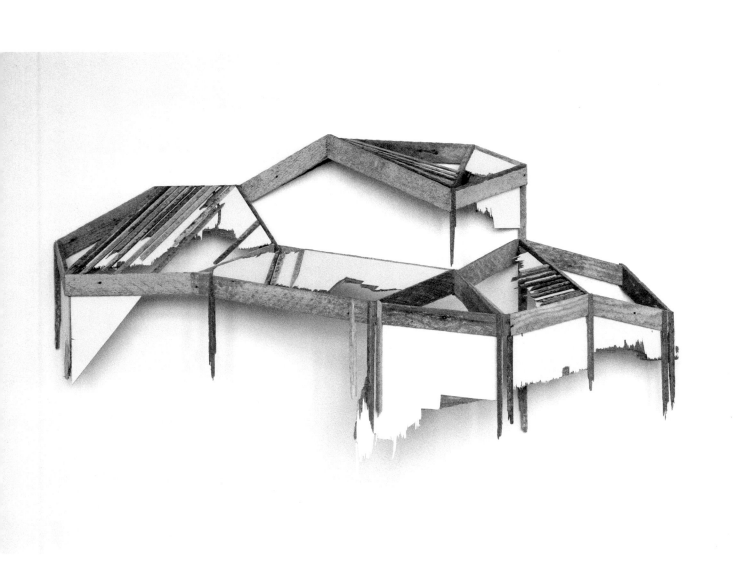

Skin & Bones, salvaged wood, acrylic, 107 x 35.5 x 55.9 cm, 200

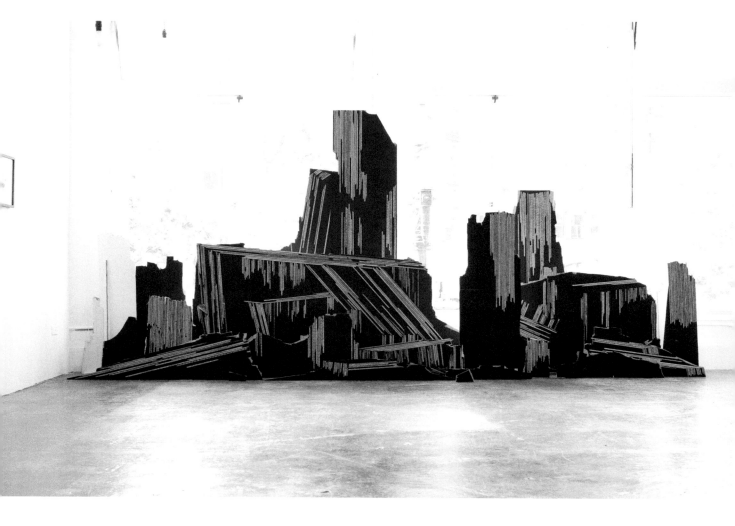

alf Timbre, Half Tone, salvaged wood, acrylic, 602 x 218.5 x 78.7 cm, 2008

)8

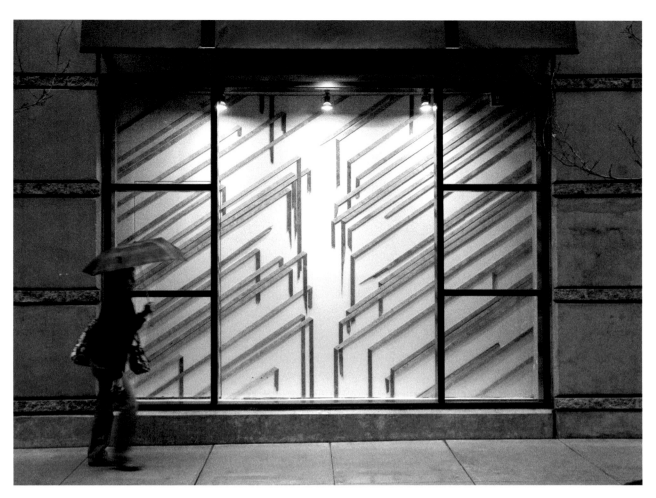

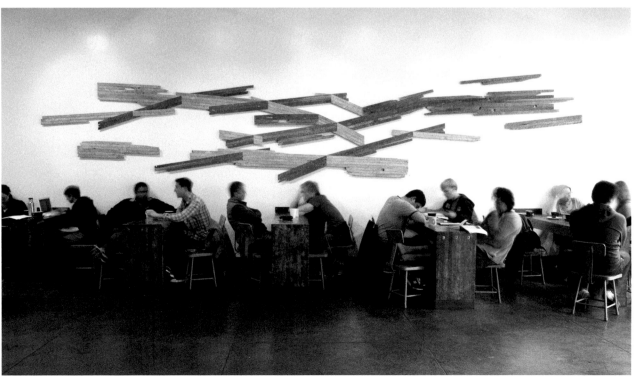

Untitled (Minna), salvaged wood, 365.7 x 304.8 cm, 2010 (top
Barren Echelon, salvaged wood, 762 x 183 cm, 2007 (bottom

Untitled, analog photography, 61×91.5 cm, 2008
Untitled, digital print, 61×91.5 cm, 2010 (opposite)

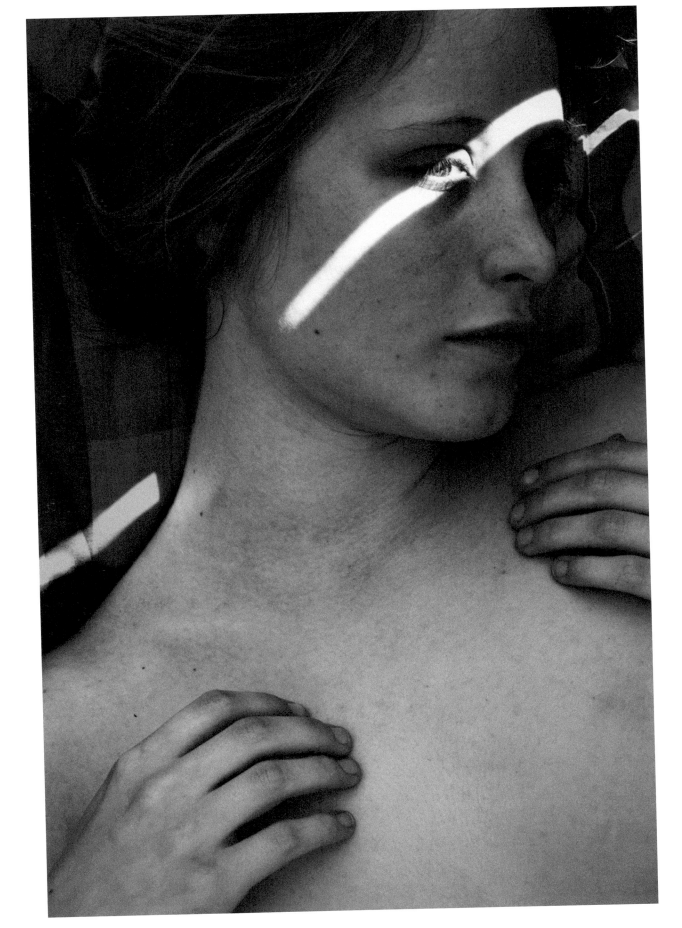

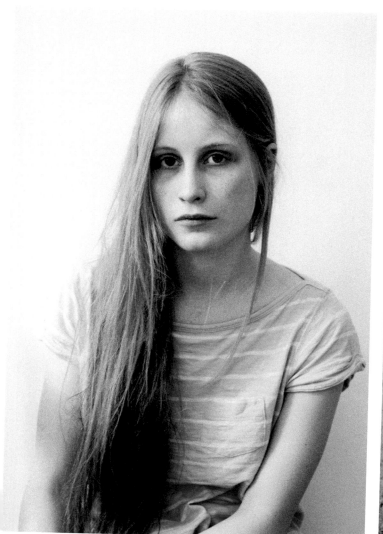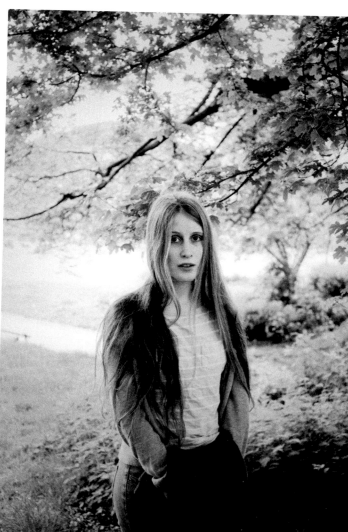

Untitled, digital print, 61x91.5cm, 2010 (left)
Untitled, digital print, 61x91.5cm, 2010 (right)
Untitled, analog photography, 61x91.5cm, 2010 (opposite)

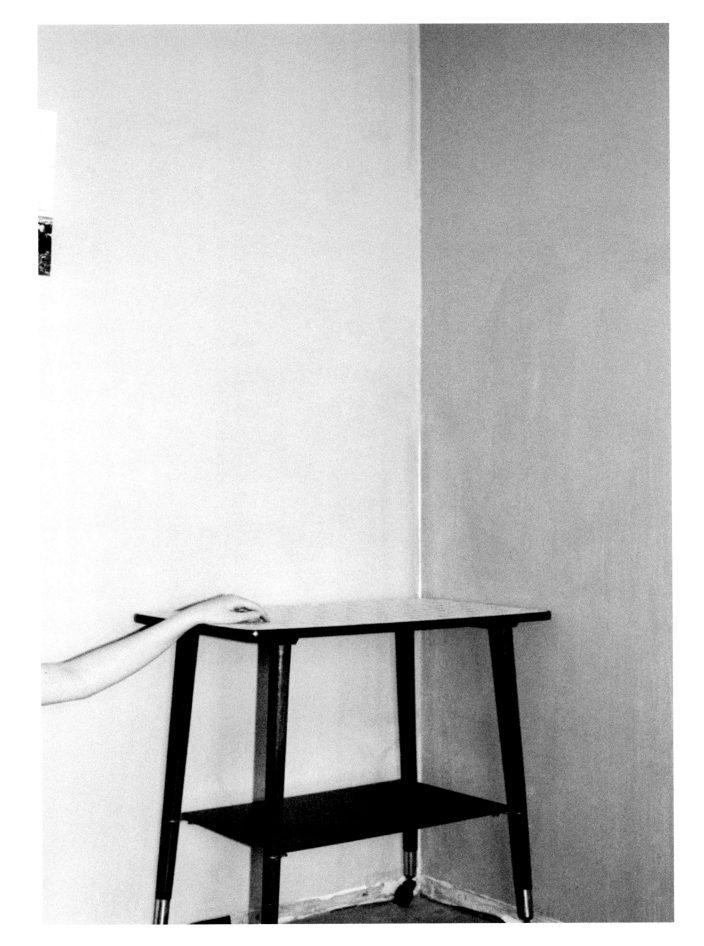

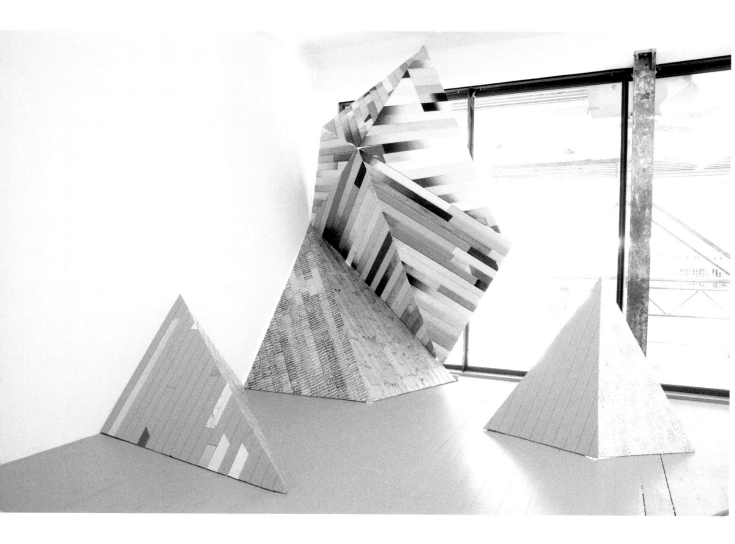

titled, wood, acrylic paint, varnish, 2008

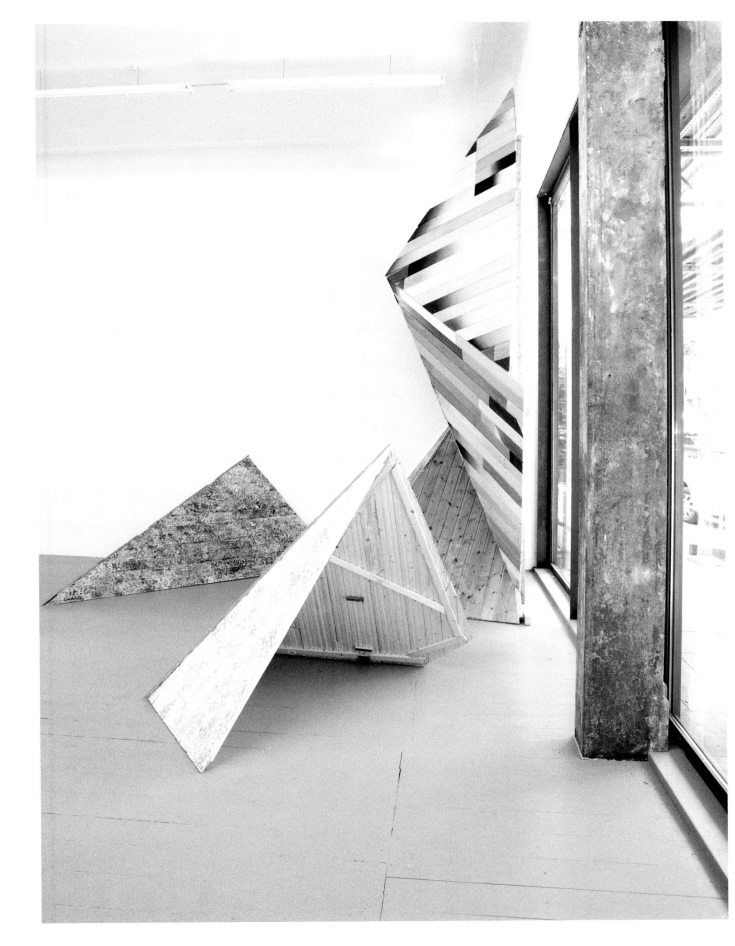

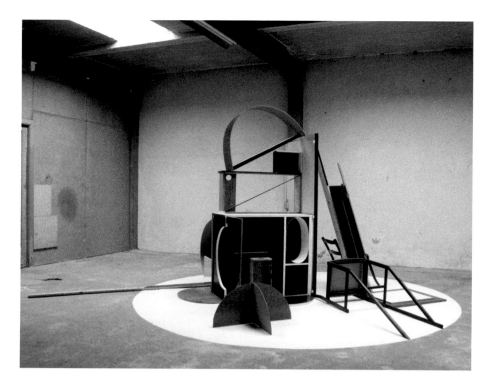

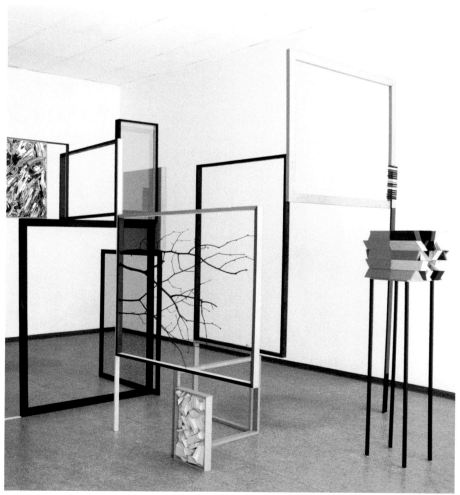

titled, wood, acrylic paint, varnish, 2008 (top)
r Berg und der Baum, wood, glass, acrylic paint, varnish, 2010 (bottom)

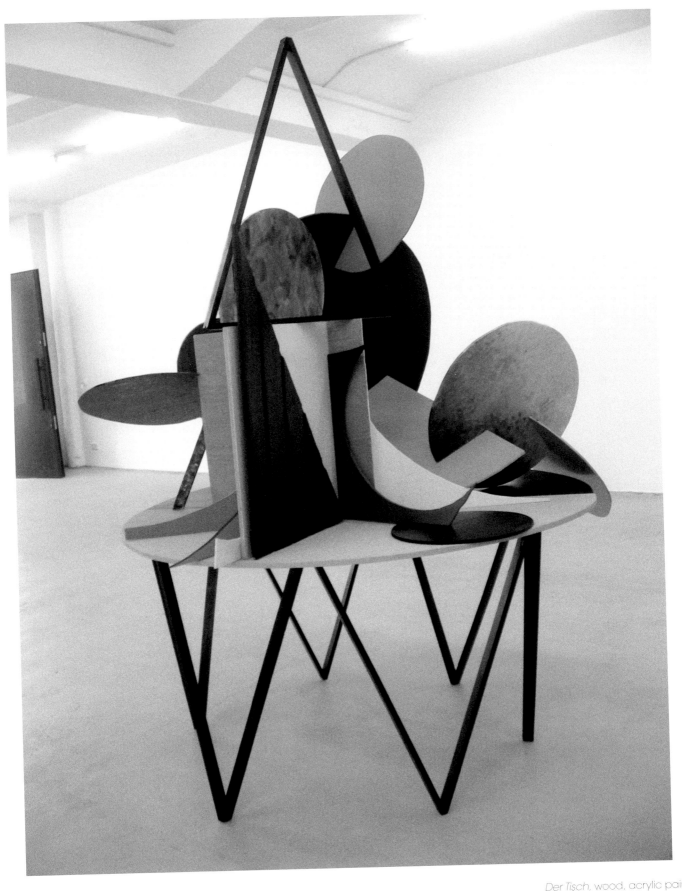

Der Tisch, wood, acrylic paint, 200

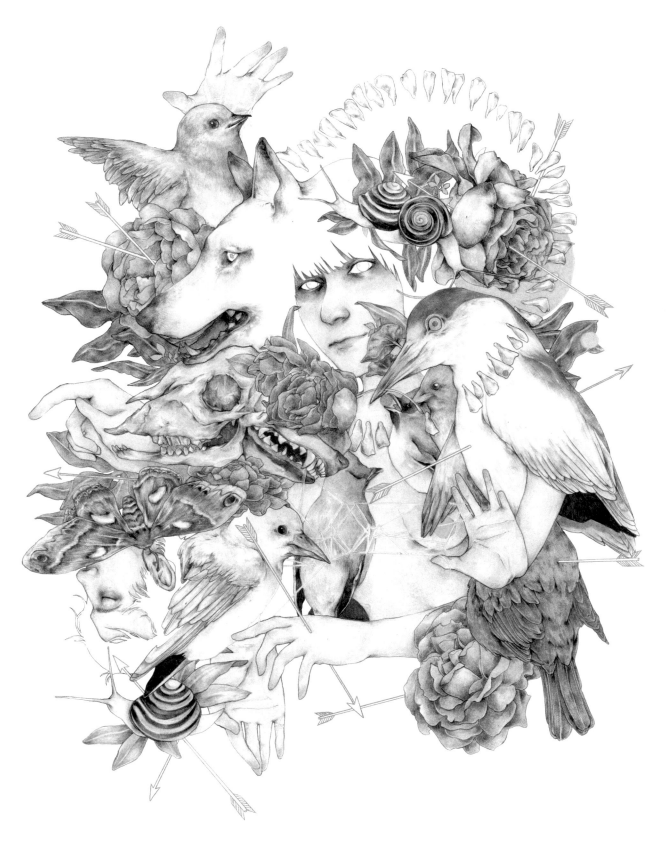

Your Soul Are Infinitely Precious Things That Cannot Be Taken From You, color pencil and graphite, 28×36cm, 2010

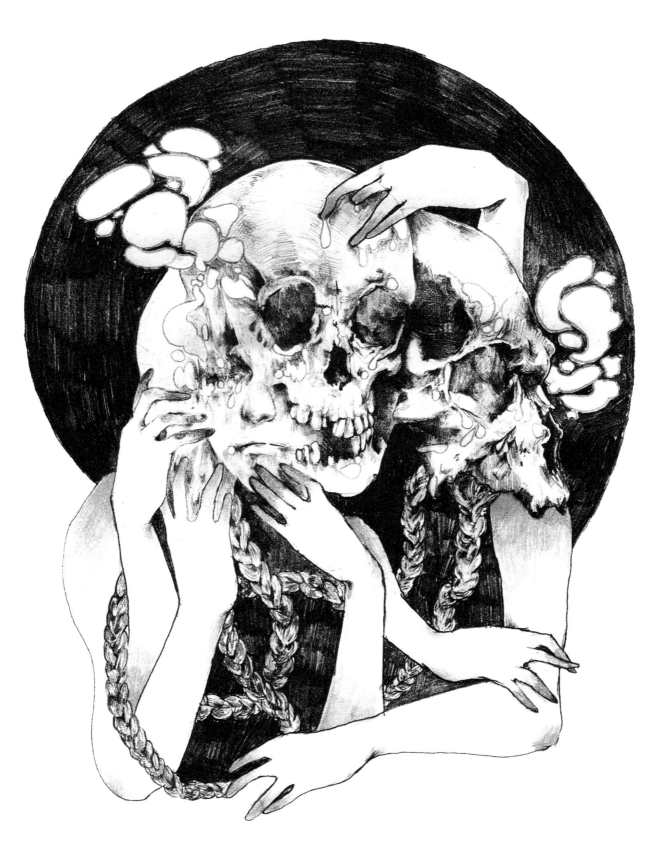

A Dream About Your Ghost, color pencil and graphite, 28x36cm, 20*

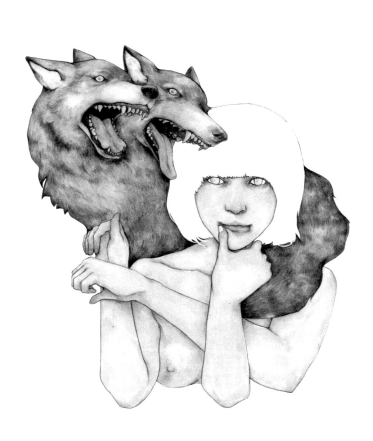

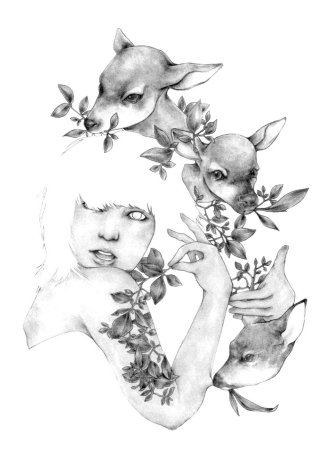

Shapeshifter: One, color pencil and graphite, 28×36 cm, 2008 (left)
Shapeshifter: Two, color pencil and graphite, 28×36 cm, 2008 (right)

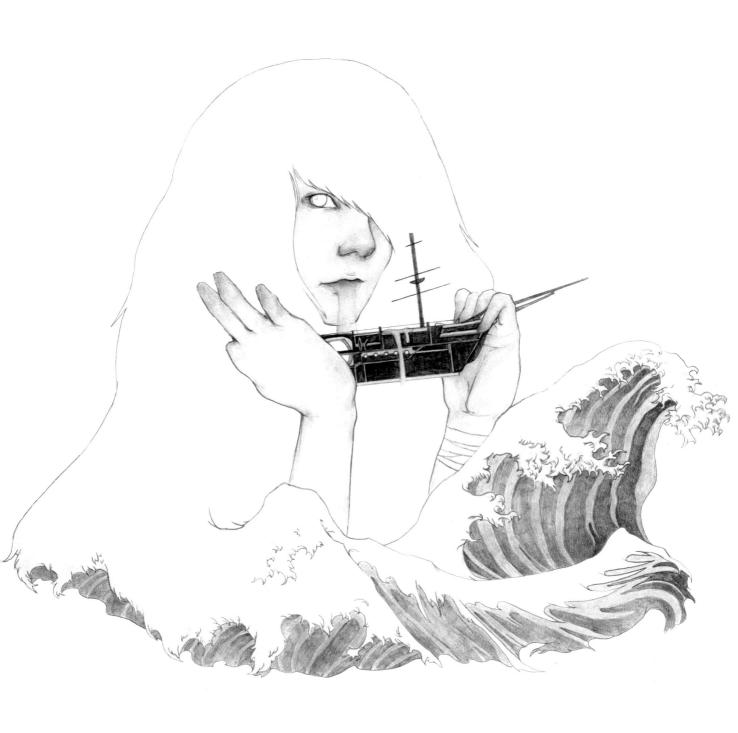

Sink Black Boat With My Heart, color pencil and graphite, 46x61 cm, 20[...]

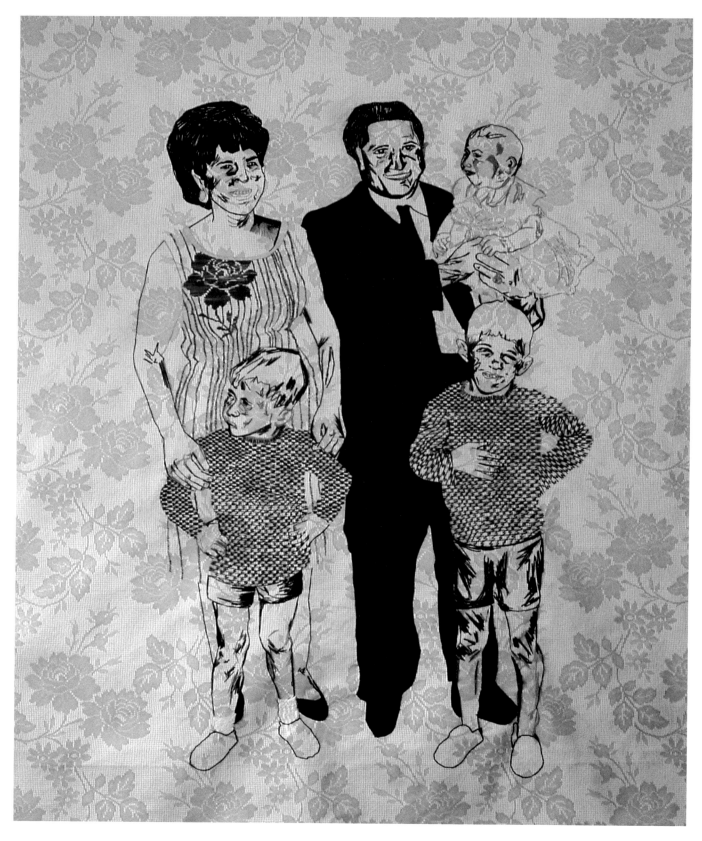

etrato de Familia I Tarzia-Tarzia, hand embroidery on rubber tablecloth, 150x180cm, 2007 (front side)

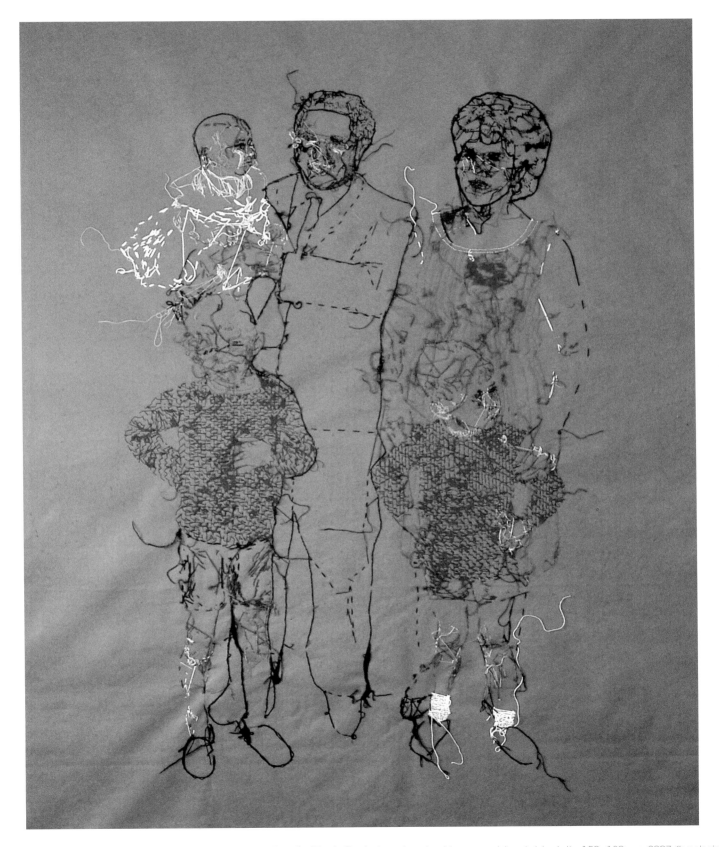

Retrato de Familia I Tarzia-Tarzia, hand embroidery on rubber tablecloth, 150×180 cm, 2007 (back sic

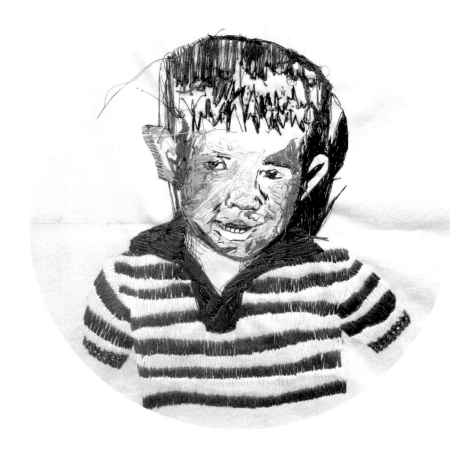

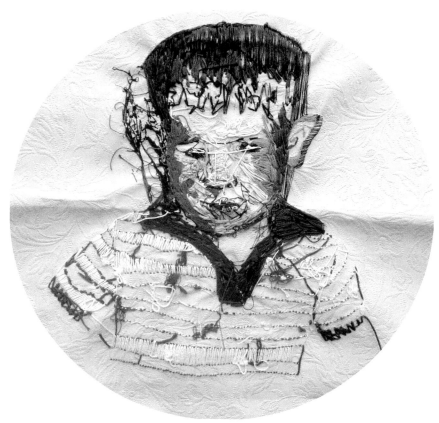

dre e hijo I, hand embroidery on rubber tablecloth, 50x50cm, 2008 (front) (top)
dre e hijo I, hand embroidery on rubber tablecloth, 50x50cm, 2008 (back side) (bottom)

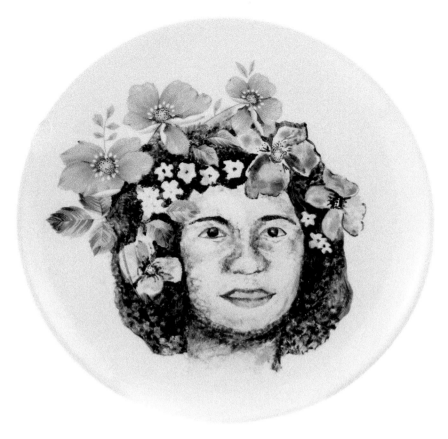

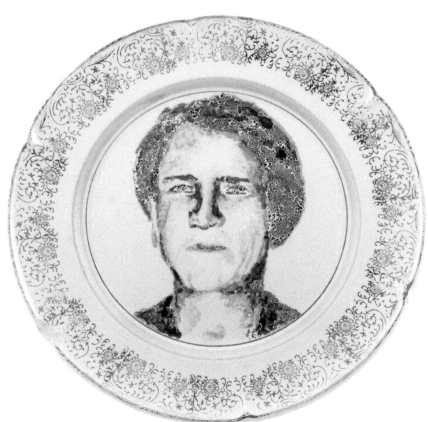

Ellas (Miguelina Casada), enamel on faience, 2009–2010 (top)
Ellas (Nona María), enamel on faience, 2009–2010 (bottom)

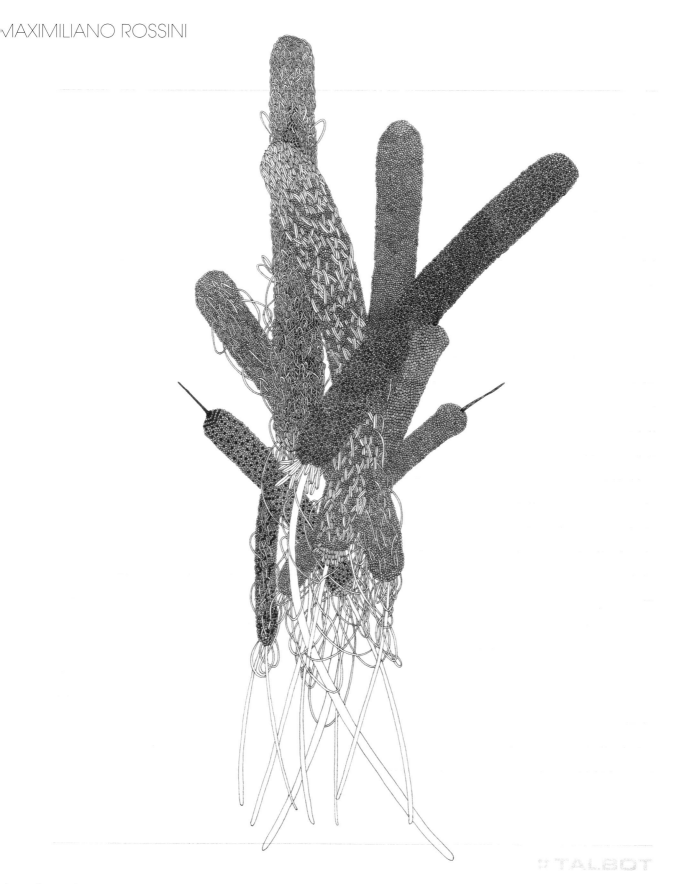

ptoras (La gente se muere porque extraña), Rotring ink on notebook sheet, 29×21 cm, 2009
ntitled (La gente se muere porque extraña), Rotring ink on paper, 42×29.5 cm, 2010 (opposite)

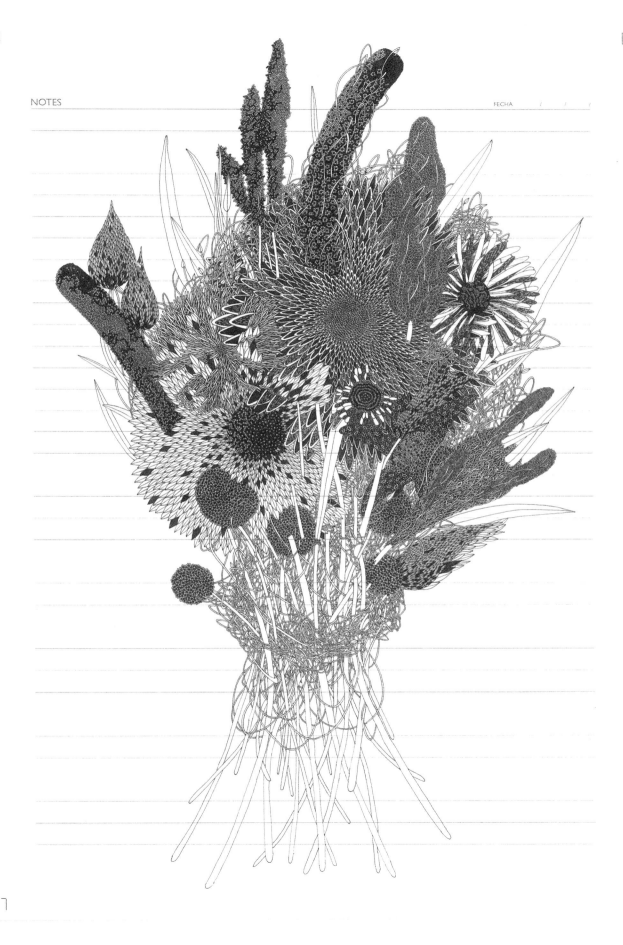

esta (La gente se muere porque extraña), Rotring ink on notebook sheet, 26x37 cm, 2009
gunos días (La gente se muere porque extraña), Rotring ink on notebook sheet, 37x26 cm, 2010 (opposite)

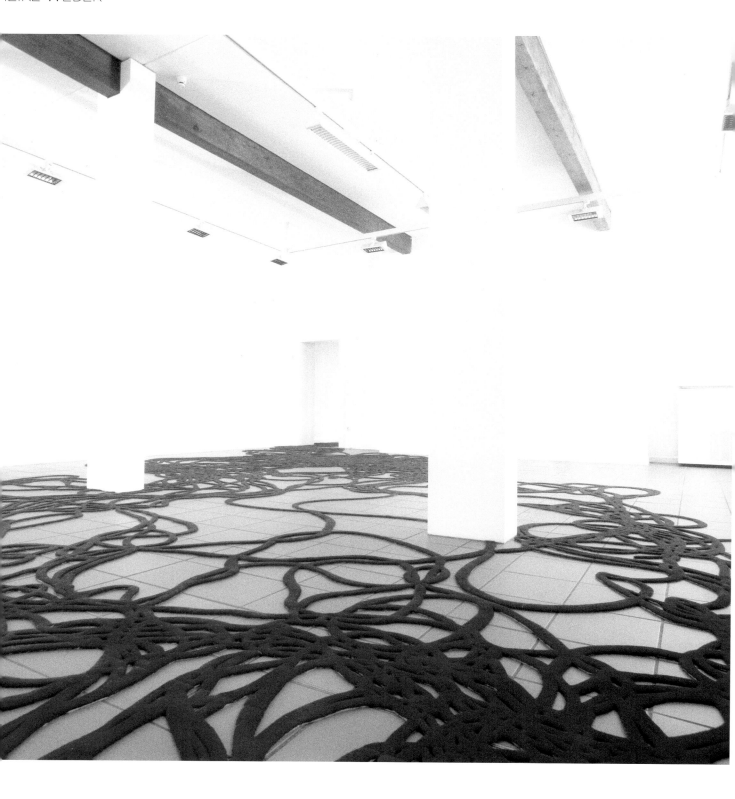

rocco, carpet cutout, 160 m², 2004
lonstück, permanent marker on vinyl floor, 65 m², 1998 (opposite)

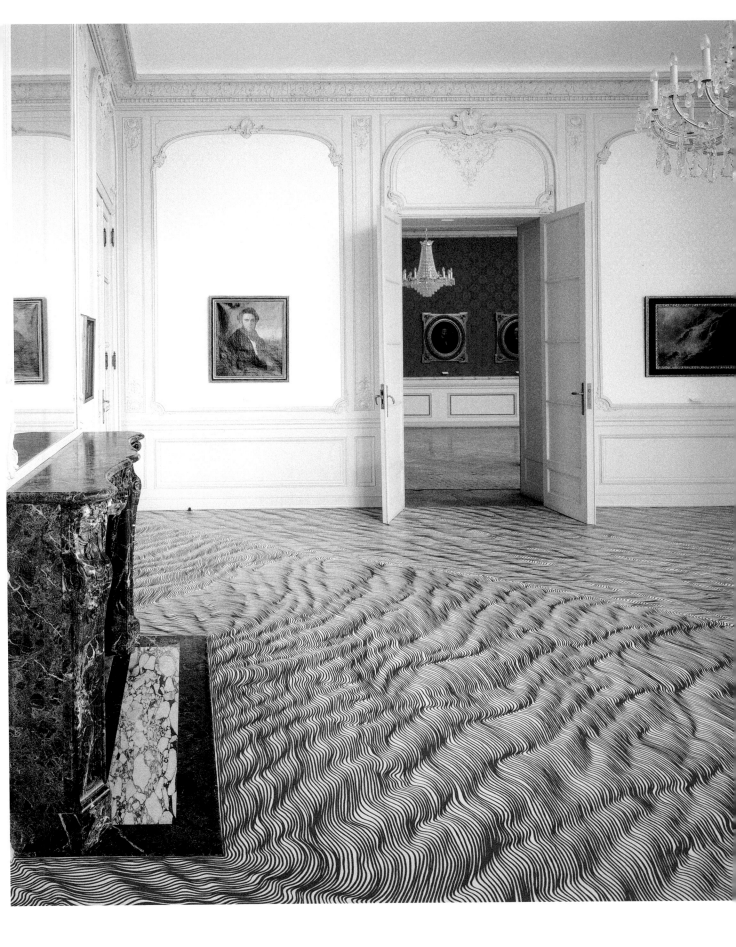

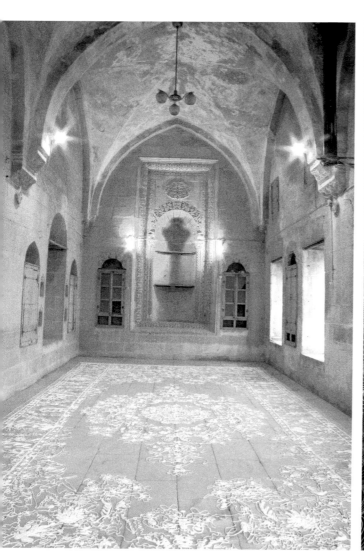

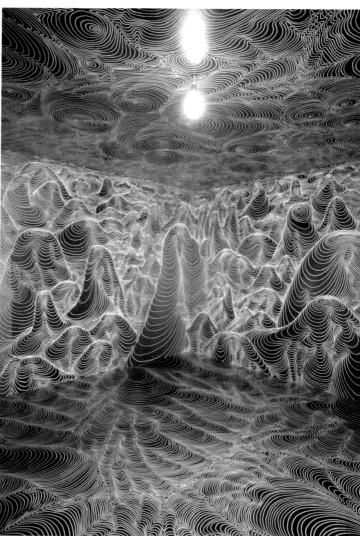

, silicone, 680×340 cm, 2007/2010 (left)
ia, permanent marker on wall and vinyl floor, 30 m², 2009 (right)
, silicone, 1100×220 cm, 2008 (opposite)

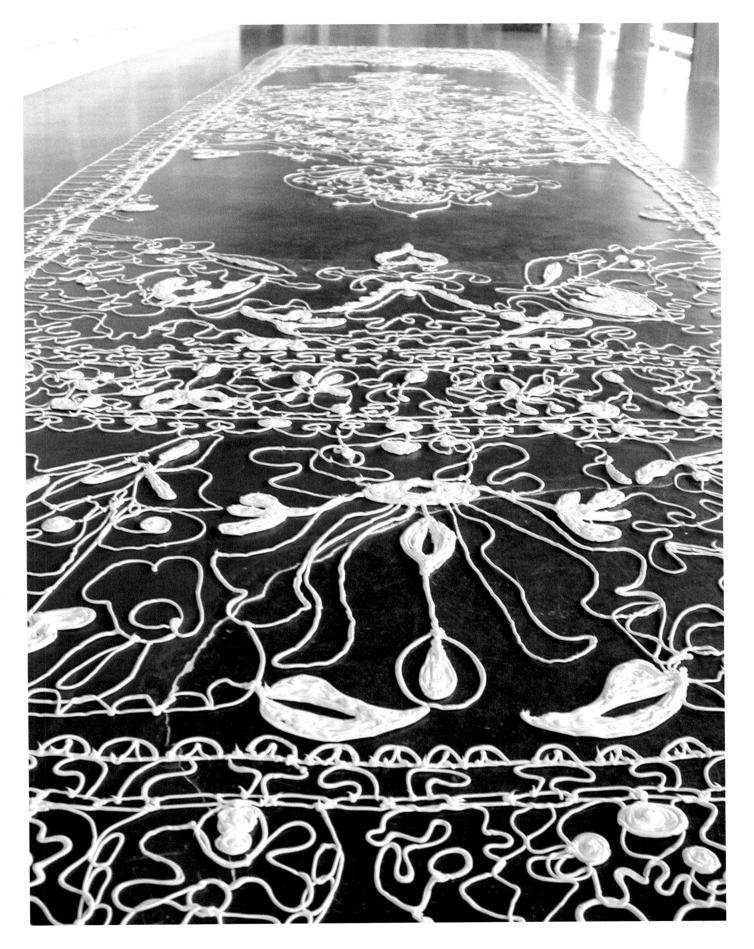

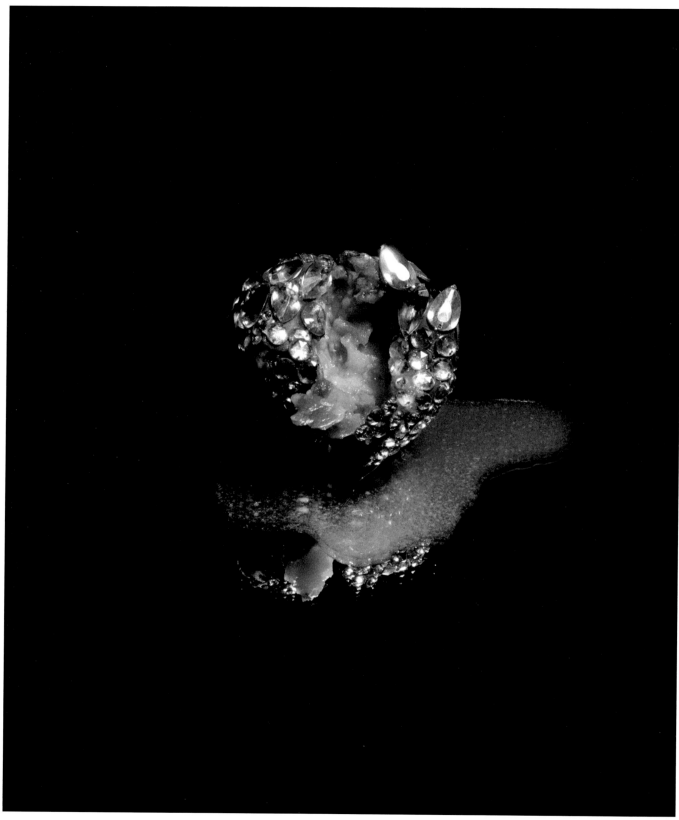

, fruits and plastic gems, 2010
as, fruits and plastic gems, 2010 (opposite)

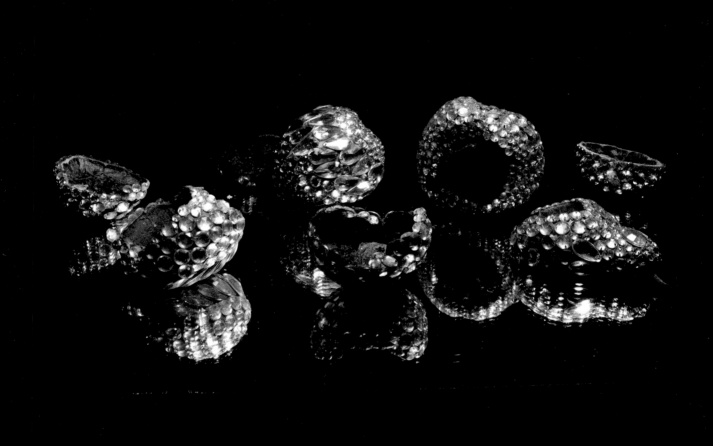

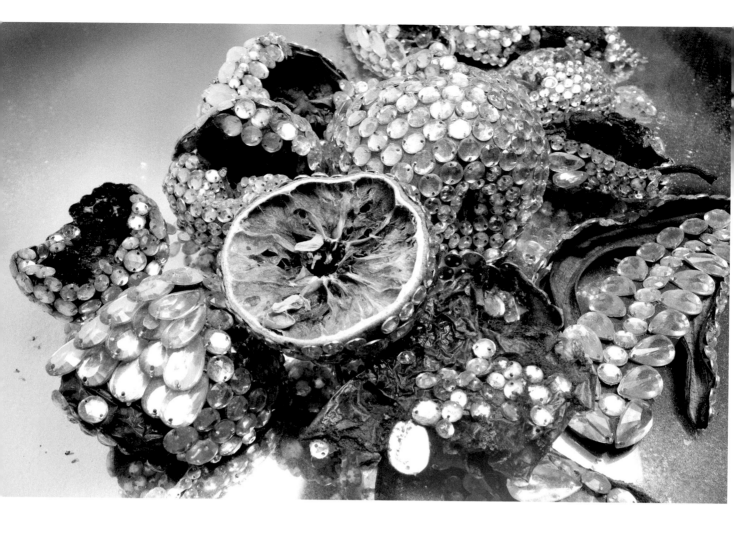

enid en piedra (detail from installation), mirror, fruits, and plastic gems, 2010

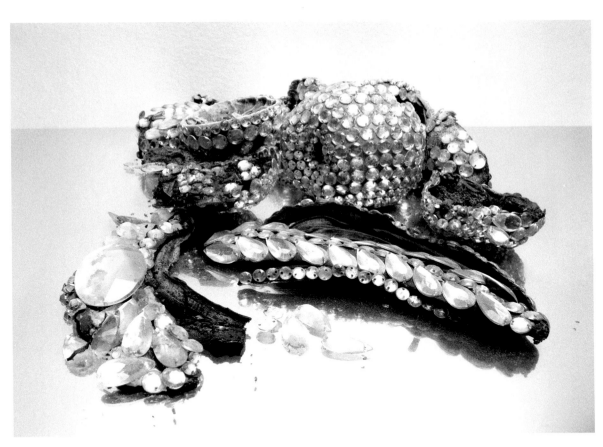

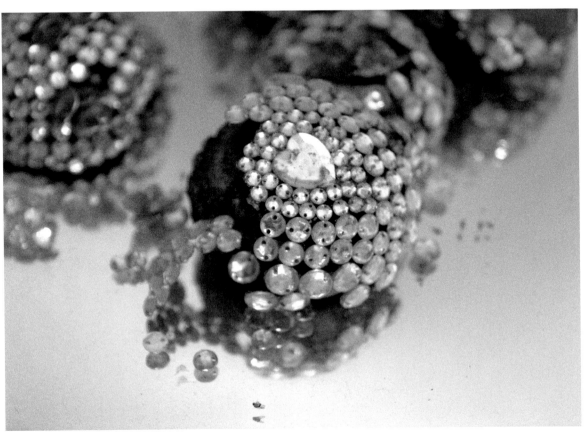

Devenid en piedra (detail from installation), mirror, fruits, and plastic gems, 2

ARTISTS

AGATHE DE BAILLIENCOURT
Germany
www.agathedeb.com

AILI SCHMELTZ
USA
www.ailischmeltz.com

AJ FOSIK
USA
ajfosik@gmail.com

AMY BENNETT
USA
www.amybennett.com
(images are courtesy of the artist, Tomio
Koyama Gallery and Richard Heller
Gallery)

AMY CHAN
USA
www.amychan.org

ANA LAURA PÉREZ
Argentina
www.analauraperez.com.ar

ANDREW BURTON
Australia
andrew.burton@newcastle.ac.uk
(images courtesy of NAC, Luke Tan,
Bernd Borchardt and Edwin Roseno)

ANDY VOGT
USA
www.andyvogt.com

BEATRIZ DIAZ ZURITA
Mexico
www.beatrizdiaz.com

BETSY WALTON
USA
www.morningcraft.com

BIANCA GUTBERLET
France
www.picnicparc.com

CÈLINE CLANET
France
www.celinette.com

CHRISTIAN HAGEMANN
Germany
www.christian-hagemann.com

CODY HOYT
USA
www.codyhoyt.com

DAEHYUN KIM a.k.a. MOONASSI
Korea
www.moonassi.com

DERICK MELANDER
USA
www.derickmelander.com

ESTELLE HANANIA
France
www.estellehanania.com

ERIK MARK SANDBERG
USA
www.eriksandberg.net

FUCO UEDA
Japan
www.fucoueda.com

FUMI NAKAMURA
USA
www.miniminiaturemouse.com

GINETTE LAPALME
Canada
www.ginettelapalme.com

GUERRA DE LA PAZ
USA
www.guerradelapaz.com

HEIKE WEBER
Germany
www.heikeweber.net
(images photographed by Carl-Victor
Dahmen and Raimo Rudi Rumpler)
HERNÁN PAGANINI
Argentina
www.hernanpaganini.com.ar

HOLLY ANDRES
USA
 www.hollyandres.com

JACKSON EATON
South Korea
www.jacksoneaton.com

JEAN PHILIPPE HARVEY
Canada
georgesgris@hotmail.com

JEFF DEPNER
Canada
www.jeffdepner.com

JONATHAN JACQUES
Belgium
www.jonathanjacques.be

KATHARINA TRUDZINSKI
Germany
www.katharinatrudzinski.de
(images photographed by Florian de
Rün and Petrus Heeren)

LEAH ROSENBERG
USA
www.leahrosenberg.org

LIANG-YIN WANG
Taiwan
www.wangliangyin.net

LOVISA RINGBORG
Sweden
www.lovisaringborg.se

LUCIANA RONDOLINI
Argentina
www.lucianarondolini.com

MARCUS OAKLEY
UK
www.marcusoakley.com

MARTÍN PISOTTI
Argentina
www.martinpisotti.com

MAXIMILIAN HAIDACHER
Austria
www.maximilianhaidacher.com
(*Alpenrose II* image is in collaboration
with Magdalena Fischer)

MAXIMILIANO ROSSINI
Argentina
maxrossini@gmail.com

MÁXIMO PEDRAZA
Argentina
tiermusik@hotmail.com

MEGAN CUMP
USA
www.megancump.com

MISAKO INAOKA
USA
www.misakoinaoka.com

MONA MOE MACHAVA
South Africa
www.monamoe.com

NICHOLAS HAGGARD
USA
www.nicholashaggard.com

NICHOLAS HANCE MCELROY
USA
www.nhmcelroy.com

NICK VAN WOERT
USA
www.fourteensquarefeet.com

OLIVIER LAUDE
France / USA
www.olivierlaude.com

ORNELA TARZIA
Argentina
glamourbizarro@hotmail.com

PASCALE MIRA TSCHAENI & MICHAEL
HUSMANN TSCHAENI
Switzerland
www.husmanntschaeni.com

PAUL WACKERS
USA
www.paulwackers.com

PLACERDESHACER
Uruguay
www.placerdeshacer.com

RACHELL SUMPTER
USA
www.rachellsumpter.com

REBECCA STEVENSON
UK
www.rebeccastevenson.net
(images photographed by Anders
Sune Berg)

RIIKKA SORMUNEN
Finland
www.riikkas.com

ROGER BALLEN
South Africa
www.rogerballen.com

RUSSELL LENG
Canada
www.russellleng.com

SARAH WILMER
USA
www.sarahwilmer.com

SCARLETT HOOFT GRAAFLAND
The Netherlands
www.scarletthooftgraafland.com

SERGIO MORA
Spain
www.sergiomora.com

SHARY BOYLE
Canada
www.sharyboyle.com
(images photographed by Brian Boyle
and Rafael Goldchain)

SOL SANTARSIERO
Argentina
www.solsantarsiero.com.ar

SOPHIE JODOIN
Canada
www.sophiejodoin.com

TAKASHI IWASAKI
Canada
www.takashiiwasaki.info

TOMMY STØCKEL
Denmark
www.tommystockel.net

VICENTE GRONDONA
Argentina
vicente.grondona@gmail.com

WILLIAM EDMONDS
UK
www.williamedmonds.co.uk

RUBY

OTHERWORLDLINESS

A project by Irana Douer
Edited by Irana Douer
Introduction text by Sofia Dourron

Cover image by Luciana Rondolini
Layout by Irana Douer
Typeface: Avant Garde Gothic

Project management by Julian Sorge for Gestalten
Production management by Martin Bretschneider and Janine Milstrey for Gestalten
Proofreading by Tammy L. Coles
Printed by Sing Cheong Printing Company Ltd, Hong Kong
Made in Asia

Published by Gestalten, Berlin 2011
ISBN 978-3-89955-343-7

For more information, please visit www.gestalten.com
www.ruby-mag.com.ar

Bibliographic information published by the Deutsche Nationalbibliothek.
The Deutsche Nationalbibliothek lists this publication in the Deutsche Nationalbibliografie;
detailed bibliographic data is available online at http://dnb.d-nb.de.

None of the content in this book was published in exchange for payment by commercial parties
or designers; the selection of all included work was based solely on its artistic merit.

This book was printed on FSC®-certified paper.

Gestalten is a climate-neutral company and so are our products. We collaborate with the non-profit carbon offset
provider myclimate (www.myclimate.org) to neutralize the company's carbon footprint produced through our worldwide
business activities by investing in projects that reduce CO_2 emissions (www.gestalten.com/myclimate).